Testament to Union

TESTAMENT TO UNION

Civil War Monuments IN WASHINGTON, D.C.

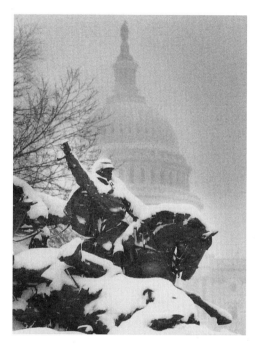

Kathryn Allamong Jacob

Photographs by
Edwin Harlan Remsberg

THE JOHNS HOPKINS UNIVERSITY PRESS BALTIMORE AND LONDON

© 1998 The Johns Hopkins University Press
All rights reserved. Published 1998
Printed in the United States of America on acid-free paper

9 8 7 6 5 4 3 2 1

The Johns Hopkins University Press
2715 North Charles Street
Baltimore, Maryland 21218-4363
www.press.jhu.edu
The Johns Hopkins Press Ltd., London

Library of Congress Cataloging-in-Publication Data will be found
at the end of this book.
A catalog record for this book is available from the British Library.

ISBN 0-8018-5861-5

FRONT MATTER ILLUSTRATIONS
title page: detail, cavalry group, Grant Memorial
dedication page: Energy, Fame, and Loyalty on Meade Memorial
contents page: detail, Pension Building frieze

For Rob, Charlotte, Annie,
and my mother, Doris Allamong

Contents

APPENDICES

Acknowledgments

IN THE COURSE of researching this book, I've learned a great deal about remembrance and the power of sculpture to evoke memories. Certainly some statues conjure up memories for me, though not those the artist had in mind. The monuments lining the lanes that crisscross the Gettysburg Battlefield evoke vivid, happy memories of family excursions on cold October days. The statue of the Archangel Michael holding the dead soldier in his arms that stands in Philadelphia's 30th Street Station brings back memories, not of sacrifice, but of Christmastime train trips with my grandmother and apple dumplings pulled from automat windows. The statuary groups of massed men and women on either side of the entrance to the State Capitol in Harrisburg, where I grew up, remind me of peanuts and feeding squirrels with my mother in the adjacent park. The statue of Major General George B. McClellan in Washington will for me always be associated not with the loyalty he inspired in his men but with a naked man sleeping amidst dense boxwood at the statue's pedestal, whom I took for dead when I invaded his resting spot one hot August day, in my quest to read the obscured inscription.

Looking over Edwin Remsberg's handsome photographs of Washington's Civil War monuments reminds me of my indebtedness to the staffs of many institutions and to friends and colleagues. The staffs of the Historical Society of Washington, D.C., the Washingtoniana Division of the Martin Luther King, Jr., Public Library, the Manuscripts Division and the Prints and Photographs Division of the Library of Congress, the Office of the Architect of the Capitol, the historical office of Arlington National Cemetery, and Congressional and Fort Lincoln Cemeteries, the Archives of American Art, and the library of the National Portrait Gallery and National Museum of American Art have been both gracious and helpful. I would especially like to thank Christine Hennessey and her staff at the Inventory of American Sculpture, and Sam Anthony and the staff of the library at the National Archives for their help. Special thanks go to my colleagues at the National Archives, the National Historical Publications

and Records Commission, and the American Jewish Historical Society, who led me to sources, read drafts, facilitated research, listened to anecdotes, and risked stares and worse to check out the gender of General Scott's horse. Those who joined me on sculpture expeditions, braving wild dogs at Congressional Cemetery and derelicts in parks, are good friends indeed. I am deeply grateful to Robert Brugger and Anne Whitmore of the Johns Hopkins University Press; James Goode, whose pioneering work on outdoor sculpture in Washington has been invaluable; Nancy Sahli, Stanley Remsberg, and Mike Meier, whose sharp editorial eyes and red pencils and knowledge of the Civil War saved me from many blunders; and John Higham, my mentor, for his continuing guidance and advice.

Every page of the manuscript reminds me of the support for and interest in my work, the patience with my stories, and the time carved out to write that have been afforded me by Rob, Charlotte, Annie, and my mother, Doris Allamong. K.A.J.

I'M NOT SURE one can completely interpret three-dimensional artworks in only two dimensions. The two-dimensional creation is a wholly separate entity created from the original. With lenses and lighting I try to trick the viewer into seeing depth in a flat surface. Reducing an experience that involves all the senses into one that is merely visual is its own struggle. The calm, rested Lincoln looms larger after you arrive winded at the top of all those stairs at the Lincoln Memorial. I cannot look at any of the Arlington Cemetery pictures without hearing the constant funeral dirges that are always present in the quiet there. These still, silent monochromes are at best only clues about the reality from which they are rendered.

The crimes of modernism have left us with a society that fears public art. The great mass of people, offended by the average modern scrap heap sculpture, are made to feel ignorant and uncultured for their offense. We end up with private art in a public space that pretends to be otherwise. I have a great respect for the honesty of the war memorials. They are egos mounted on pedestals and completely unapologetic about it.

With my wooden view camera and old straw hat I often became part of as many pictures as I took. At the Lincoln Memorial a group of Japanese tourists each took turns being photographed with me. At Sherman, I was videotaped as I worked. Thus history goes on repeating itself as I myself am preserved documenting memorials.

I wish to thank Tenny Mason at Patuxent Publishing for use of their large format lenses, Trudy Slinger for her darkroom support, and all of the helpful staff at the National Park Service, the Interior Department Museum, and Arlington Cemetery who allowed me to disrupt the peace and quiet of their institutions. Also my students at the University of Maryland, Hooman Shafee, Andrea Lightman, and Elizabeth Sanchez, who helped at various times. And my two-year-old assistant, Bennett Remsberg, who hiked around Washington with Dad, waiting for one of those statues to move. E.H.R.

Testament to Union

INTRODUCTION

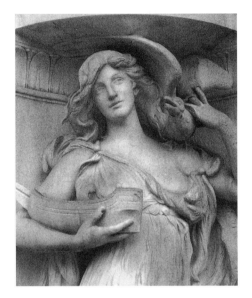

Illustration: *detail of The Sea on Du Pont Fountain*

THICK, DARK CLOUDS BEGAN TO GATHER OVER THE SLOPING HILLS of Arlington National Cemetery on the afternoon of June 4, 1914, as a large crowd assembled for an event that would have been unthinkable fifty years earlier: the dedication of a monument to the Confederate dead. In June 1864, as the Civil War raged into its third year, the graves of more than four thousand Union dead already dotted the old Arlington estate, which the federal government had seized from Mary Anne Custis Lee, wife of Confederate general Robert E. Lee, and turned into a national cemetery. Union quartermaster general Montgomery C. Meigs had ordered Mrs. Lee's rose garden uprooted and graves dug almost to her doorsill. By the end of the war, the graves of more than ten thousand Union soldiers, including that of Meigs's only son, covered Arlington's acres.

For as long as he was quartermaster general, Meigs, whose hatred of the South was never slaked, refused entry to the cemetery to the families of the several hundred Confederate dead, mostly prisoners of war, buried there. Meigs must have rolled over with wrath in his own Arlington grave on the June afternoon in 1914 when several thousand people gathered to dedicate the largest monument in the cemetery, the Confederate Monument. Erected by the United Daughters of the Confederacy with the blessing of the United States government, the 32-foot-high monument honors the Southern dead. Heavy with symbolism, the elaborate statue is crowned by a woman, representing the South, wearing olive leaves of peace in her hair and holding a plowshare and a pruning hook.

At the dedication, joining the ladies of the United Daughters of the Confederacy in their summer hats of shimmering pastels were hundreds of elderly Confederate veterans in faded gray and dozens of frail Union veterans in worn-out blue. Together they looked on as the ceremonies began with a procession of dignitaries, including President Woodrow Wilson, himself a son of the South, preceded by the stars and stripes of the United States and the stars and bars of the Confederacy. Afterwards, speech followed speech, all long and emotional, all on the twin themes of valor and unity.

The commanders of both the United Confederate Veterans and the Grand Army of the Republic addressed the appreciative crowd. In the wake of the Spanish-American War, in which former Confederates had enlisted in great numbers, the G.A.R. spokesman evoked a vivid image of a reunited brotherhood ready to "fight shoulder to shoulder against all the world for country's sake." His U.C.V. counterpart ended his address on an equally positive note: "May the hands that fought be the hands that clasp and the hearts that bled be the hearts that rejoice."

As lightning flashed and thunder rumbled, President Wilson accepted the Confederate Monument on behalf of all of the American people. After a hasty benediction, the crowd hurried away. Down from the hilltop, wrote the *Washington Star*'s reporter, tottered the elderly Confederate and Union veterans, leaning on each other for support.

What one reporter labeled a "love fest" that day was not an aberration. The speed with which reconciliation between North and South seemed to catch hold is astonishing. As many historians have documented, sectional harmony spread like a contagion after the 1880s. Events where old Yankees and Rebels joined together to honor their collective comrades had become commonplace by 1914. Just the summer before, in July 1913, on the fiftieth anniversary of the Battle of Gettysburg, units of bewhiskered Union and Confederate veterans had marched across the central Pennsylvania wheatfields once again. When they met this time, at a prearranged signal, all clasped the wrinkled hands thrust their way and smiled broadly for dozens of newspaper photographers. "Blue and Gray" banquets were popular, festive affairs in many communities. Since the late 1880s, military reunion societies had been inviting former enemies to pitch tents alongside theirs on the old battlefields.

While the phenomenon to which so many succumbed was as much an epidemic of collective amnesia as one of collective forgiveness, whether a case of forgiving or forgetting, some individuals were nonetheless immune. Occasionally resistance to reconciliation surfaced unexpectedly, revealing that, beneath the superficial healing, pockets of bitterness still festered. In 1864, Congress had created Statuary Hall in the Capitol and invited each state to send two statues of citizens "illustrious for their historic renown or for distinguished civic or military services." After the war, statues flowed in from the North and the West, but few came from the South until 1903, when Virginia announced its intended gifts: bronze portrait statues of Generals George Washington and Robert E. Lee. At the same time, a move was afoot by a group of Southerners to erect an outdoor statue of Lee elsewhere in Washington.

The outcry from the North was instantaneous. The G.A.R. flexed every political muscle it possessed—and it possessed quite a few—to prevent the "desecration" of the Capitol and the capital city by likenesses of this "treasonous conspirator." A tidal wave of angry letters

swamped congressional offices. Virginia reconsidered. It bided its time for three decades before quietly offering the statues again. Both Washington and Lee were unveiled in Statuary Hall in 1934. Other groups trying to erect public monuments to Lee in the capital fared less well. Each of their attempts—half a dozen to date—has failed, smothered under the sacks of letters and resolutions of opposition that filled the corridors of the Congress.

Many public officials were taken by surprise by the intensity of the emotions unleashed by these proposals. In 1902, Charles Francis Adams initially supported the proposal for a Lee statue in Washington, arguing that it would symbolize the South's postwar progress, its "patient building up of a people under new conditions by constitutional means." As soon as he realized which way Northern winds of opinion were blowing, Adams fell silent.

Three decades later, in the early 1930s, New York Congressman Hamilton Fish Jr. introduced a bill in Congress on behalf of a group seeking to erect an equestrian statue of Lee at Arlington Cemetery. Fish suggested that such a statue would "cement the feelings of unity between North and South engendered by both the Spanish and World War." While noting that there were few members of the G.A.R. remaining, Fish concluded, "I am confident that they would be among the first to pay tribute to the memory of their gallant foe." Fish misjudged.

G.A.R. posts and reunion societies inundated his office with protests. One resolution from Boston began: "We believe it unseemly that a statue of any man who fought with rebel forces with the object of overthrowing this government should be recognized in this manner, regardless whether it is Robert E. Lee or any other traitor." While Fish and the statue's other proponents seemed oblivious to the irony of their plan, it did not escape its opponents, one of whom wrote, "The idea of erecting a statue of him in a cemetery where he was responsible for the deaths of thousands of those buried there, seems to me outrageous."

What Adams, Fish, and all those surprised by the deep wells of bitterness tapped by these proposals failed to grasp was that far more was at stake than just another statue. The high stakes for which they were playing were quite clear, however, to the ardent proponents and opponents of the various Lee statues. They understood that statues were, and are, more than the sum of their metal and stone parts. Public monuments yield cultural power. Each one carries a heavy load of invisible ideological baggage.

Mundane as they may appear, ubiquitous as they may be, public monuments constitute serious cultural authority. They are important precisely because, by their mere presence and their obvious expense, they impose a memory of an event or individual on the public landscape that orders our lives. These monuments confer a legitimacy upon the memory they embody. Their size and costliness testify to its importance. And by imprinting one memory, they erase others.

The American colonists who pulled down the gilded lead equestrian statue of George III in New York City at the start of the American Revolution understood the power of public statues. Legend has it that they melted down the king's likeness into forty thousand bullets. The citizens of the former Soviet Union who pulled down statues of Lenin in the 1980s understood their power as well. Americans who struggle over the iconography of public monuments commemorating President Franklin Delano Roosevelt, the Holocaust, and the victims of the Oklahoma City bombing know their power still as the twentieth century draws to a close.

Historians and art historians, who have recently explored questions of memory, national identity, and monuments, offer challenging new ways of looking at public sculpture. They articulate the phenomenon that the men and women who seek to erect public monuments have always instinctively understood. Simply put, public monuments help shape collective memory. They weave an intricate web of remembrance in which certain threads are highlighted, or validated, while others are dropped and disappear.

Concern about *which* memory will endure leads self-interested groups to try to inscribe *their* memory onto the landscape, to objectify *their* side of the story, to suggest to every viewer that *this* image tells the *true* story of the past. Seen in this light, the spurts of monument-raising that follow in the wake of most wars are understandable, and, in the view of their proponents, the effort and money poured into them is entirely justifiable, because the memorial will bear witness to the justice of their cause.

War, with its grim cost in human lives, is the most extreme political action a nation can take. Because the toll is so high and so emotional, it is extremely important to those who led the nation into the conflict and those who fought it (and the two may, as in the case of the Vietnam War, see matters quite differently) that the memory conveyed by the memorial enshrining that war be the *correct* one. The stakes are high indeed. Whoever wins the battle for the monument wins the collective memory of future generations. Heavy baggage indeed for bronze and marble shoulders to bear! That the fight is still considered well worth winning is amply demonstrated by the heated debates that have swirled over the U.S.S. *Arizona* memorial in Hawaii, the monument at Little Big Horn, the Vietnam, Korean, and World War II war memorials, and monuments commemorating the roles of African Americans and women in America's wars.

The stakes were high and clearly recognized by the men and women who worked indefatigably to raise Civil War monuments. They understood the link between monuments and memory. Monuments could, they grasped, vindicate and reshape the past. The socially prominent women of the North Carolina Monument Association, dedicated to erecting statues to that state's Civil War heroes, could not have made the connection more explicit. Their motto was: "A land without monuments is a land without memories." Time after

time, at dedications throughout the North and South, audiences were assured, "These monuments will tell the story." In fact, the orators meant *our* story. At one summertime reunion of Confederate veterans, the old soldier in charge of raising funds for monuments to fallen comrades spoke of statues as teachers that would teach "the young people of today . . . that their fathers were not traitors, but brave patriotic soldiers." "These voiceless marbles," he pleaded, "in their majesty will stand as vindicators of the Confederate soldier." In 1903, at the dedication of the Washington memorial to General William Tecumseh Sherman, General David Henderson of the Society of the Army of the Tennessee summed up the raison d'être of all war memorials: "The statues of the world are silent historians."

Those who proposed and opposed the Lee statues in Washington also understood the power of monuments. Union veterans might tent next to their old enemies on long-quiet battlefields on starry summer nights. They might tolerate an allegorical figure of the South decked out in olive leaves, plowshares, and pruning hooks, and honor the sacrifice of their nameless former foes at its dedication. But were they to accept life-size, lifelike, portrait statues of handsome General Robert E. Lee himself–the traitor whose personal orders sent thousands of Union boys to their graves–the single man into whom the South had distilled all it held sacred? And set him up in the United States Capitol, in a prominent park in the federal city, in Arlington Cemetery no less? This was a leap the old soldiers and even otherwise reconciled Yankees could not make. This was a legitimacy they could not grant. They understood the message Lee's image on federal soil would send down through the years as well as did those who wanted to place it there, and they found it unacceptable.

That the Civil War should prove the catalyst for more public monuments across the nation than any other American war is hardly surprising. The Civil War remains the defining event in the nation's history. A war in which more than 620,000 soldiers lost their lives, a war between countrymen who shared a common past and a common ground, was a war ripe for memorials. Many cared passionately about the messages these monuments would convey and the memories they would reinforce or invent.

In May 1866, 29-year-old William Dean Howells was back home after spending the war years in Venice as American consul. Like others of his generation, he felt the nation had undergone an earth-shaking change. The "new" nation, forged in the crucible of battle, required some sort of tangible proof that the war had achieved a moral reformation justifying its catastrophic violence. In an essay entitled "The Question of Monuments" in the *Atlantic Monthly*, Howells surveyed the possibilities for commemorating the war and issued a challenge to practitioners of the "plastic arts" to prove that they too had "suffered the change which has come upon race, ethics, and ideas in their new world." He specifically did not want the "plastic arts" to pay homage to individual generals and battles. It was the

ideals of the war, not the warfare, the worthy ends that had justified the awful means, that Howells wanted to see immortalized.

The question of monuments was quickly answered. After the war, Civil War monuments popped up like mushrooms after a rain, but the first to arise were precisely the kind that Howells despised: unquestioning, uncomplicated tributes to the dead. As the century turned, Howells's question would be asked again; and new answers, more to his liking, would be given as Civil War statuary changed with the evolving memory of the war itself, a change reflected in the monuments in Washington's parks, avenues, and cemeteries.

The desire to honor the dead, pure and simple, seized towns throughout the North and South even while bodies still lay in the fields. While the South lacked the resources to respond to the impulse as quickly as the North, the results were nearly identical. Most of these local monuments made no claims to being great works of art. They contained no symbols to be fathomed. The simplest was the plain shaft or obelisk, but the most common was the lone soldier atop a simple pedestal. By the turn of the century, these frozen sentinels were ubiquitous. Hundreds stood guard over Northern and Southern town greens, courthouse squares, and cemeteries.

Companies like the New England Monument Company, the Monumental Bronze Company, the Maurice Powers National Fine Arts Foundry, and the Muldoon Monument Company, a Kentucky firm favored by Southerners, churned out hundreds of these statues. So great was the demand and so profitable the work that these firms sent reunion, civic, and commemorative groups all over the country illustrated catalogues offering stone and metal soldiers in Union or Confederate uniforms, at attention or at ease, with or without guns, hats, and cloaks, in sizes to fit every budget. For as little as $1,000, townspeople could order a handsome statue, albeit a small one, to honor their dead.

The Alexandria Confederate Memorial, erected in 1889 by the town's R. E. Lee Camp of the U.C.V., is a handsome example of the local genre of lone sentinels. The contemplative bronze soldier was widely copied, despite efforts of the Camp, which paid $2,000 for the figure and $1,200 for the base of Georgia granite, to keep the image as their own. The 25th New York Volunteers Monument at Battleground National Cemetery is a good example of the catalogue variety of soldier. Produced by McGibbon and Curry Company in 1914, the granite soldier with his rifle and broad-brimmed hat cost New York State $7,500.

Local monuments spoke to local people. They made no claims save to remind neighbors of the sacrifice of their townsmen and kin. National monuments, erected in a nation's capital, are something else again. Whether in Washington or Richmond, where the pantheon of Southern heroes resides, national monuments lay claim to representing the memories of an entire nation or would-be nation. They bespeak legitimacy and collectivity on a grand scale.

Nations respond to the monument-building impulse differently. In the nineteenth century, for example, the French raised monuments such as the Arc de Triomphe to collective action and monuments to the Republic. The very different approach taken by Americans is vividly evident in Washington and Richmond. Americans embodied the nation quite literally in likenesses of real individuals. In the case of the Civil War, the Union chose as its personifier Abraham Lincoln, the Confederacy Robert E. Lee, each with a supporting cast of generals. In the first century after the war, while two dozen monuments immortalizing individuals (five of Lincoln) were erected in Washington, only two honored the collective "Everyman" of the Civil War: the Peace Monument, Admiral David Porter's tribute to Union sailors and marines, and the Benjamin Stephenson and Grand Army of the Republic Monument, a tribute to the G.A.R.'s founder and to all Union soldiers.

The desire to erect monuments in Washington which seized so many Americans in the wake of the Civil War dovetailed perfectly with circumstances in the postbellum capital. The situation was a marriage of desire and opportunity. Pierre Charles L'Enfant's far-sighted 1799 plan for the infant capital, with its grid system of numbered and lettered streets pierced by wide diagonal avenues named for the states, had guaranteed a multitude of circles, triangles, and squares in which he intended public monuments to flourish. Each park, he wrote, "will admit of statues, columns, obelisks, or any other ornament . . . to perpetuate not only the memory of such individuals whose counsels or military attainments were conspicuous in giving liberty and independence to this Country; but also those whose usefulness hath rendered them worthy of general imitation."

Six decades later, at the start of the Civil War, few "ornaments" were yet to be found. The abruptly truncated stump of the Washington Monument sat forlornly just as it had since 1854, when construction had halted for lack of funds. Across from the White House, in Lafayette Park, a bronze Andrew Jackson waved from atop his rearing horse, the first equestrian statue cast in America. So pleased was Congress with the Jackson statue that it had awarded its sculptor, Clark Mills, the commission for the capital's second equestrian monument, the statue of Lieutenant General George Washington in Washington Circle. Completing the capital's inventory of antebellum outdoor statuary was Horatio Greenough's colossal white marble seated George Washington. Never intended as an outdoor work, the statue had been installed in the Capitol Rotunda in 1841 but was soon moved outside when it became clear that the floor was on the verge of collapse. Viewed as a colossal embarrassment by many, critics suggested that the father of his country, half-naked in toga and sandals, appeared to be signaling for a blanket.

The Civil War left the federal capital a mess. The rotting carcasses of mules were piled high behind splintering, makeshift stables on the Mall. Freedmen's shanties surrounded the Washington Monument.

Hardly a tree stood in Lafayette Park or anywhere else in the city; cold troops camped in the town over four winters had used them all for firewood. The *New York Tribune*'s Horace Greeley described the postwar capital as a place where "the rents are high, the food is bad, the dust is disgusting, the mud is deep, and the morals are deplorable." Diagnosing the situation as hopeless, Greeley urged that the capital be moved west, preferably to St. Louis. By 1869, Congress appeared on the verge of considering relocation.

District businessmen, keenly aware that their livelihoods were irrevocably tied to Washington's status as the federal capital, were prodded into action. Their strategy was to make the city so attractive and so accommodating that talk of moving the government would cease. As a first step, in 1870, they successfully petitioned Congress to establish a territorial government for the District of Columbia, giving local leaders more autonomy.

The short life of the Territory of the District of Columbia was tumultuous at best, scandalous at worst, but no one could argue that it did not change the face of Washington. Within a few short years, old buildings were torn down, railroad tracks ripped up, streets paved, sidewalks lit, sewers buried, and mosquito-infested canals filled in. Pennsylvania Avenue blossomed into the grand thoroughfare L'Enfant had envisioned. Sixty thousand trees were planted and dozens of small parks laid out and landscaped, mostly in the city's northwest section, into which "Boss" Alexander Shepherd was luring developers with cheap land, kickbacks, and inside information. Seemingly overnight, mansions and rows of handsome townhouses sprang up in former wastelands only recently dotted with slaughterhouses. These opulent homes were quickly snapped up by wealthy government officials, who were finding it imperative that they spend more time in the capital, where their duties had escalated since the war, and by the avant-garde of nouveau riche industrialists, who found it imperative that they spend time at the seat of the newly powerful postwar government.

This campaign for a "new Washington" perfectly matched the desire of influential groups to erect big, bold statues in the capital. The as-yet-unadorned avenues and parks would be ideal backdrops for new monuments, which could demonstrate the influence of their sponsors and confer prestige upon the new neighborhoods all at the same time. In the first fifty years after the war, a dozen monuments were erected in the squares and circles of the city's newly developed northwest section alone.

The first two Civil War monuments to arise in downtown Washington after the war were the statues of Major General John A. Rawlins and Lieutenant General Winfield Scott, both erected at the federal government's expense in 1874. President Grant took a personal interest in the Rawlins statue, prodding Congress to hurry completion of the statue of his late Secretary of War, friend, and conscience. The Scott statue, by artist Henry Kirke Brown, was the

first of what one wag called the "galvanized heroes on horseback" of the Civil War to take its place in one of the city's newly land-scaped traffic circles. The first of the Civil War equestrian statues, it is also widely regarded as the worst. Art historians lump together Scott's half-mare half-stallion, George Washington's frightened steed by Mills, and the ill-proportioned mount of Nathanael Greene in Stanton Park, also by Brown, in a three-way tie for most dreadful horse in the capital.

There are more equestrian statues in Washington than in any other city in America. Nine are of Civil War heroes (ten, if the Kearny statue at Arlington Cemetery is included; twenty-two if adding the twelve crashing, straining horses in the cavalry and artillery groups in the Ulysses S. Grant Memorial). Following Scott, generals McPherson, Thomas, Winfield Scott Hancock, John A. Logan, William Tecumseh Sherman, George B. McClellan, Philip H. Sheridan, and Ulysses S. Grant took their places in city parks astride horses that gallop, prance, and quiver with anticipation. Of these, critics consider Thomas's watchful horse, by sculptor John Quincy Adams Ward, the best. The popular favorite is Sheridan's famous horse Rienzi, immortalized in the pounding cadence of the poem "Sheridan's Ride," portrayed by sculptor Gutzon Borglum sliding into Sheridan Circle.

In a neat twist of the swords-into-plowshares theme, the Scott statue was cast of condemned cannon from the Mexican War, Scott's finest hour. Several of the galvanized heroes on horseback in Washington were cast from old cannon. Eighty-eight condemned bronze cannon were melted down and transformed into Major General George H. Thomas and his horse. The equestrian statue of Brigadier General James Birdseye McPherson was cast from Confederate cannon captured at the Battle of Atlanta, the battle in which McPherson was killed. (The statue of Admiral David Farragut in Farragut Square was cast from the propeller of his beloved flagship the *Hartford,* from whose rigging he shouted "Damn the torpedoes. Full speed ahead.")

These statues give the lie to the conventional wisdom that one can divine the fate of the rider by the stance of his horse. McPherson and Kearny are the only two among the ten who were killed in action. Both ride horses with raised right forelegs. But so do Logan and McClellan, who lived long lives after the war and died in their beds, as did Grant, Scott, Thomas, and Sherman, whose horses have all four feet firmly planted on the ground.

Of the nine equestrian statues in the city, Scott, Grant, and Hancock were erected entirely at the government's expense, as were the statues of Rawlins, Admiral David Farragut in Farragut Square, and another of Scott, who looks deserving of his nickname "Old Fuss and Feathers," at the Soldiers' Home. The other six equestrians and the Garfield monument were initiated by army reunion societies. The Society of the Army of the Cumberland sponsored Garfield, Thomas, and Sheridan statues; the Society of the Army of the Tennessee those of Logan, McPherson, and Sherman; and the Society of the

Army of the Potomac honored McClellan. Although the Du Pont family personally paid for the fountain in memory of their ancestor, Rear Admiral Samuel Francis Du Pont, most of the other Civil War–related monuments in the core of the capital were erected by private groups. Freedmen and women contributed their first earnings to erect the remarkable Emancipation monument. Scandinavian Americans raised funds for the monument to Swedish-born John Ericsson, designer of the *Monitor;* Catholic women for Nuns of the Battlefield; and the men and women of the navy, past and present, for the United States Navy Memorial.

As every group that has ever attempted to raise a monument in Washington has learned, the process requires energy, time, and money. Though the course has sometimes been bumpy, the process of erecting a monument in the capital has developed into a sort of ritual that has changed little over the years. It begins with the idea for the monument, moves on through securing congressional authorization, selecting a site and a design, and raising funds, and culminates in a glorious dedication ceremony. Snags often crop up along the way. The Sherman statue was stalled for months over the selection of an artist. A verbal brawl erupted as the losers in a nationwide competition, who called the selection method a "bunko game," took their complaints to the press and Congress.

Raising the money to pay for the monument was, and is, an important part of the ritual. At first, some organizations employed paid agents or agents working on commission to raise funds, though they never advertised the fact, because they felt it made their cause look less sincere. As the early advocates for a national monument to Abraham Lincoln learned to their sorrow, paid agents could prove disastrous. Money disappeared; waste and abuse were impossible to stop or prosecute and, when exposed, tarnished both the project and the sponsoring organization.

Some organizations held raffles and bazaars to raise funds. In 1882, the wives of members of the Society of the Army of the Cumberland raised $15,000 at the Garfield Memorial Fair in the Capitol Rotunda. The Women's Auxiliary of Alexandria's R. E. Lee Camp of the United Confederate Veterans staged a "ladies' fair," with booths selling candy, ribbons, and flowers to raise money to pay for the Camp's handsome bronze soldier.

The army reunion societies relied heavily upon written appeals to their members for fundraising. Their long, emotional letters were designed to recall the days when the veterans had snapped to attention at a word from "General X." They emphasized their old commander's concern for them and implied that the size of the donation measured the donor's allegiance to the hero's memory. Letters from the Society of the Army of the Tennessee soliciting money for the Sherman statue reminded members of "Uncle Billy's" efforts on their behalf: "He of all the preeminently great commanders during the struggle for national unity . . . was superlatively one of us. . . . His efforts for the

welfare and pleasure of the 'boys,' no matter how arduous or how great a drain upon his time, were always deemed a labor of love and duty." All such solicitations emphasized that by contributing, donors helped erect the monument just as surely as if they had lent a hand in casting the bronze. Establishing a sense of ownership was part of the ritual. Updates on progress referred to the statue as "your monument."

By whatever methods it was raised, the money that paid for the monument was always spoken of as coming from "the people." In fact, however, for every one of the monuments raised by the reunion societies, large government appropriations were necessary to finish the job. For the first of these, the McPherson monument, erected in 1876, the Society of the Army of the Tennessee raised $23,500, and Congress appropriated $25,000 for the base and pedestal, as well as the captured cannons for the bronze. Twenty years later, the same society managed to raise only $14,469.91 from its aging membership for the Sherman monument. Congress, which had initially appropriated $50,000, had to double its contribution in order to complete the project. While the government often paid the lion's share of the costs, its largesse was rarely mentioned. It was important to maintain the fiction that these monuments were the work of "the people."

At first, selecting a site and a design were among the easiest steps in the process of erecting a monument in the capital. Good sites were plentiful in the new Washington. Good, or good enough, artists who could satisfy the sponsors' desire for an "honest" likeness were never lacking. As to selection of the artist, except for the Scott equestrian statue and a few complaints about the way commissions were awarded to artists, there was usually general enthusiasm about the process and the results. In the mid-1880s, the first notes of a chorus of criticism that would swell through the turn of the century sounded. An 1885 article in the *North American Review* not only complained about the "spirit of jobbery" by which commissions were awarded but also skewered "the many bad works that disgrace the National Capital."

In 1902, the *New York Times* decried "the hopelessly haphazard and random way in which we go about to commemorate our famous men." It was absurd, complained the reporter, for public officials like the Secretary of War to be arbiters of taste. The *Times* suggested that all aesthetic decisions in the capital should be handled by a commission of experts. Support for such a commission had also been growing among artists and architects, who espoused the City Beautiful Movement, which had grown out of the 1893 Chicago World's fair, where sculpture had played such an important part. This same impulse fueled a movement to recapture for Washington the dignity of L'Enfant's original design. The results were twofold: first, the establishment in 1901 of a new congressional commission, popularly known as the McMillan Commission after its chairman, Michigan senator James McMillan, whose far-reaching plan for the city was

unveiled in 1902; and second, the Commission of Fine Arts, established in 1910 to advise the government on plans for buildings, public art, and parks.

The Commission of Fine Arts, composed of the nation's most distinguished artists and architects, dramatically changed the way public monuments were, and still are, erected in the capital. As many groups have learned to their sorrow, having the energy, time, and money to raise a bronze hero on a horse is no longer sufficient. Clearing the high aesthetic standard thrown up by the commission has proved the hurdle over which many groups have stumbled. In addition to squashing repeated proposals for a statue of Robert E. Lee, the commission has turned down other ideas for Civil War–related monuments, including a portrait statue of Lincoln's Secretary of Treasury and Chief Justice Salmon P. Chase and a monument to "Faithful Colored Mammies of the South," proposed on three separate occasions.

At the heart of the City Beautiful Movement to which the first commissioners subscribed lay the conviction that the reform of the physical landscape through art could reform civic life and values as well. In order to work this transformation, however, public monuments needed to be public works of art, not the shallow and stereotypical statues of generals of the previous century. Like William Dean Howells, the commissioners believed that public art should embody ideals. The Rear Admiral Samuel Francis Du Pont Memorial Fountain, the Lincoln Memorial, Nuns of the Battlefield, the John Ericsson Monument, and the Major George Gordon Meade Memorial are all products of the commission's first two decades; and all are embellished with allegorical figures and heavy with symbols of unity, progress, wisdom, and courage. Among the post–World War II monuments that have passed muster before the Commission of Fine Arts and reflect its philosophy are the United States Navy Memorial, and, most recently, the African-American Civil War Memorial.

Whether pre– or post–Commission of Fine Arts, once the design for a monument was approved and the work was being carved or cast, sponsoring groups could lay plans for the final and most public stage of the ritual, the dedication. In the late nineteenth century, these events often drew crowds of fifty thousand to a hundred thousand and were among the era's largest public gatherings. The dedication of the Emancipation statue in April 1876, which drew more than fifty thousand black men and women to Washington, was the largest formal gathering of African Americans that had ever taken place in America. The entire federal government usually shut down for the afternoon ceremonies. The army reunion societies chartered special trains to bring members to Washington for the ceremonies and booked hotel rooms as far away as Baltimore and Annapolis.

Huge parades preceded the ceremonies for the military statues. At first thousands, and later hundreds, of Union veterans, interspersed with soldiers, sailors, and marines in active service, midshipmen from

the Naval Academy, and cadets from West Point, would march to the foot of the monument. At the dedication of the Ulysses S. Grant Memorial in 1922, a reporter noted that the elderly veterans had painfully limped into position but that the first thud of the drums "sent a smile across the faces of the stooped veterans of the Civil War, for their day was beginning again."

These dedications were indeed *their* days. After the parades, the veterans filled the special seating sections facing the monuments and the temporary platforms upon which their representatives, the President of the United States, and a host of dignitaries sat. Following prayers and music, huge American flags suspended from wires would swing apart at someone's touch, often a child's, to the collective cheers and thunderous applause of the crowd. Then the crowd would settle down for the speeches, which were the veterans' favorite part of the afternoon. They never tired of hearing their brave deeds and those of the bronze hero before them recounted or of the praise sure to be heaped upon them by politicians who knew the value of their votes.

Occasionally speakers would wave the bloody shirt, but for the most part these were not occasions for castigating old enemies. As at the dedication of the Confederate Monument, the predominant themes were sacrifice and valor, with union and reunion close behind. Some speakers, notably President Theodore Roosevelt at the dedication of the Sherman monument in 1903, used the occasion as a bully pulpit from which to launch a call to action. Roosevelt began by commending to God and to the nation every man who had fought for the Union: "Their blood and their toil, their endurance and patriotism, have made us and all who come after us forever their debtors." It was not, however, a debt that could be repaid with monuments or words: "Our homage must not only find expression on our lips; it must also show itself forth in our deeds. . . . The living can best show their respect for the memory of the great dead by the way in which they take to heart and act upon the lessons taught by the lives which made these dead men great."

Occasionally a speaker would dismiss monuments and hold up the United States of America, the union that had endured and flourished, as the one true lasting testament to the veterans' sacrifice. At the dedication of the McClellan monument in 1907, Brigadier General Henry C. Dwight told the crowd, "Monuments will fade. Statues may crumble to dust. Veterans' graves will be obliterated by time, but the grandest monument of the service and valor of the soldiers and sailors of the Civil War, the United States of America, the hope and joy of the world, consecrated to liberty by the blood and treasure of the nation, the undying testimonial of the patriotism of her people, will continue years and years."

The veterans in the crowd were intensely patriotic men. They were all for America, military preparedness, and a strong defense. But they also wanted to believe that their brave deeds would be remem-

bered, always. They had worked for years to bring into being the statue upon which all eyes were riveted. They wanted to believe that this very tangible object in the nation's capital, which thousands would pass every day, would be an enduring testament to their courage and heroism. This monument was to be their "silent historian" to transmit their story from generation to generation.

Retired Major Daniel Sickles, who had lost a leg in the war and who represented the Society of the Army of the Potomac at the Sherman dedication, understood and shared these feelings. He had devoted a large part of his postwar years to keeping alive the camaraderie of the bivouacs, fighting for veterans' benefits, and raising funds for monuments just like this one. He believed, as he told the crowd that day, that these monuments would "recall to those who come after us the magnitude and glory of the struggle for the preservation of the Union; the unmeasured sufferings and sacrifices of our defenders; the vast multitudes that rallied to the flag after Sumter; the armed hosts that vanished like morning mists after the surrender of Lee and the capture of Davis." The veterans very much wanted to believe that Sickles was right, that this monument and all of the other Civil War monuments in the capital would be *aides-mémoire*, bearing witness forever to the brave men who had fought and died for the Union.

Well over a century has passed since the first of the Civil War–related statues took their places in L'Enfant's circles and squares. None of them has crumbled to dust, though the works in marble show their age. The pages that follow contain the histories of forty Civil War–related monuments in the nation's capital and the immediate surrounding area. They include sculpture by some of the most prominent artists in America, among them John Quincy Adams Ward, Daniel Chester French, Moses Jacob Ezekiel, and James Earle Fraser, and by some near-unknowns, like Henry Merwin Shrady, who had yet to complete a major work when he won the commission for the Ulysses S. Grant Memorial. Except for acknowledging instances when contemporaries loudly panned or praised a statue, these chapters steer clear of evaluating the artistic merit of the pieces.

Two statues—the Arsenal Monument and the Abraham Lincoln statue in Judiciary Square—are heart-felt local monuments erected by the residents of Washington. A few, such as the touching tribute to his son commissioned by Montgomery C. Meigs, are notable cemetery statuary. Most are national monuments, placed on the wide stage of the capital city to convey homage and gratitude on a broad scale. Of the forty subjects, Albert Pike, immortalized by the Masons because of his lifelong devotion to Freemasonry, is the only Confederate with his own likeness. The Alexandria Confederate Memorial honors the town's Rebel sons, and the Confederate Monument at Arlington commemorates all of the Southern dead. The women religious depicted in Nuns of the Battlefield ministered to the wounded and dying of both the North and the South. The other thirty-six monuments are

tributes to men and women, white and black, who worked to save the Union.

The monuments are discussed in spatial, rather than chronological or alphabetical order. They cluster along the city's central corridor from east to west, which also happens to be a very rough progression through time from the older sculpture to the newer. The first is also one of the oldest, the Arsenal Monument, with its eroding marble flames reminding viewers how at least twenty-one young women died making cartridges for Union soldiers. After examining the monuments along the capital's core, discussion shifts to the more distant statues in the northern reaches of the District of Columbia and just across the border in Maryland. These include the newest work, the bronze African-American Civil War Memorial, inscribed with the names of the nearly 178,000 African American soldiers who fought for the Union and the 7,000 white officers who led them. The discussion then moves to Virginia, to Arlington National Cemetery, where Montgomery C. Meigs's haunting tribute to his son lies, and finally to Alexandria, ending with the tribute to the men who assembled on that spot and marched away to fight for the Confederacy.

These monuments still have the power to "recall . . . the magnitude and glory of the struggle for the preservation of the Union," as Daniel Sickles and all who worked so hard to raise them fervently hoped they always would. Though the years have witnessed an explosion of media for conveying information, the power of public bronze and marble war memorials endures. Recognition of the continuing power of monuments to validate experience and shape the collective memory rests at the heart of efforts to raise the African-American Civil War Memorial and new monuments at Gettysburg and at other Civil War battlefields and cemeteries more than a century and a quarter after the last of the dead were dragged from the fields.

To all those who take a moment to really look at these monuments and to all who are open to the flood of memories they unleash, each Civil War statue is a silent historian still. Each is a testament to union in some sense of the word: to disunion, reunion, union, and the Union. Each reminds us that the Union was once violently fractured and that some wounds left by the cataclysm healed faster than others. Each statue dedicated to those who sacrificed and died to preserve the Union reminds us, as President Roosevelt reminded his audience in 1903, that we are "forever their debtors."

Monuments

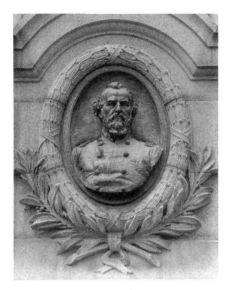

Illustration: *bust of Dr. Benjamin Franklin Stephenson on Stephenson and G.A.R. Memorial*

Congressional Cemetery, 1801
E Street, S.E., western border of the
northern third of the cemetery

SCULPTOR: Lot Flannery

DATE: 1865

MEDIUM: Marble

The Washington Arsenal, located along the Potomac River on Green-leaf's, or Arsenal, Point where Fort McNair now stands, was the largest of all the federal arsenals during the Civil War. Row after row of cannon, mortars, gun carriages, wagons, and ambulances stretched from shore to shore across the point. Enormous stores of artillery ammunition stood everywhere in neat stacks. Thousands of rifles and pistols and tons of small arms ammunition filled the warehouses. As soon as ordnance and munitions were shipped out to the battlefields, more would pour out of the perpetually busy armories. Hundreds of Washingtonians—men and women, black and white—worked feverishly to keep the Union troops supplied.

Just a little past noon on June 17, 1864, something terrible happened at the Washington Arsenal. A deafening explosion blew to smithereens a 100-foot-long munitions shed, sending bricks, boards, and huge hunks of its tin roof hurtling in all directions. The investigation that followed revealed that thousands of cartridges filled with powder had ignited. It also found the superintendent "guilty of the most culpable carelessness and negligence in placing highly combustible substances so near a building filled with human beings, indicating a most reckless disregard of human life."

More than one hundred young women had been at work in the shed, making cartridges for small arms. Twenty-one of the dead could be identified, but there were others whom no one could recognize or even find. Dozens more women were burned, blinded, or otherwise maimed. Survivors told of friends burning to death as their long dresses and petticoats burst into flames.

Medical personnel from the city's military hospitals rushed to the scene. As word of the disaster spread, the road leading into the Arsenal became clogged with distraught parents seeking news of their daughters. The whole city was horrified by the carnage and moved by

Clouds of marble smoke billow in the bas-relief on the base of the Arsenal Monument, erected by the citizens of Washington in memory of the twenty-one women killed on June 17, 1864, while making cartridges for Union troops.

the harrowing stories related by witnesses and carried in the extra of the *Washington Star* that hit the streets just hours after the explosion.

One funeral service for all of the dead, paid for by the government, was held at the Arsenal on June 20, and it was packed with the grieving and the curious. President Lincoln and Secretary of War Edwin Stanton attended. The coffins of both the known and the unknown rested before the audience on a large, temporary platform, from which clergy led the crowd in prayers. At the end of the service, a long funeral procession of more than 150 carriages, led by one carrying the President and Stanton, followed the wagons bearing the coffins from the Arsenal to Congressional Cemetery, where most of the bodies of the women who had worked together would be buried together. After the wagons and carriages came hundreds of Washingtonians on foot, among them all of the employees of the Arsenal—blacksmiths, carpenters, armorers, painters.

After a brief graveside service, the crowds dispersed, but the citizens of the capital did not forget the women of the Arsenal disaster. A public subscription was taken up to place a monument over the common grave of fourteen of the victims. The commission for the monument went to Lot Flannery (1836–1922), an Irishman who had immigrated to America as a young man, settled in Washington, and by 1864 was directing, with his brother, one of the city's largest stonecarving firms. Two years later, Flannery carved the statue of Abraham Lincoln that stands in front of the old City Hall. (See #11.)

Exactly one year after the Arsenal disaster, the monument to its victims was dedicated. Flannery created a 20-foot-high marble shaft topped by a statue of a despairing neoclassical woman with clenched hands, who weeps for the dead. On the pedestal, a low-relief panel depicts the fire after the explosion. Clouds of smoke billow from the flaming shed. The inscription on the south face reads, "Killed by an Explosion at the United States Arsenal, Washington, D.C., June 17, 1864." The north face reads, "Erected by Public Contribution by the Citizens of Washington, D.C., June 17, 1865." Carved on the east and west faces are the names of the twenty-one known victims of the blast.

While not marked with sculpture, many of the graves at Congressional Cemetery hold the remains of men and women who played roles large and small in the drama of the Civil War. Among them are Joseph Bell Alexander, co-owner of the undertaking firm that prepared Lincoln's body for his funeral tour; Mathew B. Brady, whose photographs of grisly battlefields made the war excruciatingly real for those far from the fighting; Ann G. Sprigg, Lincoln's landlady when he first came to Washington as a congressman in 1847; and a small army of military men, mostly Union soldiers but also a few Confederates.

SOURCES

Cemetery Records, Congressional Cemetery, Washington, D.C.

Conversations with John Hanley, Friends of Congressional Cemetery, Washington, D.C.

Stephen M. Forman, *A Guide to Civil War Washington* (Washington, D.C., 1995), 144–64.

Richard Lee, *Mr. Lincoln's City: An Illustrated Guide to the Civil War Sites of Washington* (McLean, Va., 1981), 147–54.

Washington Star, June 17–21, 1864.

Lincoln Park, East Capitol Street
between 11th and 13th Streets, N.E.

SCULPTOR: Thomas Ball

DATE: 1876

MEDIUM: Bronze

American sculptor Thomas Ball (1819–1911) heard the news of Lincoln's assassination while visiting Munich. In his autobiography, Ball described how, as soon as he got back to his studio in Florence, he began work on a piece "impatiently bubbling in my brain ever since receiving those horrible tidings." He envisioned a statue of Lincoln extending his hand over a newly freed slave. Pleased with the results, Ball kept the model of Lincoln and the freedman on display in his studio, which, by the mid-1860s, was a popular destination for Americans visiting Italy. Ball's fame as a sculptor rested upon his most famous work up to that point, his equestrian statue of George Washington in Boston's Public Garden.

Charlotte Scott, a former slave from Virginia, heard the news of Lincoln's assassination in Marietta, Ohio, where she was supporting herself as a washerwoman. Telling her employer that "the colored people have lost their best friend on earth," Scott explained that she wanted to honor Lincoln with a monument, and she wanted to donate the first money she had earned in freedom, five dollars, to the project. Her employer forwarded Scott's idea and her money to the Western Sanitary Commission in St. Louis with a letter: "A poor woman of Marietta, Ohio, one of those made free by President Lincoln's Proclamation, proposes that a monument to their dear friend be erected by the colored people of the United States. . . . Would it not be well to take up this suggestion and make it known to the freedmen?"

The commission did take up the idea, and freedmen and women responded enthusiastically. The 70th U.S. Colored Infantry sent $3,000 contributed by 683 enlisted men. Within just two years the memorial fund had grown to $18,000, and the commission began to look for an appropriate design for the memorial. In his autobiography, Ball relates how, in 1869, he received a letter from Commissioner William Eliot, who remembered seeing the Lincoln piece in his studio. Eliot asked him to submit photographs of the group and his terms for furnishing it in bronze, 9 to 10 feet high. Ball responded immediately. Though he did not mention a price, he was accustomed to receiving more than the $18,000 the commission wrote back that it could afford. Nonetheless, Ball wrote, "Of course I accepted their offer, for you must remember that every cent of this money was contributed by the freed men and women."

The commission ordered the statue with one condition: the figure of the slave, who appeared too passive and devoid of Negro features in the model, had to be redone. Ball agreed. He sculpted a new figure, modeled after a real former slave, Archer Alexander, said to be the last man captured under the Fugitive Slave Act, whose photographs Ball had sent to him in Italy. Ball oversaw the casting of the statue in Munich and shipped it off to the United States. Meanwhile, Congress

approved a site for the memorial in Lincoln Square (later renamed Lincoln Park), eleven blocks east of the Capitol, and appropriated $3,000 for the base and granite pedestal. The dedication was set for Friday, April 14, 1876, the first time since Lincoln's death that the sad anniversary had again fallen on Good Friday.

Despite showers, crowds began to form early in the morning along the parade route leading to Lincoln Square. The *Washington Star* claimed that more than fifty thousand men and women, "including many whites," turned out for the event. The mostly black crowd witnessed a remarkable parade of mostly black men, many free for barely a decade, marching with the organizations they had only recently formed. Out East Capitol Street marched dozens of bands, military units, including the 21st U.S. Colored Troops, Masons, Knights Templars in their "showy chapeaux, baldrics, belts, and swords," Knights of Saint Augustine with yellow feathers and belts, Sons of Purity wearing white aprons, Good Samaritans in gold-embroidered costumes, Sons of Levi, and a host of other clubs and religious groups.

At Lincoln Square, President Ulysses S. Grant, members of the Cabinet and Congress, diplomats, justices of the Supreme Court, and a host of dignitaries waited. When the orator of the day, the great abolitionist Frederick Douglass, arrived by carriage at the end of the parade with Professor John M. Langston, Dean of Howard University, who would preside over the dedication, the ceremony began. After "Hail Columbia," prayers, and a short speech, Professor Langston pulled a cord that parted the flags that had concealed the statue.

Then Douglass, a tall, commanding figure with his white beard and hair, addressed the African American men and women in the crowd in an eloquent speech that must have made many of the dignitaries on the platform squirm. His praise of "the Great Emancipator" was qualified. Lincoln, he told his audience, was not "one of us." He was the white man's president, with the white man's prejudices, and he had been "ready and willing at any time during the first years of his administration to deny, postpone and sacrifice the rights of humanity of the colored people to promote the welfare of the white people." But, though blacks "are at best his step-children," Douglass continued, and even if Lincoln had been motivated by political expedience, when he signed the Emancipation Proclamation, Abraham Lincoln became their liberator.

In the sculpture that now stood for all to see, Ball sought to capture the moment of liberation. Gaunt in his frock coat, Lincoln stands with his left hand outstretched and his right hand holding an unrolled copy of the Emancipation Proclamation, resting on a podium. The podium, with fasces at each corner, thirteen stars encircling its base, thirty-six stars for the number of states at the time of Lincoln's assassination around the top, and a bas-relief of George Washington, stands for the Union. At Lincoln's feet kneels the muscular figure of a former slave, his wrist shackles newly broken. Behind the freedman

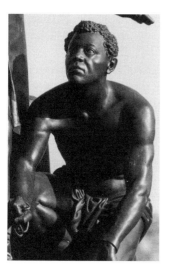

Sculptor Thomas Ball modeled the figure of the newly freed slave after a real former slave, Archer Alexander.

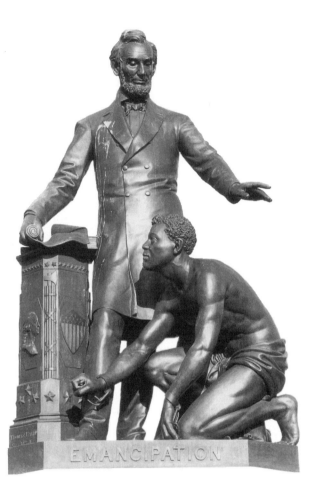

Freed men and women joined former slave Charlotte Scott in contributing $18,000 to pay for Emancipation, a monument to President Lincoln.

are shackles, a whip, and a whipping post, symbols of his former status. Entwining the post is a rose vine symbolizing that these trappings of slavery are a thing of the past.

The 12-foot-high bronze sculpture group, bearing the single word EMANCIPATION, sits on a 12-foot-high granite pedestal, whose two plaques tell the monument's story. The plaque on the east face contains words from the Emancipation Proclamation, January 1, 1863. The plaque on the west face reads:

FREEDOM'S MEMORIAL
In Grateful Memory of
ABRAHAM LINCOLN
This Monument Was Erected
By The Western Sanitary Commission
Of Saint Louis Mo.
With Funds Contributed Solely By
Emancipated Citizens Of The United States
Declared Free By His Proclamation
January 1st A.D. 1863

The First Contribution Of Five Dollars Was Made
By Charlotte Scott A Freed Woman Of Virginia
Being Her First Earnings In Freedom
And Consecrated
By Her Suggestion and Request
On The Day She Heard of President Lincoln's Death
To Build A Monument To His Memory

Until the completion of the Lincoln Memorial a half-century later, Emancipation was the most important site in the capital honoring the memory of Abraham Lincoln. Visiting dignitaries laid wreaths at its base, and annual ceremonies were held commemorating the signing of the Emancipation Proclamation in January and on Lincoln's birthday in February. Band concerts and religious revivals filled the park in the summers. Beginning in the 1960s, the monument became the site of freedom rallies and civil rights demonstrations.

SOURCES

RG 42, Records of the Office of Public Buildings, entry 201, Emancipation, National Archives, Washington, D.C.

Thomas Ball, *My Threescore Years and Ten: An Autobiography* (Boston, 1892).

F. Lauriston Bullard, *Lincoln in Marble and Bronze* (New Brunswick, N.J., 1952), 64–72.

Wayne Craven, *Sculpture in America* (Newark, Del., 1984), 219–27.

Freeman Henry Morris Cromwell, *Emancipation and the Freed in American Sculpture* (New York, 1916), 26–28.

George Olszewski, *Lincoln Park* (Washington, D.C., 1968), 1–11, 25–32.

Merrill D. Peterson, *Lincoln in American Memory* (New York, 1994).

Edward Steers Jr. and Joan Chaconas, *Everlasting in the Hearts of His Countrymen: A Guide to the Memorials to Abraham Lincoln in the District of Columbia* (Washington, D.C., 1984), 25–26.

Washington Star, April 14, 1876.

3 VETERANS OF FOREIGN WARS TRIBUTE

Maryland Avenue, Constitution Avenue, and 2nd Street, N.E.

SCULPTOR: Felix de Weldon

DATE: 1976

MEDIUM: Bronze

The Veterans of Foreign Wars, organized in 1899, responded to the nation's bicentennial in 1976 by commissioning a striking three-sided shaft for the grounds of its national headquarters on Capitol Hill. Erected "in honor and memory of the veterans of all America's wars, who by their service kept the torch of freedom burning," the shaft is composed of twelve bas-reliefs, four on each side, depicting scenes from the American Revolution, the War of 1812, skipping over the Mexican War to the Civil War, the Spanish-American War, World Wars I and II, Korea, and Vietnam.

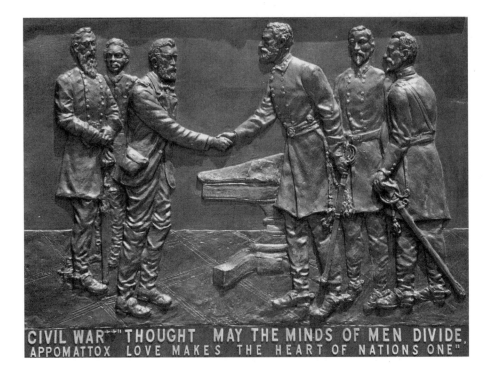

CIVIL WAR "THOUGHT MAY THE MINDS OF MEN DIVIDE,
APPOMATTOX LOVE MAKES THE HEART OF NATIONS ONE"

Three of the twelve panels are devoted to the Civil War: "Appomattox" on the main facade, facing Maryland and Constitution Avenues, "The Confederacy" on the 2nd Street side, and "The Union" on the back.

The sculptor, Austrian-born Felix de Weldon (1907–), is best known for his Marine Corps War Memorial, better known as the Iwo Jima Monument, in Virginia, north of Arlington Cemetery, modeled after Associated Press photographer Joe Rosenthal's Pulitzer Prize–winning photograph of the flag raising atop Mount Suribachi. A prolific artist, de Weldon is represented in Washington by several works, including four bas-reliefs of battle scenes for the National Guard Association that are similar to those on this shaft.

SOURCES

Public Relations Office, Veterans of Foreign Wars, Washington, D.C.

James Mayo, *War Memorials as Political Landscape: The American*

Experience and Beyond (New York, 1988), 253.

Washington Post, June 3 and 23, 1993.

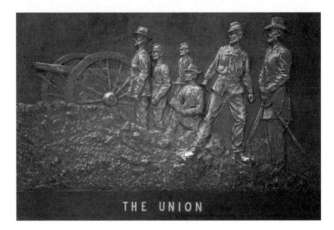

Of the twelve panels on the shaft erected by the Veterans of Foreign Wars to honor the veterans of all of America's wars, three feature Civil War themes.

4 FREEDOM

Surmounts the dome of the United States Capitol

SCULPTOR: Thomas Crawford

DATE: 1863

MEDIUM: Bronze

On the morning of December 2, 1863, at the start of the third long winter of war, there was a brief respite in Washington as a potent symbol of the Union, the colossal statue Freedom, took her place atop the Capitol building. Even though there was to be no official ceremony, several thousand men and women, flourishing opera glasses for a better look, crowded onto the Capitol grounds, according to the *Washington Star*. What they saw at a little after eleven o'clock was a huge steam-powered hoist lifting the last bronze piece, Freedom's head and shoulders, in a crate to the roof, and then a hand-cranked winch raising it into place. At noon, workmen secured the piece in place, and an official at Freedom's feet unfurled an American flag, signaling to all below that the statue was complete. Although Architect of the Capitol Thomas U. Walter had ordered his workmen not to hurrah, "cheer after cheer filled the air," said the *Star*, as a thirty-five-gun salute—one for each state in the United States by the federal government's count—boomed from cannon near the grounds

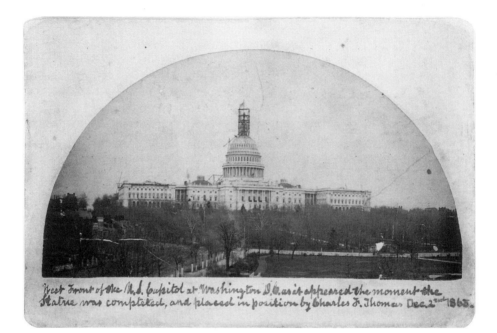

West Front of the U.S. Capitol at Washington D.C. as it appeared the moment the Statue was completed, and placed in position by Charles F. Thomas Dec. 2nd 1865.

When the flag was unfurled above the Capitol, the crowd below knew that the last piece of Freedom had been set in place. The caption reads: "West Front of the U.S. Capitol at Washington D.C. as it appeared the moment the Statue was completed, and placed in position by Charles F. Thomas Dec. 2nd 1865." Courtesy of the Office of the Architect of the Capitol.

and was answered by salutes from all twelve forts ringing the city. Freedom's path to the top of the Capitol had been arduous, involving patronage, a famous sculptor who died young, a leaky ship, and a meddlesome Secretary of War, Jefferson Davis.

As a young boy, Freedom's creator, sculptor Thomas Crawford (ca. 1813–57) apprenticed with tombstone carvers and marble mantlepiece makers. In 1835, he went to Italy to study and joined a group of American painters already ensconced in Rome. Among the Americans who visited his studio was Massachusetts senator Charles Sumner, who became his lifelong friend and supporter, steering federal patronage his way whenever possible.

In 1850, while on a visit to America, Crawford went to Washington, fishing for commissions. His friendship with Sumner and his connections with genteel society through his wife, wealthy Louisa Ward Crawford of New York, opened important doors to him. Although entertained by the city's elite, Crawford despised the capital. He wrote Louisa that it was a "contemptible city," a "hot bed of hypocrisy and double-dealing," filled with "rascally politicians, dirty waiters, abominable tea." He especially ridiculed the low, wooden dome of the Capitol. It looked, he wrote Louisa, like a "mustard pot."

Crawford's politicking paid off handsomely. Early in 1853, he received a letter from Captain Montgomery C. Meigs of the Corps of Engineers, asking him to submit drawings for sculpture to adorn the pediments of the huge new House and Senate wings being added to the Capitol. Crawford sent back drawings almost immediately. In the fall, he learned that he had won the commission for the Senate pediment, and he set to work. This was the first of several major commissions for the Capitol that kept Crawford busy at his Rome studio. Next came a request from Meigs, who was superintendent of construction, for drawings of sculpture to go above the doorway and on the huge, bronze doors to the new Senate wing. It was over plans for the doorway that Crawford first tangled with Secretary of War Jefferson Davis, under whose jurisdiction all work on the Capitol fell. Crawford had designed two female figures, History and Justice, to go above the doors. One wore a liberty cap modeled after the cap worn in ancient Rome by freed slaves. Davis strongly objected to this symbol of freedom, and Meigs conveyed those sentiments to Crawford. The cap disappeared.

Beginning in early 1855, Meigs wrote to Crawford constantly with questions about the inside and outside of the massive new iron dome for the Capitol that would replace the old wooden "mustard pot." Finally, Meigs brought up the subject of the statue that would crown the dome and asked Crawford to submit designs. Meigs suggested a statue of Liberty: "We have too many Washingtons, we have America in the pediment. Victories and Liberties are rather pagan emblems, but a Liberty I fear is the best we can get." Crawford accepted the challenge. The figure, he calculated, would have to be colossal due to the height of its perch, 288 feet above the ground. Since detail would be minimal at that distance, he estimated his fee at $3,000.

All of Crawford's drawings called for a woman dressed in flowing robes. On the small model he submitted, he once again included the liberty cap, though he knew that Davis would object. In October 1855, Crawford wrote to Meigs, "It is quite possible that Mr. Jefferson Davis may, *as upon a former occasion,* object to the cap of Liberty." Davis did object. In a letter to Meigs in January 1856, Davis called the Roman badge of emancipation "inappropriate to a people who were born free and would not be enslaved" and suggested instead a helmet with a "circle of stars, expressive of endless existence, and of heavenly birth." Once again, Crawford acquiesced. He replaced the cap with a helmet encircled with stars and crested with an eagle's head, feathers, and talons. This headgear has led Freedom, as she came to be called, to be mistaken for a Native American woman. After this revision, Crawford's design met with Davis's approval, and he completed a model by the end of 1856. In her final form, Freedom wears flowing robes trimmed with elaborate fringe and gathered at the waist in a brooch inscribed "U.S." She has her hands full: her left hand holds a laurel wreath for victory and a shield with thirteen stripes, her right the hilt of a sheathed sword.

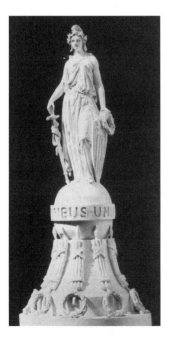

Thomas Crawford's first model for Freedom wore a liberty cap, styled after those worn in ancient Rome by freed slaves, and this drew the ire of Secretary of War Jefferson Davis. Courtesy of the Office of the Architect of the Capitol.

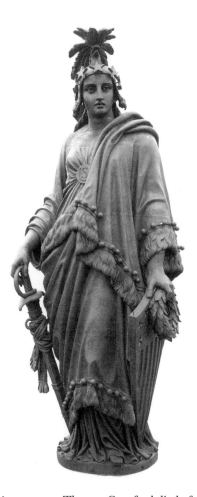

In the final version, Crawford replaced the liberty cap with a helmet encircled with stars and crested with an eagle's head and clothed Freedom in elaborate robes. Courtesy of the Office of the Architect of the Capitol.

Thomas Crawford died of cancer in Rome in October 1857, at the age of 44. Under Louisa Ward Crawford's supervision, the model of Freedom was crated up for shipment to America in April 1858 aboard the bark *Emily*. The *Emily* promptly sprung a leak, put in for repairs, set sail again, and leaked again. Rumors circulated that the ship had sunk, but enough other cargo was jettisoned that the *Emily* could limp across the Atlantic with Freedom still aboard. The model was sent for casting in five main pieces to the foundry of sculptor Clark Mills in the District of Columbia near Bladensburg, Maryland, work for which Mills received $20,796.82. Ironically, the laborers at Mills's foundry who helped cast Freedom included slaves.

Architect of the Capitol Walter pronounced the statue complete in November 1862. Freedom measures 19½ feet in height and weighs 15,000 pounds. She stands on a globe 7 feet in diameter inscribed "E Pluribus Unum." For a year, she stood on the Capitol grounds, awaiting the completion of the dome. In 1993, after more than a century and a quarter of exposure to the elements, Freedom retraced her journey and again spent the better part of a year on the Capitol grounds, this time undergoing cleaning and repair. Her descent and

ascent were assisted by helicopters rather than steam-powered hoists. As in 1863, cheering crowds assembled to witness the historic occasions, but most carried video cameras, not opera glasses.

SOURCES

Freedom files, Office of the Architect of the Capitol, Washington, D.C.

William Allen, *The Dome of the United States Capitol: An Architectural History* (Washington, D.C., 1992).

Architect of the Capitol, *Art in the United States Capitol* (Washington, D.C., 1976), 343–55.

Sylvia Crane, *White Silence: Greenough, Powers, and Crawford* (Miami, Fla., 1972), 273–407.

Wayne Craven, *Sculpture in America* (Newark, Del., 1984), 123–35, 173, 401.

William Gerdts, *American Neo-Classic Sculpture: The Marble Resurrection* (New York, 1973), 28–30.

George Hazelton Jr. and Howard F. Kennedy, *The National Capitol: Its Architecture, Art, and History* (New York, 1914), 60–66.

Washington Star, December 2, 1863.

5 JAMES A. GARFIELD MEMORIAL

1st Street and Maryland Avenue, s.w.

SCULPTOR: John Quincy Adams Ward

ARCHITECT: Richard Morris Hunt

DATE: 1887

MEDIUM: Bronze

The Society of the Army of the Cumberland was in the midst of its annual reunion in Chattanooga, Tennessee, on September 19, 1881, when news reached the veterans that one of their members, President James A. Garfield, for whose recovery they had prayed at the opening invocation, had died in Elberon, New Jersey. The President's death marked the end of the agonizing eleven-week battle for life that he had waged since being shot in Washington by Charles Guiteau, a deranged office seeker. Before adjourning, the members of the society, many of whom had served under Garfield as he was rising through the ranks to major general, voted to establish the Garfield Memorial Committee to erect a monument to their slain comrade in the nation's capital.

Despite the outpouring of affection for Garfield, raising funds for the memorial proved difficult. Though the committee members liked to say that contributions ranging from 2¢ to $1,000 were pouring in from across the nation, in fact the flow was more trickle than cascade. In 1882, Congress contributed $7,500 realized from the sale of condemned cannon, but what really got the project moving was the Garfield Memorial Fair that year. Organized by committeemen but run largely by their wives and held in the Rotunda of the Capitol, the fair raised almost $15,000. The society eventually raised about $25,000, while Congress appropriated an additional $30,000 for the monument's base in 1884.

At its 1883 reunion, the Society of the Army of the Cumberland chose New York sculptor John Quincy Adams Ward (1830–1910) to create its monument to Garfield and agreed to pay him $60,000 for

the statue and pedestal. The society and Ward had worked together before in the 1870s on the handsome equestrian statue of General George H. Thomas in Thomas Circle in Washington, which the society had also commissioned. The Thomas statue had immediately won praise as one of the finest equestrian statues in the capital, and the society was very pleased with it and with Ward. (See #16.) Ward had something else to recommend him to the members of the society: he, like many of them, had known Garfield. One year older than the late President, Ward and Garfield both grew up on the Ohio frontier and had much in common.

In 1883, John Quincy Adams Ward was one of the most prominent sculptors in America. During this era, which one art historian calls the age of "galvanized heroes," Ward excelled at creating bronze generals. His work made him a rich man, and he traveled in New York's elite social, literary, and art circles. Born in 1830 on a farm near Urbana, Ohio, even as a little boy Ward modeled farm animals and men on horseback from clay. When he was 19, he visited his sister in Brooklyn, New York, and she took him to meet the sculptor Henry Kirke Brown at his studio. Brown asked him to model a figure on the spot and, pleased with the result, took Ward on as a pupil. (See #19 for Brown.)

Ward struck out on his own in 1856. He spent the next two winters in Washington, modeling busts of the men most deeply involved in the escalating sectional tension. Ward's 1861 bronze statuette, The Freedman, of an African American man contemplating the shackles from which he had just been released, was very popular. His first Civil War statue was the 7th Regiment New York Infantry Memorial, a heroic bronze soldier on a high pedestal, created for Central Park, which was followed by his statue of Major General John F. Reynolds, for the Gettysburg battlefield, where he fell. Next came Ward's first equestrian piece, the Thomas statue, then the Garfield monument and an equestrian statue of General Philip Sheridan, intended for Washington but cast after Ward's death and erected in Albany, New York (see #28). Ward had just completed his third equestrian statue, that of General Winfield Scott Hancock, for Fairmont Park in Philadelphia, in 1910, when he died at the age of 80.

For the Garfield memorial, Ward worked with his friend and frequent partner architect Richard Morris Hunt, who designed the base. Garfield stands 9 feet tall on top of Hunt's marble pedestal, as if pausing in the middle of an address. He holds his text across his chest. His gaze is direct and steady, although, because of the statue's height, he appears to be gazing not at an audience but into space.

While the statue of Garfield is considered one of Ward's best, the three larger-than-life bronze figures seated around the memorial's base are equally interesting. Ward conceived of these three figures as representing the three phases of Garfield's life. First is the scholar, representing Garfield's career as a student, professor, and school principal before the war. The contemplative young man, barefoot and

John Quincy Adams Ward posed in his New York studio while working on the model of the Garfield monument, about 1885. From John Quincy Adams Ward: Dean of American Sculpture, *by permission of Lewis Sharp.*

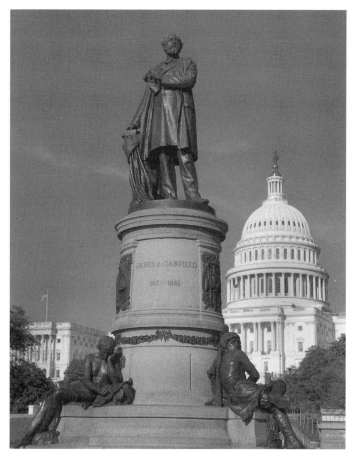

James A. Garfield stands as if in mid-speech, with his text held against his chest. The three figures seated around the base of the monument represent three phases of Garfield's life: student, soldier, statesman.

The bearded warrior, with tall boots and a wolfskin draped over his head, clutching the hilt of his sword, represents Garfield the Civil War soldier.

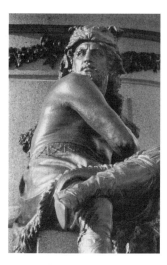

draped in a sheepskin, reads from an unrolled parchment. The second figure represents Garfield the soldier. This powerful, bearded warrior, with a furry wolfskin draped over his head and shoulders, warily looks over his shoulder and clutches the hilt of his sword. Finally, there is the statesman, representing Garfield the congressman and President of the United States. This mature man in a toga and sandals, his right foot resting on a stack of books, holds a tablet inscribed "Law-Justice-Prosperity."

It was on these three figures that Ward labored the longest, and they caused him to fall further and further behind. He asked for extension after extension and worked on the figures up until the absolute deadline for casting to insure that the monument would be finished by May 12, 1887, the date set by the Society of the Army of the Cumberland for its dedication.

May 12 dawned hot and cloudless. A colorful procession formed at eleven o'clock and proceeded up Pennsylvania Avenue to the foot of Capitol Hill, where the monument was concealed behind huge American flags. The Society of the Army of the Cumberland turned out in force and filled the first rows of seats. Among the guests of honor on the platform were President Grover Cleveland, justices,

congressmen, Ward and Hunt, most of Garfield's cabinet, Garfield's sons James and Harry (his widow Lucretia sent her regrets and thanks), and a bevy of Civil War generals that included J. Warren Keifer, who gave the main address, and Philip Sheridan, president of the Society of the Army of the Cumberland.

President Cleveland accepted the memorial on behalf of a grateful nation; the audience cheered as the flags parted, revealing the monument; and Garfield's former comrades-in-arms surged forward to get a good look at the memorial their dollars had helped erect.

SOURCES

Garfield Memorial Files, Office of the Architect of the Capitol, Washington, D.C.

Wayne Craven, *Sculpture in America* (Newark, Del., 1984), 245–53.

J. Walker McSpadden, *Famous Sculptors of America* (New York, 1927), 26–28.

Lewis Sharp, *John Quincy Adams Ward: Dean of American Sculpture* (Newark, Del., 1985), 18–81, 182, 223–26.

Washington Star, May 12, 1887.

6 ULYSSES S. GRANT MEMORIAL

Union Square, east end of the Mall

SCULPTOR: Henry Merwin Shrady

ARCHITECT: Edward Pearce Casey

DATE: 1922

MEDIUM: Bronze

The Grant Memorial is one of the largest, most important sculptures in the capital. The central figure, an equestrian statue of General Ulysses S. Grant, towers 40 feet above the 252-foot-long and 71-foot-wide marble platform. Grant and his horse constitute the second largest equestrian statue in the world, second only to the statue of Victor Emmanuel in Italy. Altogether, the memorial features thirteen horses sculpted in the round, making it one of the world's most complex equestrian statues and making artist Henry Merwin Shrady (1871–1922) one of the most prolific equestrian sculptors of all time.

Located at the foot of Capitol Hill, in Union Square, the Grant Memorial is also one of the city's most prominently placed monuments. The architects of the Senate Park Commission's 1902 plan to redesign the capital city, known as the McMillan Plan, envisioned Union Square as Washington's Place de la Concorde. The Grant and Lincoln Memorials, dedicated the same year, were designed to anchor the east and west ends of the Mall, the long rectangle stretching west from the Capitol. The monuments' preeminent placement was intended to enshrine the Civil War for all time.

Somehow things have not turned out as the planners hoped. Only the Lincoln Memorial has achieved the prominence intended for both monuments. Dwarfed by the Capitol building behind it and the reflecting pool in front of it, separated from the Capitol by little-used 1st Street and from the Mall by an expanse of water, the Grant Memorial is isolated from the city's activity.

The statue of Ulysses S. Grant and his horse Cincinnatus at the base of the United States Capitol is the second largest equestrian statue in the world.

The once-popular image of Grant himself has also diminished over the years, something the planners could not have foreseen in 1900, when Grant's place in the pantheon of American heroes seemed assured. Grant's funeral in 1885 had drawn more than one million mourners, making it one of the largest public gatherings in America in the nineteenth century. But while Lincoln's stock has continued to rise, Grant's has fallen. While the Lincoln Memorial remains one of the capital's most visited attractions, few visit the Grant Memorial. Its steps, designed as a reviewing stage for passing military parades, have instead been appropriated by commercial photographers, who pose and photograph there a perpetual parade of high school students.

Visitors who forgo the Grant Memorial miss one of the most passionate evocations of war to be found anywhere. No interpreters are needed for Shrady's stunning sculptural groups. There are no allegorical figures of gods and goddesses, no laurel wreaths of victory, no olive branches of peace, only the harsh face of war in the awful beauty of richly detailed men and horses rushing to battle. Twenty years in the making, when the Grant Memorial was finally unveiled in 1922, this startlingly different Civil War memorial confirmed the wisdom of

the selection committee in taking a long shot and sticking with a young, unknown sculptor like Shrady.

Grant had been dead barely two months when speculation about the most appropriate memorial to honor his memory surfaced. In September 1885, the *North American Review* raised the question in an article entitled "Grant's Memorial: What Shall It Be?" Complaining of the "many bad works that disgrace the national capital" and the "spirit of jobbery in which they are too often carried out," several critics offered suggestions and wrestled with the problem of how to portray a military hero whose enemies were his fellow Americans. The monument "*must* represent him as a military victor," noted one, but it should "contain no suggestion in its groups or its tableaux or its bas-reliefs that he ever gained a battle in which the defeated army was composed of his countrymen in rebellion." After all, argued another, "the great end accomplished by his splendid services was not victory over a foe, but reconciliation between brothers." Any monument to Grant, these writers agreed, "should be full of meaning in every line and form from base to apex; it should be simple, though full; pure, grand, unique, though not strained, and indigenous to the soil. In short, it should be an epitome of the simply great character it commemorates."

A decade went by before any action was taken on these grand, tortured ideas of what a national monument to Grant should look like. The first real seeds were sown at the 1895 encampment of the Society of the Army of the Tennessee, Grant's old command. The society voted to send members to Washington to lobby Congress for a monument to "the victor of Vicksburg and Shiloh and the Wilderness." They found friends in Representative William Hepburn of Iowa, a Civil War veteran, and Representative David Mercer of Nebraska, who was just 8 years old when the war ended. These congressmen introduced a measure providing for a Grant memorial, a commission to select an artist and a site, and, as testament to the high esteem in which Grant was held, an astonishing $250,000 for the project, the largest appropriation up to that point for a memorial.

Within two weeks of passage of the legislation, the Grant Memorial Commission, chaired by Secretary of War Elihu Root, was up and running. Its members began with the assumption that they would first select a site and then request models designed for the chosen location, but it quickly became clear that site selection would be more difficult than anyone had anticipated. Anxious to move forward, the commission decided to announce the competition anyway and simply note all locations in contention. Interested artists were to submit plaster models on a scale of one inch to one foot between March 1 and April 1, 1902. To be eligible, artists were required to be American citizens by birth or naturalization and to promise that all statue work and casting would be done in the United States. Notably absent were any restrictions regarding style or iconography, only that the models represent "the character and individuality of the subject."

As the first models began to arrive, Root named an advisory committee that included some of the nation's most prominent architects, Daniel H. Burnham and Charles F. McKim, sculptors, Augustus Saint-Gaudens and Daniel Chester French, and military men, General John M. Schofield and General Wesley Merritt. Their job was to judge the models, which, by the deadline, numbered twenty-seven, submitted by twenty-three artists, and which were displayed in the basement of Washington's Corcoran Gallery of Art, and from these to select a winner. Among the artists whose models were on view were Franklin Simmons, who had already created the Naval Memorial at the foot of Capitol Hill, a portrait statue of Grant that stood in the Capitol Rotunda, and a huge equestrian monument to Major General John A. Logan, dedicated the previous April. Another strong contender was Charles Niehaus, intensely bitter over having narrowly lost a similar competition to design the equestrian statue of General William Tecumseh Sherman for Washington and who was at work preparing his model for the just-announced competition for an equestrian statue of Major General George B. McClellan for the capital. (See #7 and #15 for Franklin Simmons, #18 and #27 for Charles Niehaus.)

Visitors and reporters alike were struck by the virtual consensus among all of the artists on the characterization of Grant's persona. Nearly all had created quiet, strong figures. In their written statements, the sculptors explained the effects they had sought to capture in words like "quiet and thoughtful," "calm determination and deep thought," "the absence of self-consciousness," and "quiet and dignified." Since it was Grant's role as defender of the Union that won him so large and expensive a monument, not Grant the President, whose administrations were marred by scandal and jobbery, it was no surprise that most of the artists emphasized Grant the commanding general of the armies over Grant the statesman. But just how Grant's ruthlessly won victories and the war itself were portrayed varied greatly as the artists wrestled with the issues raised in the 1885 article, mainly that the Civil War was an internal conflict and that Grant's triumph had not been over a foreign enemy but over his fellow Americans.

Most of the sculptors emphasized peace, reconciliation, and reunion by employing hosts of allegorical figures. Explaining his model to the commission, one artist wrote that it included a group representing "the triumph of Progress and Prosperity, led by Intellect, Labor, Art, Industry." Another balanced an allegorical group representing War with a seated figure of Peace, whose apron overflowed with plenty, which she shared with a figure representing Labor. Simmons balanced groups representing War, which included a soldier with drawn sword, and Peace, in which a soldier sheathes his sword.

Several artists wrote of their explicit efforts to skirt the fratricidal nature of the war. One artist proposed a long relief panel depicting "northern and southern soldiers fraternizing and helping each other; proof that there is no bitterness between the former combatants." In

one model, a maternalistic North reaches for the hand of the defeated South as Peace unites the two while Justice, History, and Education look on. In another, North and South are "clasping hands in forgiving oblivion" above a group depicting a "Northern warrior . . . succoring a wounded Southern brother, to whose lips Mercy is lifting . . . the cup of reconciliation."

And then there was sculptor Henry Merwin Shrady and architect Edward Pearce Casey's model, like none of the other twenty-six. Their design, calling for a massive platform 252 feet wide and 71 feet deep, with an equestrian statue of Grant at the center flanked by large groupings of soldiers, gave no nod to peace or reconciliation, no hint of reunion and progress. Shrady's Grant is surrounded not by figures of Education and Justice but by cavalry, infantry, and artillerymen rushing headlong into battle. Shrady portrayed war's carnage untempered by hope and rebirth. The men in his groupings depict the terror, suffering, and fatigue of war. There is no glory here, only raw reality.

The advisory committee viewed all of the models at their first meeting on April 7, 1902, and announced their first, second, and third choices. Scottish-born sculptor John Massey Rhind's austere equestrian statue placed third (see #12 for John Massey Rhind). Second place went to Niehaus and architect Henry Bacon for their model of Grant on horseback, led by two soldiers on foot, one carrying the battle flag of Grant's regiment, the other a laurel wreath symbolic of victory (see #24 for Henry Bacon). The winning model was the work of the team of Shrady and Casey. The committee members were lavish in their praise of Shrady's model, commenting on the "brilliant character" of its composition, but they were hesitant about his ability to carry it off. Well they might have been, because Shrady was a nearly unknown artist. Just 29 years old, he had begun his career as a sculptor four years earlier.

Shrady was from a prominent, old New York family. His father, George Shrady, had been one of Grant's attending physicians during his final agonizing bout with cancer and offered his son valuable advice as he modeled Grant's features. Henry Shrady graduated from Columbia University in 1894 and entered Columbia's law school but withdrew after a year to go into the match business with his brother-in-law, Edwin Gould, son of millionaire financier Jay Gould. A bout with typhoid fever and the failure of the Continental Match Company forced upon Shrady a period of idleness, and during his recuperation he spent his time at the zoo in Bronx Park, where he began sketching and modeling the animals. He found that he was surprisingly good at it, a discovery that changed his life. His small bronze groups attracted notice and won him an invitation to enlarge his statuettes of a moose and a buffalo for the Pan-American Exposition in Buffalo, New York, in 1901. Also in 1901, just before the Grant competition was announced, Shrady learned that he had won his first big public commission. Still barely known in art circles and working out of a spare

An unknown 29-year-old sculptor when he won the Grant memorial commission in 1902, Henry Merwin Shrady devoted the next two decades to creating the remarkable monument, only to die two weeks before its dedication. Courtesy of the Library of Congress.

room in the large house he and his wife shared with his mother-in-law, Shrady won the competition for an equestrian statue of George Washington that would stand in Brooklyn near the Williamsburg Bridge. Among the more experienced artists he bested for the prized commission was Charles Niehaus.

A big moose and buffalo and an unfinished statue of Washington represented the extent of Shrady's public career as a sculptor when the committee chose his model over all of the others submitted for the Grant competition. So concerned were committee members about his ability to follow through that they recommended to the commission, which agreed, that both Shrady and Niehaus enlarge their models for a second round of judging. The newspapers carried the story of the second competition and fanned it into a full-blown drama that caught the public's imagination. Niehaus and Rhind provided reporters with plenty of fuel.

Niehaus was furious that Shrady had won first place in the competition. In letters to the commission, he sarcastically referred to the lone moose and buffalo and fumed that Shrady could not possibly bring off such a large project. Rhind launched pointed barbs against the "dilettante," whose model was inferior to "the offerings of serious and matured thought of men who have to their credit acknowledged works of art." Other artists added criticism of the judges and the judging process to the fire. Artists who were not members of the National Sculpture Society, which one characterized as a "vicious" monopoly, charged that Saint-Gaudens and French, who were prominent members, were partial to fellow member Shrady. "The bunko game in art," one charged, "does not differ materially from that practiced by the animals who infest the criminal belt of large cities." Still others complained that Shrady's status within New York society had weighed heavily in his favor with Saint-Gaudens.

Niehaus's increasingly shrill letters to the commission served only to make him look jealous and petty. Shrady, on the other hand, though well aware of Niehaus's efforts to discredit him, quietly worked away on his enlargement. His letters to the commission were measured and respectful, a fact that did not go unnoticed by staff and members, one of whom wrote: "Mr. Shrady's replies contain no such personal remarks and insinuations as characterize Mr. Niehaus's communications."

The enlarged models went on public display at the Corcoran on October 1, 1902. The advisory committee was called into service again, but members found their task more difficult this time around. Two months later, they still had not chosen a winner. During those two months, Niehaus had not let up on his allegations. Convinced that Shrady could never produce so large and complicated a memorial for the allotted $250,000, Niehaus charged that the Goulds and other wealthy New Yorkers had secretly promised to pay the difference in order to secure the commission for one of their own.

By mid-December, Secretary Root had had enough of the "spectacle of a fierce feud between two rival sculptors," and asked the committee members to hurry up. Generals Merritt and Schofield reported back first and strongly favored Shrady. While they spoke of his model's artistic merit, that these two generals and Root himself favored Shrady's realistic depiction of war is of a piece with the prevailing mood within the administration of President Theodore Roosevelt and the military. Shrady's model spoke of sacrifice and hardship. It was a vivid reminder of the high price of freedom. Constant vigilance and a sense that the victories of the past should spur the nation on to fresh effort were watchwords of Root's and Roosevelt's rhetoric in those years hard on the heels of the Spanish-American War. All of these men believed in the power of public sculpture to inspire citizenry. For them, a monument that suggested that war was a thing of the past, as did Niehaus's and most of the others, simply would not do.

Architect Burnham deferred to McKim's judgment, and McKim voted for Shrady. In carefully reasoned statements befitting esteemed sculptors, Saint-Gaudens and French also cast their lot with the young, inexperienced Shrady. Saint-Gaudens, who saw his age as a plus, not a minus, given how long the project was likely to take, was swayed by Shrady's "youth, his suppleness and the distinct artistic beauty and superiority of his conception of the monument as a whole." On February 3, 1903, the Grant Memorial Commission announced that it would award the coveted commission to sculptor Henry Merwin Shrady and architect Edward Pearce Casey.

Even though the two still did not know for certain where their memorial would be placed, Shrady began work on the lions for the four corners of the central pedestal and immediately made the first of several small but significant changes to his design. He had proposed ferocious, snarling lions poised to spring. But, after some thought, he decided to bring them into harmony with the statue of Grant, at whose feet they lay. All four reconfigured lions lie watchfully, merely suggesting strength and power, as does the statue of Grant. Beneath the lions, Shrady placed American and army flags to "personify the character of General Grant and his army in protecting the national ensigns." The commission was pleased with the new lions when Shrady sent photographs of the clay models in the fall of 1906 but dismayed that it had taken him two and a half years to produce the beasts. This first taste of Shrady's perfectionism and chronically slow pace was, the commission learned, a harbinger of things to come.

While Shrady labored over the lions, the Grant Memorial Commission wrestled with the Park Commission, Congress, and public opinion over the site for the huge memorial. A consensus had emerged that it should be placed at the east end of the Mall on a line with the planned memorial to Abraham Lincoln to the west. The desire to juxtapose Lincoln and Grant, twin icons of the Civil War, on

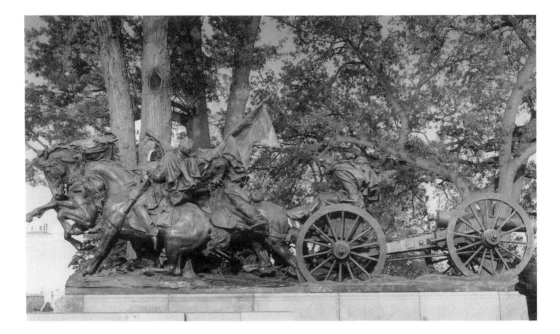

Shrady haunted the stables of the New York Police Department and joined an artillery regiment of the New York National Guard in preparation for sculpting the artillery group.

the two most prominent undeveloped sites in the capital emphasized the enduring importance of the war. The problem with the logical spot, however, was that it would displace the Botanic Garden and require the uprooting of several hallowed old trees. Powerful Speaker of the House "Uncle" Joe Cannon came to the trees' defense. The *Washington Star* did, as well, and spearheaded public opposition to the "tree butchers." In the end, the architects, planners and "tree butchers" wore down the opposition. In the spring of 1908, the superstructure for the Grant Memorial was erected.

After the lions were finished, Shrady immersed himself in preparations for work on the massive artillery group for the south end of the platform. He joined an artillery regiment of the New York National Guard. He haunted the stables of the New York Police Department. He borrowed Civil War uniforms and equipment from the obliging War Department. The remarkably detailed artillery group, featuring a caisson pulled by four powerful horses, carrying three soldiers and a cannon, and accompanied by a mounted guidon carrier, is the fruit of Shrady's exhaustive research. When it was cast in four pieces in 1911, the 15-ton artillery group was the largest bronze group ever cast in America.

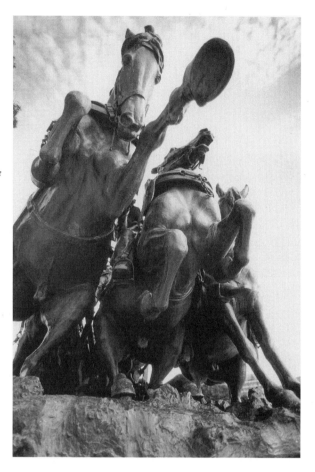

The powerful horses in the lead of the artillery group thrash the ground.

One of the three artillerymen riding in the caisson stares out over the horses to the battlefield beyond.

The three artillerymen huddle in the cold, apparently oblivious to the desperate maneuvers of the driver struggling to control the horses, which are a mass of tense muscles and swollen veins. Some of the horses have begun to stop, but one paws the air, straining forward violently. A close look reveals the explanation: the perfectly rendered bridle strap of the lead horse has broken, making him difficult to curb. The man with the upturned collar seated on the left of the gun carriage grimly grips his pitching seat. The middle man, with mouth drawn down and shoulders hunched, is the picture of weariness. The man on the right with the lush mustache, his coat blown back and his hands in his pockets for warmth, stares out beyond the horses to the battlefield to which he is being drawn. And what of the young, bare-headed guidon bearer, twisted around so violently in his saddle? Has he been shot? Has he just heard a new order? The passengers pay him little heed.

Once the artillery group was ready for casting, Shrady, far behind schedule and showing the physical toll the project was taking, turned to the cavalry group. He spent days at West Point, near his home on the Hudson River, where the superintendent staged cavalry charges

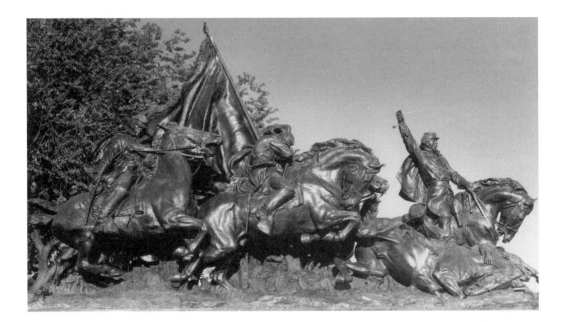

The color squad of a cavalry regiment charges into battle. The leader's sword has been broken off by vandals and replaced several times. The forearm clutching the fallen horse's neck suggests a rider pinned beneath it.

while he sketched. He had his young sons play water over his own horses so he could better understand their musculature. In the spring of 1914, he wrote the commission that he had completed a quarter-scale model. French was dispatched to inspect it and to prod Shrady to speed up. French, however, came to Shrady's defense. He lauded Shrady's work, defended his care and attention to detail, alluded to Shrady's delicate health, and urged the commission members to be patient, reminding them that sculptors "generally reckon that an equestrian statue will take two years to make and reproduce in bronze, and in the Grant Monument there are, in the Cavalry Group, seven or eight horses with riders and in the Artillery Group, I think four. In addition to this is the statue of General Grant himself."

There are, in fact, seven horses and riders in the color squad of the regiment charging into battle in the cavalry group. In both the artillery and the cavalry groups, viewers are not neutral observers but are forced to project themselves into the soldiers' maelstrom as they rush at an unseen enemy. So densely packed is the cavalry group that the viewer feels the dangerously limited perspective of every soldier in the desperate pack.

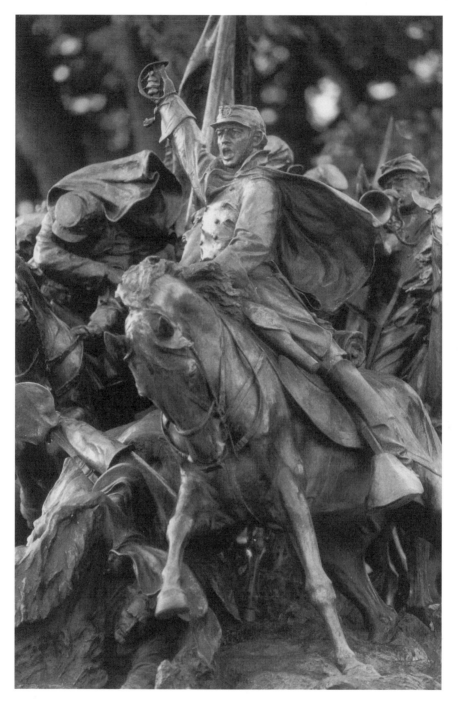

A bugler in the rear sounds the charge as the commanding officer surges forward. Visible behind the lead horse's right front hoof is the face of the fallen rider.

Head on, from a distance, the viewer sees the suddenly downed horse, front legs buckled, rear legs still kicking. Only a forearm clutching the horse's neck suggests that the rider is pinned beneath. Behind this pair and unaware of their plight, the commanding officer charges ahead with his sword drawn (it has been repeatedly broken off by vandals), urging his men forward. Closer up, the viewer grasps the sickening reality that the fallen rider is about to be trampled. It is clear that this horrible knowledge has just dawned on the two riders to his rear, the only ones able to see him. One shields his face with his arm as his horse's two front legs are about to stab downward. The other throws back his arm, pulling up his horse so hard that its jaw has been wrenched out of line, in a desperate effort to avoid the fallen pair. The men to their left, who cannot see the tragedy for the crush of flanks and bodies, plunge forward full speed. The oblivious flag bearer strains to wrestle his huge flag upright.

The ground over which these horses pound and the heavy artillery caisson rolls reflects the infinite pains Shrady took to get the details right and heighten the realism of his scene. Deeply rutted and uneven, the ground is strewn with the jettisoned debris of war. Broken sabers and a canteen with a frayed strap litter the muck.

After the cavalry and artillery groups, Shrady had only the statue of Grant and the infantry panels for the pedestal to complete. He was falling further and further behind (his contract was extended ten times over eighteen years) and growing weaker and weaker, and his whole family was suffering from what was becoming real financial hardship, since a large portion of the funds would not be released until completion. Shrady was forced to borrow money from his friends.

French became genuinely alarmed in 1915 and urged the commission to ease up on Shrady: "He is an intensely nervous man, working evidently all the time and at high tension, and any thing that can be done to make him feel easy in his mind will be for the good, not only of himself, but of the monument." The commission heeded French's advice and left Shrady in relative peace to work on the Grant statue. Though the terrible influenza epidemic of 1918–19 afflicted Shrady and his whole family and the First World War made materials difficult to obtain, he finished the equestrian statue in 1919.

Shrady wanted a fine, big horse like Grant's charger Cincinnatus, and he modeled the horse in clay four times before he was satisfied. In contrast to the alert horse, Grant sits with shoulders slouched, wearing a battered hat, a heavy cloak, no sword, a stiff wind to his back, calmly watching the crashing, churning groups below him. His face is haggard. Shrady examined Grant's life mask to get the proportions right. Grant's oldest son, Frederick Dent Grant, and Shrady's own father offered suggestions.

Only the two infantry panels remained unfinished. When they were still not finished by the summer of 1921, the commission issued

Desperate to avoid the fallen horse and rider, a man in the rear pulls up his horse with all his might.

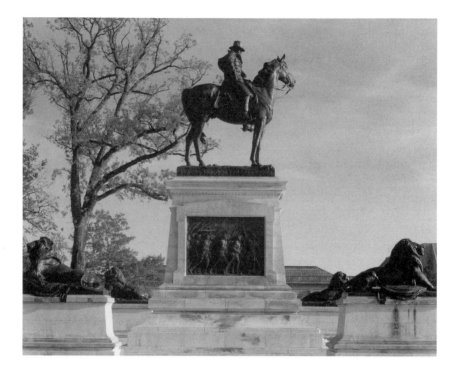

Four lions keep watch at the base of the central statue. The infantry panels on the pedestal were completed and installed after Shrady's death.

an ultimatum: finish them by October or they would be given to another artist. Shrady was crushed by the news. Frantic for her husband's peace of mind, Harrie Shrady wrote to family friend and commission member Charles Moore, asking him to intervene: "[His] whole soul is in his work. No one else has touched it, and to do so now seems too cruel. . . . He does not know I am writing, but I cannot stand seeing his agony of spirit, without making an appeal to you."

Though Moore tried his best, the other commissioners were unrelenting. Shrady reluctantly took on a young assistant, Edmund Amateis, to help finish the low-relief panels of dozens of marching infantrymen, which he had already sketched out in clay. Shrady's health deteriorated. With the panels still unfinished as the new year approached and its patience worn thin, the commission decided to move ahead without them and scheduled the dedication of the Grant Memorial for Thursday, April 27, 1922, the centennial of Grant's birth. (The panels were completed by sculptor Sherry Fry and installed in 1924.) Shrady was hospitalized in February 1922. He died on April 12, two weeks before the dedication of the memorial over which he had labored for almost two decades.

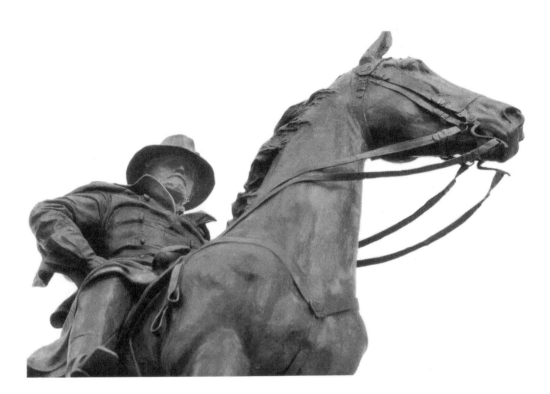

A stiff wind at his back, Grant sits calmly astride his alert horse, surveying the tumultuous battlefield below.

All federal offices were closed on April 27 so that government employees could attend the unveiling. Bunting once again sprouted from homes and office buildings. Visitors eager to witness the ceremony clogged the capital. Though unveilings of Civil War statues were becoming less frequent, this one began, as did most such occasions, with a huge military parade. Cadets from West Point, midshipmen from Annapolis, army, navy, and marine units marched from the White House to the foot of Capitol Hill past appreciative crowds, but the spectators reserved their loudest cheers for the Civil War veterans in the line of march.

According to the *Washington Star*, hundreds of elderly Union veterans and dozens of aged Confederate veterans had "limped into position" at dawn. At the command of "forward," the thud and roll of the drums began to beat out a cadence that "sent a smile across the faces of the stooped veterans of the Civil War, for their day was beginning again." Some of these old men claimed they had shaken Grant's hand, some had taken commands from him, some had marched this same route in the Grand Review in May 1865. The old Rebels boasted that they had been on the receiving end of Grant's battle orders. Behind the Civil War veterans marched the progressively

younger survivors of the Indian Wars, the Spanish-American War, and the recent World War.

Peace, unity, reconciliation, and progress were the brightest threads running through the afternoon's speeches. Beginning with the invocation, which thanked God for General Grant, whose heroic leadership "gave peace and unity to a distracted and bleeding nation," the emphasis was on Grant the peacemaker. Grant the ruthless general and Grant the two-term President were hardly mentioned.

Much was made of the fact that among the huge floral tributes from the Grand Army of the Republic and Union army reunion societies heaped about the base of the memorial was an enormous wreath from the United Confederate Veterans. The commanders of both the U.C.V. and the G.A.R. were featured speakers. In the past, the men who held these offices could usually be counted on for rhetoric that fanned the embers of the hot emotions of 1861 back into flames, but not this time. In his remarks, the G.A.R. commander cast the war in terms of a disagreement over constitutional authority and offered bland platitudes about reconciliation. For his part, the U.C.V. commander praised Grant effusively and expressed the wish that "if there ever was a day in all the calendar of days that should be blotted out from the book of recollections . . . it is that dark period of the sixties."

The rhetoric of the day closely echoed the themes of twenty-six of the twenty-seven models that had been submitted in 1902 for the Grant Memorial competition: the joining of hands of North and South, the peace and prosperity that come with unity, the reuniting of brothers. Secretary of War John Wingate Weeks, for example, who presented the memorial to Vice President Calvin Coolidge, standing in for President Warren Harding, who was off in Point Pleasant, Ohio, dedicating the Grant birthplace, took as his theme Grant's words "Let us have peace" and invoked Grant's blessing on his own plan for negotiations among nations to limit armaments that would bring about everlasting peace.

Twenty years earlier, all of the models heavy with allegory had been rejected in favor of the one realistic depiction of the uncompromising war that General Grant had won for the Union at a horrible price. Henry Merwin Shrady's model beat out its placid rivals precisely because of its realism, its reminder that such a high price might be exacted again for freedom's sake. But speakers at the dedication of the Grant Memorial were oblivious to the contrast between their conciliatory words and the harsh reality depicted behind them. The irony was lost on them. Only Coolidge briefly alluded to military preparedness and "militant freedom" in his remarks. The message that Shrady's work had so strongly conveyed to the men who selected it spoke not at all to the orators that afternoon. Shrady must have rolled over in his freshly dug grave when Coolidge later told the crowd, "A grateful Republic has raised this monument, not as a symbol of war, but as a symbol of peace."

SOURCES

RG 42, Records of the Office of
Public Buildings, Grant Memorial
Commission Papers, National
Archives, Washington, D.C.

RG 66, Records of the Commission of
Fine Arts, Executive Correspondence,
1915–16, National Archives, Washington, D.C.

Charles Moore Papers, Manuscript
Division, Library of Congress,
Washington, D.C.

Henry Merwin Shrady Papers,
Archives of American Art, Washington, D.C.

Commission of Fine Arts, *Annual
Report of the Commission of Fine Arts*
(Washington, D.C., 1919).

Congressional Record, 56th Cong., 1st
sess., 840, 3285–86; 56th Cong., 2d
sess., 302, 1111, 2291, 2417, 2492, 2495,
2559, 3167.

"Grant's Memorial: What Shall
It Be?" *North American Review* 141
(September 1885): 276–93.

William McFeely, *Grant, A Biography*
(New York, 1981).

Dennis Montagna, "Henry Merwin
Shrady's Ulysses S. Grant Memorial in
Washington, D.C.: A Study in Iconography, Content, and Patronage,"
Ph.D. dissertation, University of
Delaware, 1987.

Myrtle Murdock, *Your Memorials in
Washington* (Washington, D.C., 1952),
33–36.

John Reps, *Monumental Washington:
The Planning and Development of the
Capital Center* (Princeton, 1967), 105–
117, 150–52.

Kirk Eugene Savage, "Race, Memory,
and Identity: The National Monuments of the Union and the Confederacy," Ph.D. dissertation, University
of California, Berkeley, 1990.

Washington Post, December 6, 1902;
April 27, 1922.

Washington Star, April 15, October 4,
December 6, 1902; October 19, 22, 25,
November 13, 27, December 19, 1907;
January 14, March 23, 1908; April 27,
1922.

7 PEACE MONUMENT

Pennsylvania Avenue at 1st Street, N.W.

SCULPTOR: Franklin Simmons

DATE: 1877

MEDIUM: Marble

Most of the Civil War statues in Washington honor individuals. The
Peace Monument honors a group. Its inscription explains that it was
erected "In Memory of the Officers, Seamen, and Marines of the
United States Navy Who Fell in Defense of the Union and Liberty of
Their Country, 1861–1865." Most of the Civil War statues in the city
had elaborate dedication ceremonies complete with colorful parades
and moving speeches. Not the Peace Monument. No bands played.
No one eulogized the Civil War sailors and marines. The monument
appeared with no fanfare whatsoever at the base of Capitol Hill in
1877.

The Peace Monument's unheralded advent is probably due to a
running feud between Admiral David Dixon Porter and Secretary of
the Navy Gideon Welles that dated from the first days of the Civil
War. In his highly personal account of the navy's role in the war,
Porter wrote of Welles that he "served his country . . . with fidelity
and zeal, if not with conspicuous ability." The statue was Porter's
idea. At the war's end, correctly sensing that most of the glory would
go to the army, he decided that the nation's capital needed a memorial
to the heroes of the navy. Acting on his own, using all of the power at
his disposal as Superintendent of the United States Naval Academy,
Porter launched a fundraising campaign among officers, sailors, and
marines for what he called the Naval Monument and eventually collected contributions totaling $21,000. Porter knew exactly how he
wanted the monument to look, and he drew his own crude sketch.

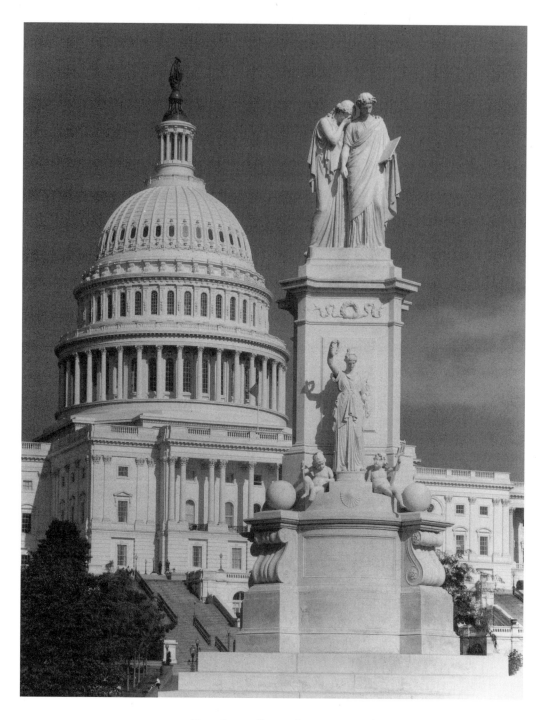

Planned as a tribute to the sailors and marines "who fell in defense of the Union," the Peace Monument is crowned by allegorical figures of America weeping on the shoulder of History, who holds the book in which the heroes' deeds are inscribed.

In 1871, Porter personally selected noted American sculptor Franklin Simmons (1839–1913), apparently without a competition, to make his ideas real. Porter may have come to know Simmons in the mid-1860s, when Simmons moved his studio from Maine to Washington and began sculpting busts of prominent statesmen. Porter may also have been familiar with Simmons's 1867 Civil War Memorial in Lewiston, Maine, one of the first such memorials commissioned in the nation. During his prolific career, Simmons created more than one hundred portrait busts, statues, and monuments, including a marble statue of Ulysses S. Grant in the Capitol, a gift to the nation from the Grand Army of the Republic, and the equestrian statue of General John A. Logan in Logan Circle, considered one of his best works (see #15).

While Porter did a great many things to make the monument he envisioned a reality, he did not consult with Secretary of the Navy Welles, who was furious at his presumption. When Porter finally did approach him, Welles ignored his request for funds and refused to designate a site for the statue. Undaunted and not at all contrite, in 1872 Porter appealed to Congress, which not only appropriated $20,000 for the base and installation but threw in the magnificent site right at the foot of the Capitol.

Simmons worked on the Naval Monument at his studio in Rome, where he had moved in 1867. To Porter's crude sketch, he brought his own brand of mid-nineteenth-century naturalism. When he completed the monument in 1876, Simmons shipped it to Washington in sections. It wasn't until the white carrera marble pieces were assembled on the base of blue granite designed by Architect of the Capitol Edward Clark that Porter really knew what he had wrought. Over 40 feet tall, the monument is crowned by two elaborately draped allegorical women, who represent America, sometimes identified as Grief, weeping on the shoulder of History over the loss of her naval defenders. History holds the book in which these heroes' deeds are inscribed. Its cover reads, "They died that their country might live."

On the west facade stands Victory, a woman holding a laurel wreath in her right hand and an oak branch in her left. She crowns the triumphs of the U.S. Navy at sea, represented by the two chubby infants who play at her feet—Neptune, god of the sea, with his trident, and Mars, god of war, with his helmet and sword. Peace, another woman, gazes out from the east facade holding an olive branch in her right hand. To her left, a dove, now broken off, once alighted on a sheaf of wheat, which together with a cornucopia symbolize plenty and agriculture. On her right are a gear, a book, an angle, and other tools of science, literature, and art, symbols of the progress that accompanies Peace. Surrounding the monument is a basin made up of four semicircles into which water once flowed from low fountains on each side. Though the original plans called for bronze dolphins and lamps around the base, Porter's funds would not stretch that far, and

he had exhausted the good will of the Congress to make additional appropriations.

Porter was delighted with Simmons's work and wrote to Architect of the Capitol Clark: "If this statue don't make members of Congress feel peaceful I don't know what will, for I think it looks very soothing." The local press was less enthusiastic. In the summer of 1877, the *Washington Star* called the new monument "deficient in originality and power." But, in defense of Simmons, the critic added, it is "rumored that the artist was in some degree hampered in his efforts, since it is given out that the design is in whole or in part that of a high naval officer, who probably knows more about the high seas than he does about high art."

Sometime after its quiet installation in 1877, what Porter had long envisioned as the Naval Monument began to be referred to as the Peace Monument. Local newspapers called it that at the turn of the century when they noted that the marble of the statue had already begun to deteriorate. In the early 1970s, antiwar protestors made the Peace Monument a rallying point. Although the monument was cleaned and restored in the early 1990s, several pieces have since broken off, including little Mars's sword and his left foot and Peace's olive branch and dove. The arrival of the automobile and changing traffic patterns have left the Peace Monument isolated on its circle amid a sea of asphalt and concrete. Once, however, it was a prominent city landmark and meeting place. The Peace Monument was the starting and ending point for the "old belt line" streetcar system on which one could circle the city and come all the way back for a nickel.

SOURCES

RG 66, Records of the Commission of Fine Arts, entry 4, Peace Monument, National Archives, Washington, D.C.

Peace Monument Files, Office of the Architect of the Capitol, Washington, D.C.

David D. Porter. *Incidents and Anecdotes of the Civil War* (New York, 1885), 66.

Washington Star, June 16, 1877.

8 MAJOR GENERAL GEORGE GORDON MEADE MEMORIAL

Pennsylvania Avenue between 3rd and 4th Streets, N.W.

SCULPTOR: Charles Grafly

DATE: 1927

MEDIUM: Marble

In the spring of 1927, government workmen demolished the last of the Botanic Garden greenhouses and uprooted the Bartholdi Fountain from the east end of the Mall to make way for a new monument, this one honoring the memory of Major General George Gordon Meade. The Meade monument, a gift of the Commonwealth of Pennsylvania, was to be erected in front and to the north of the dramatic Ulysses S. Grant Memorial at the base of the Capitol. Meade would be Grant's subordinate in marble as he had been in the flesh during the Civil War. Though it never came to pass, planners hoped for a triad of monuments, with one of a naval hero erected in front and to the south of the Grant Memorial.

Over the summer, the gleaming white marble sections of the Meade monument were moved into place and readied for the dedication ceremonies on October 19, 1927. Meade's would be one of the last of the Civil War statues to be erected in Washington, and the more

than six decades that had passed since the war's end were evident in the modest crowd that turned out for its dedication. Hundreds of veterans from the Army of the Potomac had surrounded the nearby Garfield memorial at its dedication in 1887. Though Meade had commanded the Army of the Potomac, only a handful of his men still lived in 1927 and, of those, few could travel to the capital. The majority of those who made up the crowd were members of the postwar generation, the children and grandchildren of the men who had fought with Meade. President Calvin Coolidge and Pennsylvania governor John S. Fisher, the featured speakers that day, were born in 1872 and 1867, respectively.

One reason so few of Meade's men survived to see their leader honored was because it had taken so long for his memorial to take shape. The delay was not due to a lack of admirers. Stubborn and self-righteous, Meade may not have been popular with the press, or with President Lincoln, or with Grant and his fellow officers, but he was extremely popular in Pennsylvania long after his death in 1872. Although born in Cadiz, Spain, Meade was from an old, wealthy Philadelphia family. Members of the Grand Army of the Republic and of the Society of the Army of the Potomac lobbied the Pennsylvania legislature to fund a statue of "the victor of Gettysburg." The likeness of this native son who won the most dramatic battle fought in the state, the most important battle, they believed, of the entire war, should stand in Washington and do the state proud. The state legislature appropriated the handsome sum of $200,000 for the statue and, in 1915, Pennsylvania's powerful congressional delegation pushed approval of the statue through Congress. There followed twelve years of bickering, by the end of which many of the movement's most ardent supporters were dead.

When Congress approved the Meade Memorial, it stipulated that its site and design be approved by the Commission of Fine Arts. Because the monument was a gift of the Commonwealth of Pennsylvania, there was also a Meade Memorial Commission, in Pennsylvania, appointed by the governor. The backgrounds of the members of the two groups could not have been more different, and their differences guaranteed that a rocky road stretched before them. The arts commission was composed of professional artists, architects, and planners. The memorial commission included Republican party hacks and veterans devoted to Meade but devoid of expertise in art. The two groups agreed on the site and that, because of the monument's placement, it should be interesting from all sides. They agreed on little else.

John W. Frazier, an aging veteran who had served under Meade at Gettysburg, was secretary of the memorial commission and one of the few members who took his job seriously. Frazier was also abusive and tactless, and the tone of his letters to the arts commission ranged from shrill to insulting. In one of his first letters, he stated his disdain for "culture," his deep hatred of the Grant Memorial, his distrust of

the members of the Commission of Fine Arts, and his own ideas for the Meade monument. It should, he insisted, represent the Battle of Gettysburg via a huge platform with Meade on a raised pedestal in the center. A vertical panel behind Meade should include a large bronze relief of corn and cotton plants, along with annual production statistics for each crop from 1860 to 1912. Higher up on the panel should be billowing clouds with cherubs proclaiming "Peace on Earth." The base should include a boulder from the battlefield and, perched on top of it, a large eagle with a ribbon in its beak reading "E Pluribus Unum." No matter that the work he envisioned would present a blank wall to anyone viewing it from the back. Frazier proclaimed his idea the perfect tribute.

The chairman of the arts commission sent Frazier's letter on to another commission member with the notation "to excite your hilarity," but also with a premonition of disaster. "Having some experience of the depth of the Secretary's convictions, his imperviousness to suggestions from any source, his absolute persistency in carrying out his ideas, and the political pull he has," the chairman despaired of making any progress.

A year later, plans for the Meade monument had progressed no further. Frazier repeatedly submitted designs he knew to be unacceptable and became increasingly rude in his correspondence. The members of the Commission of Fine Arts dreaded their meetings with him. In May 1916, one member wrote to the chairman that he could not stand another afternoon with Frazier, calling him "obstructive and insulting" and saying that it was "only because of the forbearance of the Commission that they have continued to show him the courteous consideration that he has long since forfeited."

Exasperated, the chairman wrote to the memorial commission asking it to submit no more drawings until they incorporated some of the arts commission's suggestions: "The Commission of Fine Arts regrets extremely that after repeated conferences with the Meade Memorial Commission, both in Washington and in Harrisburg, and after patiently explaining the accepted usual prerequisite of obtaining works of art, this Commission has failed to impress upon that body an adequate comprehension of the problem which they are called upon to solve—namely, to secure a memorial that shall at once express the place of General Meade in the history of this nation and constitute a contribution of the great state of Pennsylvania to the adornment of the city of Washington."

The impasse lasted for two years and was broken only when Frazier became too ill to argue and then died, in 1918. The memorial commission, which had always wanted a Pennsylvania artist to create the statue, suggested Philadelphia sculptor Charles Grafly (1862–1929), the longtime chairman of sculpture at the Pennsylvania Academy of the Fine Arts. While Grafly was well known and at the peak of his career, the arts commission was dubious. Grafly sculpted outstanding portrait busts, but his symbolic works had drawn criticism,

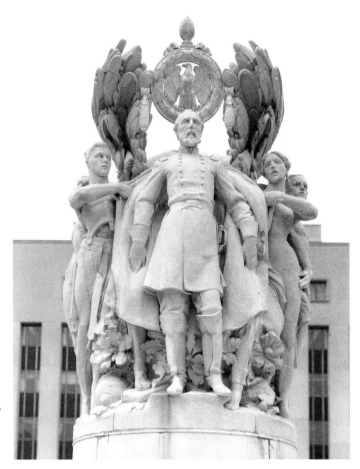

Youths representing Loyalty, to General Meade's right, and Chivalry, to his left, lift the mantle of war from his shoulders as he strides confidently toward the future.

indeed scorn, for being incomprehensible. His Fountain of Man at the Pan-American Exposition in 1901 was so loaded down with inscrutable figures that critics recommended that it should be accompanied by a printed commentary. Despite little confidence in Grafly, the Commission of Fine Arts agreed to consider his design and finally found in it and in Grafly something and someone they could work with. After several months of negotiations and refinements, they approved a preliminary design for the Meade monument in August 1918. Relieved, the Governor of Pennsylvania sent a personal letter to the arts commission, thanking the members for their patience.

Grafly masterfully interwove the real and the ideal in the monument. The symbolism, while plentiful, is less recondite than in his earlier works. He created a dense group of eight figures, striking from any angle. In the forefront is the lean, stern figure of Meade in uniform and bareheaded. To the rear, his back to Meade, is the grim personification of War, whose ominous wings sweep over the heads of all the others. His is a brutal face, with cruel eyes and a beetling brow. (War looked far fiercer before his nose broke off. The small, snub replacement nose takes away much of his menace.) War holds a two-edged sword and tablets inscribed with the names of Meade's

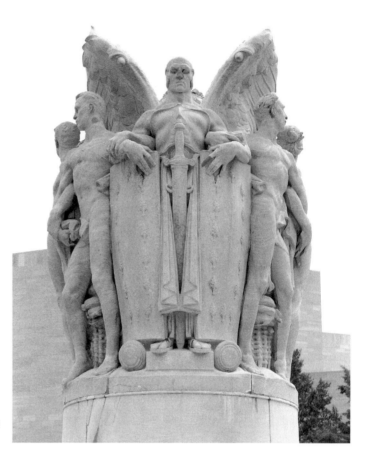

War, with his back to Meade and his ominous wings sweeping over the heads of the other figures, flanked by Energy on his left and Military Courage on his right, glares back into the past.

battles. He glares back into the past, while Meade looks confidently forward to the future.

Between Meade and War stand six nude figures portraying qualities important in shaping Meade's character. Loyalty, to Meade's right, and Chivalry, to his left, lift the mantle of battle from his shoulders. He is done with fighting. Loyalty holds aloft a standard embossed with a gold eagle above Meade's head like a halo. Next to Loyalty is Fame. She is straining up and beyond in the hope of seeing the future. Behind Fame, to War's left, is a muscular Energy. Energy is letting go his grip on War as Fame draws him forward and is steadied by his strength. Next to Chivalry is Progress. Like Fame on the opposite side, Progress actively pushes forward. Military Courage, next to Progress and to the right of War, stands with a look of grim determination. He clings to War's arm. Like War, he is not about to turn toward the future.

Though some wags complained that the real attributes of Meade's personality—moralizing and arrogance—were missing from the naked youths, the Meade monument was hailed as a triumph by most art critics. Grafly was lauded as a "pioneer in the wilderness of hero-

worship epitomized by the portrait statue," who had risen above "crude sentiment" to create a work that was uplifting and progressive.

In 1969, after forty-five years of being Grant's subordinate on the Mall, the Meade memorial was dismantled to permit highway construction under the Mall. In 1983, after fourteen years in storage, Meade reemerged, this time to be the centerpiece of a plaza northwest of the old site. Embedded in the plaza at the base of the monument are these words: THE COMMONWEALTH OF PENNSYLVANIA TO MAJOR GENERAL GEORGE GORDON MEADE WHO COMMANDED THE UNION FORCES AT GETTYSBURG. Meade looks out onto Pennsylvania Avenue to the spot that marked one of his proudest days. At nine o'clock on the morning of May 23, 1865, Meade rode down the avenue on his garlanded horse at the head of the Army of the Potomac as the leader of the Grand Review of troops. As he passed, the enormous throng picked up the chant of the Pennsylvanians in the crowd, "Gettysburg, Gettysburg, Gettysburg!"

SOURCES

RG 42, Records of the Office of Public Buildings, entries 387–90, Meade Memorial, National Archives, Washington, D.C.

RG 66, Records of the Commission of Fine Arts, entries 4 and 17, Meade Memorial, National Archives, Washington, D.C.

Christian Science Monitor, May 3, 1920.

Commission of Fine Arts, *Annual Reports of the Commission of Fine Arts* (Washington, D.C., 1913–17).

Wayne Craven, *Sculpture in America* (Newark, Del., 1984), 437–41.

Washington Post, August 17, 1983.

Washington Star, April 20, October 19 and 23, 1927.

9 ALBERT PIKE MEMORIAL

3rd and D Streets, N.W.

SCULPTOR: Gaetano Trentanove

DATE: 1901

MEDIUM: Bronze

The base of the Albert Pike statue bears seven words that his admirers believed summed up his career: "philosopher, jurist, orator, author, poet, scholar, soldier." Pike's enemies might have added libertine, traitor, and other unflattering titles. Pike was a large man—over 6 feet tall, "with the proportions of a Hercules and the grace of an Apollo"—with large appetites, who inspired great affection and bitter hatred. While his statue was erected by the Masons, who held him in high regard as the explicator of their ritual, it was Pike's brief, ignoble career in the Confederate army during the Civil War that earned him the greatest animosity. Although he is depicted in civilian clothes, his is the only statue of a Confederate officer in the nation's capital.

Born in Boston in 1809, Pike claimed to have spent a year at Harvard, though there is no record of it. Somehow he acquired a thorough knowledge of the classics and command of half a dozen languages, which helped him find work as a schoolteacher. Pike's

distaste for the confines of the classroom, plus difficulties with school supervisors over his amorous carryings-on, propelled him westward. After a series of picaresque adventures, which he turned into a popular narrative, he settled in Arkansas, where he unsuccessfully tried his hand at farming.

Teaching again rescued Pike from poverty. At night, he wrote poetry and pro-Whig pamphlets and studied law. He began a lucrative career as a lawyer specializing in Indian claims against the government. Pike's practice often took him to Washington, where he earned a reputation as a savvy lawyer, a shrewd political observer, and a heavy drinker.

Though previously a vocal Whig and antisecessionist, Pike cast his lot with the South in 1861. Because of his knowledge of Native Americans, he was commissioned a brigadier-general in the Confederate army and charged with negotiating treaties with the Indians to ally them to the Southern cause. Pike's Indian troops fought ingloriously at the Battle of Pea Ridge, Arkansas, and the atrocities they allegedly committed were laid at his feet.

Vocally chafing under what he regarded as interference by his superior officers, Pike resigned his commission. Before it was accepted, he wrote a string of pamphlets, some addressed to the Indians, critical of Confederate leadership. For these, Pike was dubbed "either insane or untrue to the South" and ordered arrested. While he talked his way out of a prison term that time, two months later, when he again criticized his superiors in print, he was taken prisoner and held until his resignation was finally accepted.

After the war, Pike was viewed with suspicion in both the South and the North. His land confiscated, a son killed in the war, and estranged from his wife, he wandered to upstate New York but fled to Canada when he was charged with inciting the Indians to revolt. Eventually he settled in Tennessee, where he practiced law, wrote poetry, edited a newspaper, and devoted more and more of his time to Freemasonry.

While Pike was living in Memphis, rumors circulated linking him to the Ku Klux Klan, whose members were spreading havoc throughout the South. Whispers suggested that Pike collaborated with Grand Wizard Nathan Bedford Forrest to develop Klan ritual. No evidence then or since has corroborated Pike's involvement, save his abiding love of secret rites.

Pike became a Mason in 1850, a Scottish Rite Mason in 1853. In 1859 he was elected Sovereign Grand Commander of the Supreme Grand Council, Southern Jurisdiction of the United States, an office he held for thirty-two years. During these years, he rewrote and interpreted the Masonic rituals, an enormous task for which he was highly revered by Masons in the United States and abroad.

Pike moved to Washington, D.C., in 1868 to practice law and be nearer his work as Grand Commander. Gossip dogged his steps. Sixty years old and still married, though he had not lived with his

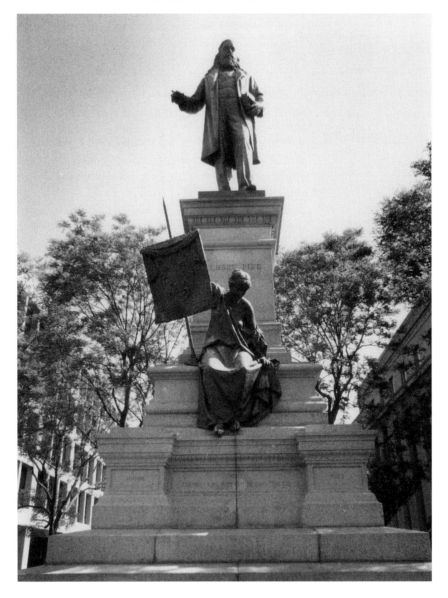

wife for years, Pike was captivated by 19-year-old Vinnie Ream, the flirtatious sculptor whose statue of Lincoln had just taken the capital by storm. (See #20 and #39.) Ream wanted to sculpt Pike's massive, leonine head. Her frequent, unchaperoned visits to Pike's quarters caused tongues to wag, and they wagged all the more after he issued a public statement proclaiming the purity of their relationship.

Pike died in Washington in 1891. Much was made in his obituaries of his poetry and his work for Freemasonry, little of his Civil War career. Pike once claimed that, "When I am dead, I wish my monument to be builded only in the hearts and memories of my brethren of the Ancient and Accepted Rite." While he was indeed remembered in their hearts and memories, shortly after his death the Masons also laid plans for a more tangible monument in Washington. The Supreme Council awarded the commission, without competition, to Italian-born sculptor Gaetano Trentanove (1858–ca. 1920), who had known Pike and whose statue of Jacques Marquette in the Capitol had recently won favorable reviews.

While Trentanove worked on the 11-foot-tall figure of Pike and the goddess of Masonry, who sits at his feet holding the banner of the Scottish Rite, Masons lobbied Congress, many of whose members were Masons themselves, for a place in the capital for their monument. Pike's Civil War career proved an obstacle. When word got out that the Masons were seeking federal land for a statue honoring Pike, congressmen began hearing from their local G.A.R. posts, warning them that a monument to the Confederate general would disgrace every Union soldier. The Masons emphasized that Pike was being honored not as a soldier but as a civilian, and they prevailed. Congress approved the site in April 1898.

The unveiling of the Pike monument on October 23, 1901, began with a colorful parade of thousands of Masons from all across the country in full regalia. Speech followed speech throughout the afternoon, but there were few references to Pike the Confederate general. Instead Pike was portrayed as a kindly poet, a friend to all: "In every line he wrote he impressed upon all his belief in the fatherhood of God and the brotherhood of man."

One speaker prophesied that "the name and fame of Albert Pike will grow brighter and brighter as the ages roll by," but few passersby today have any idea who Albert Pike was. The United Daughters of the Confederacy no longer holds ceremonies there on Pike's birthday; the Masons rarely decorate the monument. Curiosity was piqued only briefly in the early 1990s, when a conservative political group exhumed the rumors of Pike's involvement with the Klan and called for the statue's removal.

SOURCES

Vinnie Ream Hoxie Collection, Library of Congress, Washington, D.C.

Fred Allsopp, *Albert Pike: A Biography* (Little Rock, 1928).

Congressional Record, 55th Cong., 2d sess., 2256, 2311, 2717, 2804, 3152, 3532, 3560, 3644, 3647, 3757, 6807.

Robert Duncan, *Reluctant General: The Life and Times of Albert Pike* (New York, 1961).

Theodore Gatchel, *Rambling Through Washington* (Washington, D.C., 1932), 111–12.

Washington Star, October 23, 1901.

Judiciary Square, F Street between 4th
and 5th Streets, N.W.

SCULPTOR: Caspar Buberl

DATE: 1882

MEDIUM: Terra cotta (frieze)

From the beginning of the war until the end, General Montgomery C. Meigs, a West Point graduate and gifted engineer who oversaw the building of the Capitol extensions and dome, agonized over the welfare of the Union's forces. As quartermaster general of the army, Meigs held himself personally responsible for the shoes, rations, blankets, ammunition, horses, medicine, coats, drums, canteens, tents, and rifles of every Union soldier, sailor, and marine. During four years of war, he performed the seemingly impossible, capably disbursing millions of dollars in contracts and supplies, even while mourning the death of his only son, shot by Confederate guerrillas in October 1864 (see #35).

When the opportunity came to Meigs in 1881 to design a new building for the Pension Bureau, which was swamped by the rising tide of claims cascading in from Civil War veterans and their families, he knew just the sort of building he wanted. It had to be grand and noble, a fitting reflection of the glory of the cause for which the veterans had fought. Meigs, who was well traveled, drew upon the sixteenth-century Farnese Palace in Rome for his model. He designed an enormous Italian Renaissance rectangle, 400 feet by 200 feet, of red bricks (about 15½ million of them) with a large inner court graced by eight huge pillars and topped by a great, gabled clerestory. Mindful of the 1,500 workers who would toil within its walls, Meigs made certain the building was fireproof and labored to provide ample light and good air circulation.

From the very beginning, Meigs envisioned a dramatic frieze, like the one at the Parthenon, that would encircle the building. His plans called for a 3-foot-wide frieze between the first and second floors that would be 1,200 feet long. Meigs didn't want classical or allegorical figures for the frieze. He wanted realism—men and boys who looked just like the ones he was so proud of, like his own son—and he wanted every buckle, boot, wagon wheel, crutch, saber, saddle, and sidearm that he had supplied to be visible.

Meigs specified that the frieze be made of terra cotta, which was relatively inexpensive, durable, and able to be worked to a high degree of detail. He wrote to the Boston Terra Cotta Company soliciting models and suggesting a list of possible subjects that included gun boats on the Mississippi River and a cavalry charge. Which of these the Boston Terra Cotta Company chose to submit is not known, but it is clear that Meigs did not like any of its models. The technique and the perspective, he wrote back, were all wrong. He then sent photographs of the models to New York sculptor Caspar Buberl (1834–99) with a note, "I think you can do better."

Born in Bohemia in 1834, Buberl studied sculpture in Prague and Vienna before immigrating to the United States in 1854. By 1882, Buberl had sculpted several well-received pieces and established his

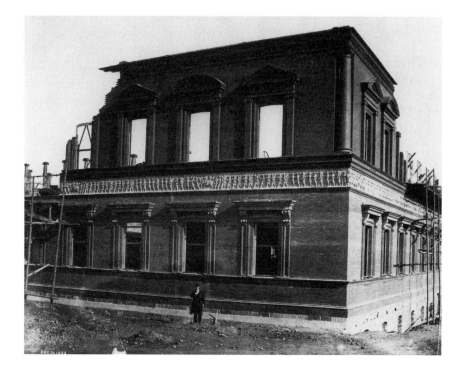

studio in New York. Meigs probably had come to know him through the allegorical group representing Science and Industry that Buberl created in 1880 for the north entrance of the Smithsonian's new Arts and Industries Building, a building Meigs had designed. Later in his career, Buberl sculpted a number of pieces with Civil War themes, notably the Alexandria Confederate Memorial (see #41) and contributions to the New York monuments at Gettysburg and Chickamauga.

One month after receiving Meigs's letter, Buberl sent him three plaster panels representing the infantry, and they were exactly what Meigs had in mind. Meigs wrote Buberl, "The design is spirited and the light and shade are good; the modeling is effective and as set up at height of 19 feet . . . it is large enough and strong enough to be a very pleasing and effective feature in the architecture of such a building."

In the weeks that followed, Buberl and Meigs sparred in letter after letter over the details of the undertaking. Buberl suggested 300 feet of original models in panels that would be repeated in various sequences around the building. Meigs replied that he could afford only 30 feet of original work and spelled out nine themes he wanted treated within that limited space, including a boat filled with sailors, marching sol-

diers, and, because he well knew that "without beef the army never marches," a herd of cattle. When Buberl calculated that the cattle alone would require 60 feet of original models, Meigs reluctantly abandoned them. After much negotiation, Buberl produced 28 panels measuring about 69 feet in all to be cast by the Boston Terra Cotta Company onto dozens of terra cotta slabs.

Because the slabs were set in place in sections as the walls rose, it was not until the entire building was completed in 1887 that the full effect of Buberl's incredible frieze dawned on Meigs, who was overcome. The high relief of the panels, the earthy, raw quality of the clay, the realism of the figures, the palpable sense of urgency and purpose that pulls the viewer along gave exactly the effect he had hoped for. No one man among the approximately 1,355 figures was singled out. Together these soldiers and sailors were all caught up in a great drama. The figures lean forward, marching, rowing, galloping, bumping and limping along in an inexorable cadence that is difficult to resist and impossible to buck.

Buberl and Meigs agreed on six separate groupings: infantry, cavalry, artillery, naval, medical, and, of course, quartermaster. The infantry is featured most prominently in the frieze, occupying almost 450 feet altogether, including the place of honor over the south entrance, the Gate of the Infantry. The infantrymen display the techniques that make Buberl's panels so compelling. While most of the men appear in profile, some look directly out at the viewer, while others are turned toward the rear. Dressed for battle, their rifles slung over their shoulders, they shout to one another and cock their ears to catch a reply. Some even smile. Their officers on horseback break out of the 3-foot-wide confines of the frieze with their hats extending above the borders, as do the staffs of the standard bearers, adding to the sense of energy and tension. On the cavalry panels, men astride powerful horses, whose energy is barely kept in check, advance with flags flying. More horses with intricate trappings appear on the artillery panels, where their riders urge them onward as they strain to pull the heavy caissons.

The naval panels presented Buberl with a problem. The navy had to be included, but artistically the introduction of water breaks the motion and destroys the rhythm of the frieze. Buberl did his best, placing stands of tall grass at the ends of the naval panels to mark the transition between land and water. Above the east entrance, the Naval Gate, and at points all around the building, six sailors strain at the oars to propel a small wooden boat forward through choppy waters while a seventh calls the strokes.

In his correspondence with Buberl, Meigs stressed the importance of depicting the medical corps in the frieze. He wanted the toll of battle visible but not maudlin. He was delighted with Buberl's interpretation and assigned the group to the north gate, the Gate of the Invalids. There are no pathetic amputees here, no dying men on stretchers. These are the walking wounded, with slings, crutches, and

While most of the men in the infantry panels appear in profile, some look directly out at the viewer.

Animated horses paw the ground in the cavalry panels.

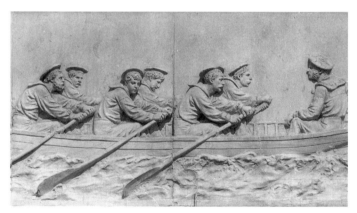

Sailors strain at the oars to propel a small boat through choppy waters in the naval panels.

The quartermaster panels were especially close to the heart of Quartermaster General Montgomery C. Meigs, architect of the Pension Building.

canes, helped along at a brisk pace by the men of the medical corps, who offer steadying arms to lean on.

Meigs designated the west entrance the Gate of the Quartermaster. Even without the cattle, each set of quartermaster panels is 12½ feet long. Six sturdy mules and the baggage wagon they pull are richly detailed. The driver is a black man. After receiving a packet of photographs of muledrivers from Meigs to help him sculpt the proper clothing, Buberl wrote back to inquire whether the driver was a Negro. Meigs emphatically replied, "Most of the drivers of Baggage wagons were freedmen Blacks. . . . By all means make the driver a Negro full blooded. . . . I leave all the clothes to your taste, but he must be a Negro, a plantation slave, freed by war."

While the Pension Building was heralded as an architectural triumph upon its completion in 1887, it had its share of critics. Local wags referred to it as Meigs's "old red barn." A story attributed to both General William T. Sherman and General Philip Sheridan has them lodging only one complaint: "Too bad the damn thing is fireproof." From 1887 until 1926, while the Pension Bureau for which it was designed lodged there, the Pension Building saw the disbursement of more than $18 billion to nearly 3 million veterans and their

survivors for service in the Revolution, the War of 1812, the Mexican War, the Civil War, the Spanish-American War, and World War I. Today the Pension Building is home to the National Building Museum.

SOURCES

RG 48, Records of the Office of the Department of the Interior, Office of Supervising Engineer and Architect, Pension Building, Daily Memoranda 1882–87, National Archives, Washington, D.C.

Pension Building Files, National Building Museum, Washington, D.C.

General Services Administration, *Historical Study No. 1: Pension Building* (Washington, D.C., 1964).

Joyce McDaniel, "Caspar Buberl: The Pension Building Civil War Frieze and Other Washington, D.C., Sculpture," *Records of the Columbia Historical Society* 50 (1980): 309–44.

Michael Wilson Panhorst, "Lest We Forget: Monuments and Memorial Sculpture in National Military Parks on Civil War Battlefields, 1861–1917," Ph.D. dissertation, University of Delaware, 1988.

11 ABRAHAM LINCOLN

Judiciary Square, D Street between 4th and 5th Streets, N.W.

SCULPTOR: Lot Flannery

DATE: 1868

MEDIUM: Marble

The life-size marble statue of Abraham Lincoln that stands in front of the Superior Court of the District of Columbia, built in 1820 as City Hall, is the oldest extant memorial to the slain president in the nation. It was not, however, the first built. That distinction belonged to a plaster statue of Lincoln that was erected in San Francisco in 1866 and which, when it eroded, was replaced by a metal one, which was destroyed in the fire of 1906.

Most of the citizens of Washington were horrified by the assassination of President Lincoln. They had endured four years of civil war with him, watched him grow older and sadder by the week, grown fond of his young sons if not his wife, grieved with him at Willie's death, and prayed beside him in their churches. They were also mortified that he had been murdered in their city. The city's loyalty had been suspect throughout the war, and citizens feared reprisals from the vengeful Republicans who controlled the Congress.

A mixture of love, loyalty, and prudence propelled a group of the capital's business and civic leaders to come together on April 28, 1865, just thirteen days after the President's death, to establish a committee to erect a public memorial to Abraham Lincoln by popular subscription. Most donations were small and came from local men and women. The largest came from a former resident, John T. Ford, who had sold his Washington theater to the government and moved to Baltimore, where he operated another theater. When he heard of plans for a Lincoln statue, Ford held a benefit performance and contributed the proceeds—about $1,800—to the fund.

The monument committee considered several designs, according to the *Washington Star,* but unanimously agreed upon the model submitted by Lot Flannery, declaring it to be the "most spirited" and "an excellent likeness." Flannery (1836–1922) and his brother, who had immigrated from Ireland as young men, owned one of the city's largest stonecarving businesses, specializing in tombstones. Detractors grumbled that Flannery was not really an artist, only a gravestone maker, but he had already proven to many Washingtonians that he was a moderately skilled sculptor. In June 1865, his touching sculpture for Congressional Cemetery of a neoclassical woman grieving over the graves of the victims of the Arsenal disaster (see #1) had won him friends within the city, where leaders were anxious for the commission to go to a local artist.

The unveiling of the statue was set for April 15, 1868, exactly three years after Lincoln's death. Late on April 14, workmen moved the covered statue from Flannery's studio to City Hall. A detail of police guarded it throughout the night to prevent peeking, while carpenters hammered together a platform large enough to hold all of the expected dignitaries. The next morning dawned gray and chilly, but that did not prevent an enormous crowd from forming. All offices closed at noon. All flags flew at half staff. The *Star* put estimates of the crowd at between fifteen and twenty thousand, an incredible number, representing almost 20 percent of the city's population.

The parade formed at 9th and D Streets, N.W., and began about one o'clock. The Knights of Pythias, dozens of Masonic lodges, temperance societies, fire company bands, military bands, military units, and veterans groups marched toward City Hall. Waiting there on the platform were special guests President Andrew Johnson, sculptor Flannery, Generals Winfield Scott Hancock and William Tecumseh Sherman, two Pueblo leaders and the chief of the Creek nation in "habiliments of the sons of the forest," a bevy of diplomats, and about 390 others. Absent were members of Congress and justices of the Supreme Court, who were hunkered down on Capitol Hill at the impeachment trial of President Johnson. Also conspicuously absent from the platform was General Ulysses S. Grant, who claimed he would rather stand on the sidewalk with his fellow countrymen than share the stage with Johnson, whom he had come to despise.

Following prayers, music, and a Masonic ceremony involving a plumb and level, Major General Benjamin Brown French delivered the day's major speech. Brown, who had known Lincoln well when he served as Commissioner of Public Buildings during the war, spoke movingly of the city's affection for Lincoln and emphasized that this was a statue raised by Washingtonians out of love and respect: "*Here,* where he earned his highest honors; *here,* where he won from all who knew him—and who is there that did not know him?—golden opinions; *here,* where in the midst of his friends, while enjoying a brief respite from cares . . . he was struck down in death by the hand of the

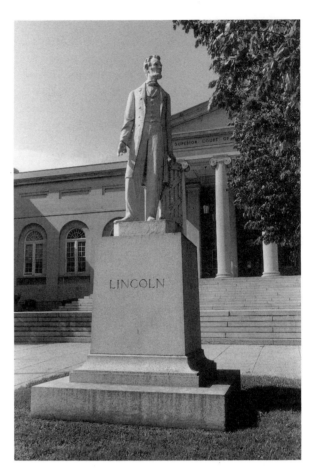

The citizens of Washington erected this heartfelt statue of Abraham Lincoln, the oldest extant memorial to the slain President, in 1868.

foul and cowardly assassin, have we this day placed upon its pedestal the plain, unassuming, but almost speaking, semblance of that plain, unassuming, but noble and god-like specimen of human nature."

After French's emotional oration, Mayor Richard Wallach introduced President Johnson, who pulled the cord, dropping the curtains that covered the statue. The crowd cheered wildly and then shouted for Flannery, who stood to acknowledge their applause. More music followed, then a benediction, and then the dedication ceremony was over and the crowd dispersed.

The life-size statue of Lincoln that the people of Washington had paid for looked down on them from atop a marble column over 30 feet high, causing consternation among local critics, who complained that they could barely make out who was up there. In fact, the features of the sculpture are sharply carved and the eyes deep set, making Lincoln unmistakable, even at a distance. He stands as if ready to speak, gesturing with his right hand, while his left hand rests on Roman fasces, a symbol of union.

In 1919, when City Hall underwent renovation for its centennial, the statue and column were dismantled and put in storage. To many, too sophisticated or too young to remember the events of 1865, this

naïve statue had become an embarrassment, especially when compared with the handsome Lincoln Memorial under construction in West Potomac Park (see #24). They urged that it be moved to a less prominent location, perhaps Fort Stevens (see #30). When a public outcry arose, led by the Sons of the Revolution, the Grand Army of the Republic, the Columbia Historical Society, and the Association of Oldest Inhabitants, demanding that the statue be returned to its original place, it couldn't be found. Finally located in crates behind the Bureau of Printing and Engraving, the statue was cleaned and placed on a simple low granite pedestal on April 15, 1923, fifty-five years after its unveiling. Once within reach, the statue fell prey to vandals. Lincoln's fingers were repeatedly broken off. Eventually his whole right hand was recarved but on far too large a scale.

SOURCES

RG 42, Records of the Office of Public Buildings, entry 97, Abraham Lincoln, Judiciary Square, National Archives, Washington, D.C.

F. Lauriston Bullard, *Lincoln in Marble and Bronze* (New Brunswick, N.J., 1952), 11–24.

Allen C. Clark, "Abraham Lincoln in the National Capital," *Records of the Columbia Historical Society* 27 (1925): 167–74.

House of Representatives, 67th Cong., 1st sess., HR 98, May 25, 1921.

Edward Steers Jr. and Joan Chaconas, *Everlasting in the Hearts of His Countrymen: A Guide to the Memorials to Abraham Lincoln in the District of Columbia* (Washington, D.C., 1984), 7–10.

Washington Star, April 14–16, 1868; December 17, 1922.

12 BENJAMIN FRANKLIN STEPHENSON AND THE GRAND ARMY OF THE REPUBLIC MEMORIAL

7th Street between Pennsylvania and Indiana Avenues, N.W.

SCULPTOR: John Massey Rhind

DATE: 1909

MEDIUM: Bronze

The program for the July 3, 1909, dedication of the Grand Army of the Republic's monument to Dr. Benjamin F. Stephenson began, "This memorial is the joint tribute of a grateful nation and his loving comrades, all that are left of an army of nearly three million men." For Stephenson, the tribute came too late. By his reckoning, the organization he founded in 1866 had spurned him, and he died in 1871 at the age of 48, impoverished and broken in health and spirit by perceived slights.

Born in 1823 in Illinois, one of eleven children, Benjamin Franklin Stephenson graduated from Rush Medical College in Chicago in 1850 and practiced medicine in Illinois and Iowa. In June 1861, at the beginning of the war, he was appointed surgeon of the newly organized 14th Illinois Volunteer Infantry and capably served for three years in the western armies. By June 1864, when he was mustered out with his regiment, he had reached the rank of major. Stephenson

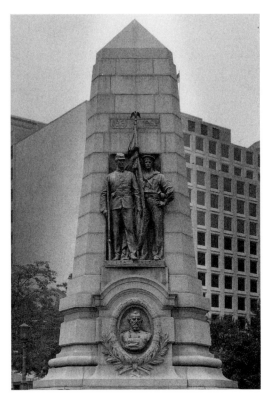

The figures on the facades of the Grand Army of the Republic's monument to its founder, Dr. Benjamin Franklin Stephenson, embody the organization's motto: Fraternity, Charity, and Loyalty.

settled down to practice medicine in Springfield, Illinois, but his experiences on the battlefields and the camaraderie of the camps would not leave him. While serving in the army, he had formulated an idea for a national association of Union veterans and, once a civilian again, he began to make his plan a reality.

Stephenson christened the new organization the Grand Army of the Republic, wrote its rituals, chose its motto, "Fraternity, Charity, and Loyalty," drafted its constitution, and set out its regulations: membership would be open to Union soldiers and sailors, officers and enlisted men alike, honorably discharged. Though he could inspire little interest among veterans in Springfield, Stephenson found support in Decatur, Illinois, where Post No. 1 of the Grand Army of the Republic was established on April 6, 1866, the anniversary of the Battle of Shiloh, in which he and most of the charter members of Post No. 1 had taken part. To get the organization started, Stephenson had declared himself commander of the Department of Illinois. He was crushed when the growing membership met to elect their first officers and selected another man for the honor of department commander. In November 1866, in his self-styled capacity as commander-in-chief of

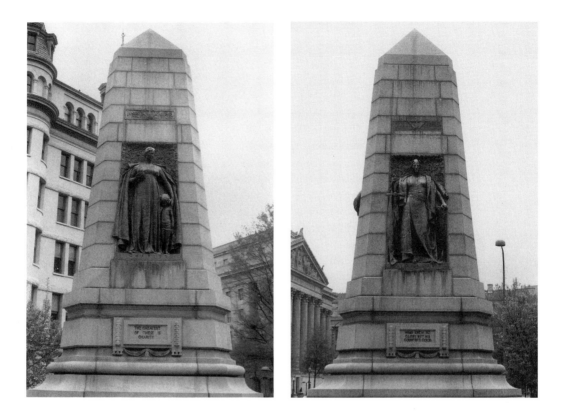

the G.A.R., Stephenson called for the first national convention and was again replaced in the election by another man, becoming relegated to adjutant general. Two years later, at the next national convention, in Philadelphia, he failed to win election to any office at all.

The members of the new G.A.R. realized what Stephenson did not. He was an "idea" man, someone who could conceive of and launch a new organization, but he was not the man to make it a success in the long run. He disliked routine duties, planning, and attending to details. His two years as adjutant general had proved that to his friends, but not to him. The G.A.R. engaged all of Stephenson's energy and imagination. His medical practice foundered, his health declined, and he died embittered, believing his efforts had been for nothing. At his death in 1871, the G.A.R. showed little promise of becoming the powerful organization that would emerge during the decade of the 1880s.

Initially a benevolent society dedicated to the assistance of wounded Union veterans and the widows of fallen servicemen, the G.A.R. grew to become the most powerful single-issue political lobby in late-nineteenth-century America. The political clout of

its tens of thousands of members was enormous. The G.A.R. justly claimed credit for securing massive pensions for veterans and veterans' preference in hiring and for helping to elect six Republican postwar presidents (Grant, Hayes, Garfield, Arthur, Harrison, and McKinley), all Union veterans. It was, however, more than a pension lobby or a bloody-shirt Republican club, both of which it certainly was. To its members, it was also a fraternal lodge, a charitable society, and a patriotic organization, keeping alive the memory of the sacrifice of those who wore the Union uniform by, among other efforts, promoting the observance of Memorial Day.

By the turn of the century, the G.A.R.'s membership and power were ebbing, as Civil War veterans grew old and died. Although its last member did not die until 1956, the G.A.R.'s leadership could clearly see the handwriting on the wall and began to think about memorializing not only the Union dead but the organization itself. The memorial to Stephenson is as much a tribute to the G.A.R. as to its founder. Members raised $35,000 for the memorial in an emotional nationwide campaign. Congress appropriated an additional $10,000 for its base.

The G.A.R. left little about the memorial to the artist's discretion. It was to be a tall, three-sided, granite shaft, with figures representing the three virtues of the G.A.R.'s motto: Fraternity, Charity, and Loyalty. John Massey Rhind (1860–1936), the sculptor chosen to execute these plans, was one of the finest architectural sculptors in America, and he excelled at this type of project. A genial Scotsman, he was the son and grandson of sculptors and had immigrated to America in 1889 at the age of 29. He had sculpted the Civil War Soldiers' and Sailors' Monument for Syracuse, New York, and an enormous statue of John C. Calhoun to go atop a towering shaft in Charleston, South Carolina. Rhind had entered and lost the competition for the Sherman monument in Washington.

For the main facade of the G.A.R. memorial, Rhind created a bronze medallion portrait of Dr. Stephenson. Above the medallion, a Union soldier and sailor stand side by side symbolizing Fraternity. On the northeast face, representing Loyalty, a gowned woman holds a shield and drawn sword above the inscription "Who Knew No Glory But His Country's Good." Charity, on the northwest face, is a woman in a flowing cape protecting a small child above the inscription "The greatest of these is charity."

The dedication of the G.A.R. memorial on July 3, 1909, was a front-page story in the *Washington Star*. Hundreds of veterans "grizzled and gray" turned out, many wearing their old uniforms. After a moving invocation recalling the sacrifice of the men who had fought and died, commander-in-chief of the G.A.R. Colonel Henry M. Nevius delivered the sort of impassioned "bloody shirt" oration seldom heard anymore by 1909. "In the Southern states," Nevius recounted, "there were many who loved party and party power and

SOURCES

RG 42, Records of the Office of
Public Buildings, entries 351, 405–8,
G.A.R. Memorial, National Archives,
Washington, D.C.

RG 66, Records of the Commission of
Fine Arts, entry 4, G.A.R. Memorial,
National Archives, Washington, D.C.

Wayne Craven, *Sculpture in America*
(Newark, Del., 1984), 486–87.

Stuart McConnell, *Glorious Content-
ment: The Grand Army of the Repub-
lic, 1865–1900* (Chapel Hill, 1992),
xiii, 1–25, 224.

Joseph Walker McSpadden, *Famous
Sculptors in America* (New York,
1927), 247–73.

Washington Star, July 3 and 4, 1909.

party supremacy better than they loved the Union; many who openly
vowed that our fathers' Constitution was a worthless rag." Nevius
held out no conciliatory hand but instead wound up by emotionally
invoking the memory of all of the Union boys by whose blood "the
flag of the United States had been raised from the dust and mire,
smoke begrimed, powder stained and bullet ridden and thrown to the
breeze to float forever over our broad land of the free."

President William Howard Taft accepted the G.A.R. memorial
on behalf of the nation and paid tribute to the veterans whose ranks,
he noted, were thinning. After the President spoke, Senator William
Warner of Missouri, past commander-in-chief of the G.A.R., ex-
horted the crowd: "Boys, the President of the United States talks like
a comrade. Get up on your feet, all of you, now three cheers for the
President of the United States." Taft was lustily cheered, as was
Rhind, who was presented to the audience. As soon as the cere-
monies ended, a huge military parade was to begin, but just before the
crowd broke up, the marine band began to play "Tenting on the Old
Camp Ground." One by one the old veterans began to sing, softly,
hesitantly at first, but gradually finding their voices and singing loud
and strong.

13 MAJOR GENERAL WINFIELD SCOTT HANCOCK

Pennsylvania Avenue and 7th Street,
N.W.

SCULPTOR: Henry Jackson Ellicott

DATE: 1896

MEDIUM: Bronze

Even as a little boy, Winfield Scott Hancock, named for General
Winfield Scott, showed a fondness for military drill and organized his
playmates into companies. He graduated from West Point in 1844,
where his contemporaries included men under whom he would serve
and against whom he would fight during the Civil War: Ulysses S.
Grant, George McClellan, John Reynolds, James Longstreet, George
Pickett, and "Stonewall" Jackson. Longstreet and Hancock fought
side by side at the Battle of Churubusco during the Mexican War.
Sixteen years later, Longstreet commanded the attack against Han-
cock's corps on Cemetery Ridge at Gettysburg, an attack led by
Pickett.

Hancock was chief quartermaster in Los Angeles in 1861 when the
outbreak of the war brought him back east. At McClellan's recom-
mendation, he was made a brigadier-general of volunteers and put
to work training the newly assembled Army of the Potomac. While
he fought throughout the Peninsular campaign and at Antietam and
Chancellorsville, it was at Gettysburg, where he commanded the 2nd
Corps, that Hancock achieved lasting fame. Arriving at Gettysburg on
July 1, 1863, Hancock, acting with broad discretionary powers from
General Meade, laid out a line of defense two miles long that wound
around Culps and Cemetery Hills and along Cemetery Ridge to Little

Round Top. On July 2, Hancock, commanding the left wing, halted the Confederate attempt to puncture the Cemetery Ridge line and turn the Union flank. On July 3, the final day of the battle, Hancock's corps repulsed Pickett's celebrated charge against the Union's center. At the height of the frenzy, Hancock was wounded. A bullet blew off the pommel of his saddle, drove a nail and bits of wood into his thigh, and left a wound that never completely healed. For his share in the victory at Gettysburg, Hancock received the thanks of Congress and was made a major general in the regular army in 1866. Hancock's army career lasted two more decades, until his death in 1886, at which point he was head of the Department of the East.

Though he had neither experience nor interest in politics, in 1868 Hancock received several votes for the presidential nomination at the Democratic convention, from men who knew the value at the polls of an untarnished military hero. His interest piqued, Hancock accepted the Democratic presidential nomination in 1880 and ran against another major-general, one with a less dramatic war record but much more political experience, James A. Garfield. After a campaign notable for its lack of issues, Hancock lost to Garfield by a small popular plurality and 59 electoral votes. Unfazed by defeat in his one and only attempt at public office, Hancock continued with his military career.

On February 9, 1886, news reached the floor of the House and Senate chambers that Major General Winfield Scott Hancock had died unexpectedly at his headquarters at Governor's Island, New York, after nearly half a century of distinguished military service. The next day the eulogies to Hancock were not only bipartisan but cut across sectional lines as well. In the Senate, Republican George Frisbee Hoar of Massachusetts spoke of the "great public calamity" of the death of "this distinguished and faithful citizen" and introduced a resolution calling for "erecting at the seat of government a statue or monument to the memory of the late illustrious soldier General Winfield Scott Hancock." His resolution passed unanimously.

In the House, Democrat Newton C. Blanchard of Louisiana, who must have recalled Hancock's mild views on Reconstruction when he commanded the Department of Louisiana after the war, arose and offered his own four-part resolution that also passed unanimously:

> Resolved, that this House has learned with profound sorrow of the great and irreparable loss which the country has sustained in the death of that great and good man Maj. Gen. Winfield S. Hancock.

> Resolved, that this House, in common with all his countrymen, mourn the death of him who was the stainless soldier for the Union in war, and the undaunted defender of the Constitution and of civil liberty in peace, and at all times the stainless man and the incorruptible patriot.

> Resolved, that as a mark of respect and affection for the exalted virtues of this hero and patriot this House do now adjourn.

In a May 12, 1896, advertisement in the Washington Evening Star, *S. Kann, Sons and Company used the occasion of the unveiling of the Hancock monument to tout its low prices.*

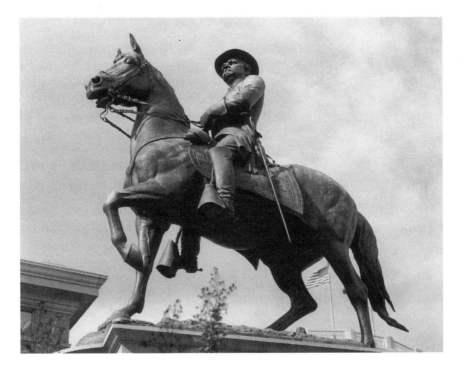

Though he was severely wounded at the Battle of Gettysburg, Major General Winfield Scott Hancock's army career lasted until his death in 1886.

Resolved, that the Speaker of the House be directed to transmit to the widow of the honored dead a copy of these resolutions and the assurance of the heart-felt sympathy of the House in the sorrowful bereavement which is alike hers and the nation's.

Congress appropriated $50,000 for an equestrian statue of Hancock and created a commission to choose a site and an artist. Six artists submitted models, including Edward Clark Potter, who had sculpted the equestrian statue of Philip Kearny at Arlington National Cemetery (see #37). Although the artists consulted by the commission rejected all six submissions, the commissioners and Hancock's family, who were growing impatient, liked the model submitted by Henry Jackson Ellicott (1847–1901), one of the chief sculptors for the federal government during the administration of Benjamin Harrison. Ellicott, the great-grandson of Andrew Ellicott, who had assisted L'Enfant in laying out the capital of the young nation in 1791, specialized in military subjects. His Civil War–related pieces include the Soldiers' Monument in Holyoke, Massachusetts, the First and Second Pennsylvania Cavalry Monuments on the Gettysburg Battlefield, and an equestrian statue of General McClellan in Philadelphia.

The Hancock statue was unveiled on May 12, 1896. All federal employees were to be dismissed in order to attend the ceremony, but officials learned that the Barnum and Bailey Circus was in town. Fearing that employees would use their time off to go to the circus, they rescinded the early dismissal. Consequently, though the *Washington Star* reported that "immense crowds" witnessed the ceremony and parade, the throng consisted mostly of veterans, officials, and soldiers from Hancock's postwar commands. The platform was packed with dignitaries, including President Grover Cleveland, justices, diplomats, congressmen, and generals. After young Gwynn Hancock, a West Point cadet like his uncle, pulled the cord dropping the drapery covering the general's statue, President Cleveland addressed the crowd, calling special attention to the sacrifice of the aging veterans in the front rows, who stood up a little straighter at the praise.

SOURCES

RG 42, Records of the Office of Public Buildings, entries 351–53, Winfield Scott Hancock, National Archives, Washington, D.C.

RG 66, Records of the Commission of Fine Arts, entry 4, Winfield Scott Hancock, National Archives, Washington, D.C.

Congressional Record, 49th Cong., 1st sess., 1314, 1327; 50th Cong., 1st sess., 3785, 4740.

Michael Wilson Panhorst, "Lest We Forget: Monuments and Memorial Sculpture in National Military Parks, 1861–1917," Ph.D. dissertation, University of Delaware, 1988, 453.

Washington Star, May 12, 1896.

14

ADMIRAL DAVID FARRAGUT, UNITED STATES NAVY MEMORIAL

8th and Pennsylvania Avenue, N.W.

SCULPTOR: Robert Summers

DATE: 1987

MEDIUM: Bronze

Around the southern rim of the world map that is the centerpiece of the United States Navy Memorial runs a low marble wall set with twenty-two bronze bas-reliefs. Most of the panels depict noncombat personnel and functions of the navy, such as chaplains, astronauts, research, and exploration. One of the liveliest of the reliefs, however, highlights one of the greatest battles in United States naval history, the Battle of Mobile Bay. The date was August 5, 1864; the ship, the *Hartford;* and the hero, Admiral David Glasgow Farragut. (See #20.)

In high relief and great detail, on a bronze panel just 36 inches square, enormous clouds of smoke billow out of the smokestacks of the steam sloops and ironclads clogging Mobile Bay. Dozens of sailors man guns on the *Hartford*'s deck. Shells land in the water all around the ship, sending up plumes of spray. Rigging is taut as the

Billowing smoke and roiling water surround Admiral David Farragut, high up in the rigging of his flagship, Hartford, *during the Battle of Mobile Bay.*

ship surges ahead, its wake churning out behind it. High up in the rigging is the tiny figure of Farragut swaying with his ship. Engraved above him are his famous words, "Damn the torpedoes! Full speed ahead."

The Farragut panel and the twenty-one others are an integral part of one of the capital's newer military memorials. Established by private citizens in 1977, the United States Navy Memorial Foundation's goal was to honor the men and women of the United States Navy, past, present, and future. The foundation worked closely with the Pennsylvania Avenue Development Corporation and selected Market Square, along Pennsylvania Avenue opposite the National Archives, as its site.

The foundation's first design, for a huge triumphal arch—a Washington version of Paris's Arc de Triomphe that would face the Archives—was rejected as too big and intrusive. The foundation's next proposal, featuring the low, subtle profile of the present monument, was approved. The 100-foot diameter amphitheater and plaza, whose deck is a granite map of the world, is encircled by a ring of fountains and pools, steps on which are carved memorable quotes, such as

Farragut's, from naval history, and the wall of bronze panels. The Lone Sailor, by World War II veteran Stanley Bleifeld, stands in the northwest quadrant.

To choose the subjects for the panels, the foundation solicited suggestions from a broad range of experts in naval and maritime history. Their instructions were to consider all eras and all aspects of the navy. The resulting list of sixty suggestions had to be winnowed down to twenty-two, but for Farragut it was no contest. Admiral Farragut, the navy's very *first* admiral, and the Battle of Mobile Bay ranked high on almost all of the experts' lists.

When the Civil War began in 1861, Farragut had already been in the navy more than forty-nine years. Born in Tennessee in 1801, he went to sea at the age of 8 and was appointed a midshipman at 9. During the War of 1812, he was given command of a captured British ship at the age of 12 and became a prisoner of war at 13. He saw action in the Mexican War but advanced slowly up the ranks. Though ambitious, his independence and stubbornness held him back. The Civil War gave Farragut and dozens of other officers the chance they had been waiting for.

Farragut was appointed to a command in the Gulf of Mexico early in 1862. His goal was to capture New Orleans—no easy task, considering the Confederate forts that lined the way on either side up the Mississippi. At two o'clock in the morning on April 24, 1862, after Union gunboats crept up and cut the chain holding a boom of hulks across the river, Farragut gave the order for his seventeen warships to weigh anchor and steam up river, squeezing single file through the hole in the boom. The Confederates let loose their mortar fleet, gunboats tried to ram Farragut's ships, and tugs sent fire rafts heaped with flaming pine his way. Aboard his flagship, the *Hartford,* Farragut never flinched. His fleet took a terrible pounding in the hour and a half it took to pass the forts, but the Rebel defense of New Orleans was smashed. A grateful Congress voted Farragut, his officers and men the thanks of the nation.

Farragut's next chance for glory came in 1864. This time his objective was to capture the Confederate defenses in Mobile Bay, thereby closing the South's last port on the Gulf. As the fog lifted on the morning of August 5, his fleet of ironclads and wooden ships steamed down the channel toward Mobile Bay and the three forts that guarded its entrance. The battle began shortly before seven in the morning. The *Tecumseh,* the leading ironclad, struck a torpedo (a mine) and went down with all her crew. In the confusion that followed, the *Brooklyn,* in front of Farragut's *Hartford,* stopped. Farragut refused to consider retreat. Hearing a cry from the *Brooklyn,* "Torpedoes ahead!" Farragut shouted back, "Damn the torpedoes! Full speed ahead." The *Hartford*'s bottom scraped over the damned torpedoes, but none exploded. Farragut's fleet passed all of the forts and entered the Bay, where they pounded the Rebel fleet into submission.

SOURCES

Thomas Coldwell, *Granite Sea: Navigating the United States Navy Memorial and Visitors Center* (Washington, D.C., 1992).

James Duffy, *Lincoln's Admiral: The Civil War Campaigns of David Farragut* (New York, 1997).

Loyall Farragut, *The Life of David Glasgow Farragut, First Admiral of the United States Navy* (New York, 1891).

Washington Post, October 13 and 14, 1987.

The intrepid Farragut, lashed up in the *Hartford's* rigging for a better view, was a natural for the wall of reliefs. The drama of the scene in Mobile Bay is what sculptor Robert Summers (1940–) sought to capture in the panel, fifth from the west end. Summers sculpted two other panels, Navy Astronauts and Recovery Missions and United States Coast Guard, on the eastern end of the wall. Summer's specialty is the American West. His best-known works include The Texas Ranger, at the Texas Ranger Hall of Fame in Waco, Texas, and John Wayne at the John Wayne Airport in Orange County, California.

The *Hartford* is highlighted once again on the glass Wave Wall leading down to the Navy Memorial's visitors' center. The Civil War panel features the *Hartford*, which was a steam sloop, the *Monitor,* an ironclad, and the *Cairo,* an ironclad river steamer.

15 MAJOR GENERAL JOHN A. LOGAN

Logan Circle, Vermont Avenue at 13th and P Streets, N.W.

SCULPTOR: Franklin Simmons

DATE: 1901

MEDIUM: Bronze

In the two decades after the Civil War, no one in Congress waved the bloody shirt with more vigor and venom than Senator John A. Logan of Illinois. No one fought harder for veterans' pensions and benefits than Logan, who helped establish both the Grand Army of the Republic and the Society of the Army of the Tennessee. And perhaps no one nursed a grudge against the West Point–trained professional soldiers of the Union army longer than Logan, who was among the best of the civilian or "political" generals of the war. "Black Jack" Logan's equestrian statue by Franklin Simmons (1839–1913) captures him in all his complexity—brave, belligerent, a bit puffed-up, theatrical.

The Logan statue was the second equestrian monument in Washington commissioned by the Society of the Army of the Tennessee. The first, a statue of James Birdseye McPherson, who was succeeded in command by Logan after his death on the eve of the Battle of Atlanta, was one of the first statues of a Civil War hero in the capital (see #17).

Logan had been elected to Congress as a Democrat in 1858 and again in 1860. In the winter of 1860–61, he denounced both Northern and Southern, Republican and Democratic extremists and remained uncharacteristically silent about the role he would take should war come. However, in the spring of 1861, with great fanfare, he took up a rifle and marched with a Michigan regiment as a volunteer at Bull Run, then returned to Illinois to recruit the 31st Illinois Regiment, of which he was at once made colonel.

Logan, who had his horse shot out from under him and was wounded twice, was an outstanding field commander, and he quickly rose through the ranks. When McPherson was killed on July 22, 1864, Logan took command of the Army of the Tennessee, but it was to be

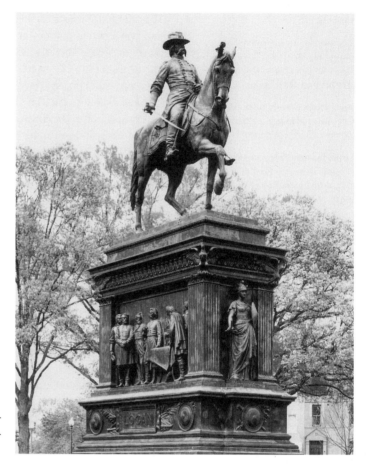

Both the equestrian statue of Major General John A. Logan and the elaborate pedestal, featuring bas-reliefs of Logan as soldier and statesman, are cast in bronze.

only a temporary appointment. To Logan's everlasting chagrin, General William Tecumseh Sherman recommended that he be replaced by West Pointer Oliver O. Howard. Logan was certain that Sherman favored Howard because of his prejudice in favor of West Point graduates, and he never ceased to vent his hatred of the military academy. In fact, Sherman considered Logan a first-rate corps commander. It was Logan the politician, and all of the "political generals," that Sherman distrusted. Logan had left the field several times in the months before Atlanta to shore up his political support in Illinois, and he would leave again afterwards on political errands.

Logan's political fence-tending paid off. After the war, he became a Republican and was elected congressman and then senator from Illinois, serving for almost twenty years, until he died in office in 1886. He unsuccessfully ran for Vice President on the Republican ticket with James G. Blaine in 1884. He was wildly popular among veterans nationwide. In Congress and out, Logan devoted himself to keeping alive the memory of the North's victory and the South's treachery. Always a champion of the poorest veterans of the lowest rank, his hatred of West Point and its elite graduates lurked just beneath the

surface of his impassioned speeches on behalf of the "boys in blue."

Given all that Logan had done for veterans, there was no question that they would want to honor him with a statue in Washington. The Society of the Army of the Tennessee, working closely with the G.A.R. and Logan's strong-willed widow, Mary Cunningham Logan, took on the project and began raising funds just after Logan's death in 1886. By 1892, the Logan Memorial Fund contained $12,972.07.

Once fundraising was under way, the society and Mrs. Logan persuaded Congress to establish the customary commission to select a sculptor and a site for the statue. The commission approached noted sculptor Augustus Saint-Gaudens about an artist. He suggested Franklin Simmons, an American sculptor working in Rome. The commissioners were probably already familiar with his work. His very first commission was for a statue of Major General Hiram Berry, killed at Chancellorsville. Simmons had created one of the nation's first memorials to the war dead, in Lewiston, Maine, and he had just finished a Civil War monument called the Republic for Portland, Maine. They undoubtedly knew his white marble Naval Monument, commissioned by Admiral David D. Porter in 1871 and erected in Washington at the base of Capitol Hill (see #7).

By December 1902, the commission had considered several models submitted by various sculptors and finally chosen the one "most agreeable to Mrs. Logan." Mrs. Logan liked Simmons's proposal best. Not only did she like the swashbuckling posture of her husband astride his impatient horse, but she liked Simmons's idea of an elaborate pedestal cast in bronze rather than carved from granite like the bases of the other statues in the city. She also liked the fact that Simmons and the commission were going to defer to her for suggestions for figures for the bas-relief panels on the base. Matters were settled: Simmons would begin work in Rome immediately and produce the statue and pedestal for $65,000, made up of funds collected by the Society of the Army of the Tennessee and appropriated by Congress, mostly the latter.

Simmons worked steadily, but the Logan statue, his first and only equestrian piece, proved more difficult than he had expected. In 1896, he wrote to the commission requesting the first of several extensions. Finally, in 1901, the statue and its pedestal were finished. The unusual piece was cast in Rome and, upon its successful completion, a ceremony was held at the foundry that was attended by the King and Queen of Italy, who honored Simmons with knighthood. Crated and shipped to America, the statue and pedestal arrived safely and were erected in fashionable Iowa Circle, which became Logan Circle in the early 1930s.

Together, Logan, his horse, and the pedestal rise to more than 25 feet. The only inscription is "LOGAN." Allegorical figures of War and Peace stand watch at the south and north ends and large high-relief panels on the east and west sides depict Logan the general and

In February 1901, General Grenville M. Dodge, president of the Society of the Army of the Tennessee, who had served under Major General John A. Logan, invited members to the unveiling of their monument to their old commander. Courtesy of the National Archives.

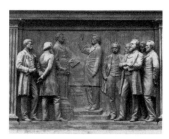

The panel featuring Logan being sworn into the Senate in 1879 drew criticism from the press: few of the gentlemen depicted in the bas-relief were actually on hand that day, and one of them had died in 1877.

SOURCES

RG 42, Records of the Office of Public Buildings, entries 351 and 376, John A. Logan, National Archives, Washington, D.C.

RG 66, Records of the Commission of Fine Arts, entry 4, John A. Logan, National Archives, Washington, D.C.

Wayne Craven, *Sculpture in America* (Newark, Del., 1984), 268, 295–300.

Pamela Hawkes, "Franklin Simmons, Yankee Sculptor in Rome," *Antiques* (July 1985): 125–29.

James Pickett Jones, *"Black Jack" John A. Logan and Southern Illinois in the Civil War Era* (Carbondale, Ill., 1995).

Washington Star, April 9, 1901.

Logan the statesman. Atop the elaborate base, Logan sits erect in the saddle, his chest thrust out, his sword drawn, awaiting the moment to command the charge.

The dedication of the Logan statue, on April 9, 1901, was front-page news. The *Washington Star* ran photographs and four columns of text, including the speeches of President William McKinley, the last of the Civil War veterans to occupy the White House, Senator Chauncey Depew of New York, and General Grenville Dodge, president of the Society of the Army of the Tennessee and the only one of the corps commanders depicted with Logan on the relief panels who was still alive.

Following the established formula for such events, the unveiling was preceded by a grand military parade featuring hundreds of veterans. Besides the President, the platform was crowded with members of Congress and the cabinet, Mrs. Logan and the Logan children and grandchildren, Simmons and his wife, and officers of the G.A.R. and the Society of the Army of the Tennessee. One of Logan's grandsons pulled the cord, parting the flags that had enveloped the statue, and a huge, appreciative roar went up from the crowd.

In the weeks that followed the unveiling, as reporters got a good look at the Logan memorial, praise of the statue turned to criticism, not of the horse and rider, not of the artist's style, but of the two relief panels that contained "absurdities." While reporters pointed out that it was almost certain that the seven stern-faced officers gathered around Logan in the military panel had, in fact, never plotted strategy all together, they could say with certainty that the panel depicting Logan the statesman was "impossible" and "ridiculous." The panel shows Logan being sworn into the Senate in 1879 by Vice President Chester A. Arthur, with Senators Shelby Cullom of Illinois, William Evarts, and Roscoe Conkling of New York, O.H.P.T. Morton and Daniel Voorhees of Indiana, John F. Miller of California, and Allen Thurman of Ohio looking on. The trouble was that Arthur himself wasn't sworn in until 1881, Cullom was not elected to the Senate until 1882 nor Evarts until 1884, and Morton had been dead since 1877.

Mrs. Logan had taken all the credit for selecting the scenes for the panels, and now she received the blame. She hotly replied in a letter to the *Star* that the events depicted were not meant to be historically accurate. "Of course," she wrote, "we knew all this, but we disregarded it because we wanted these panels to portray the most prominent men of the history of the country who were in the Senate during the 16 years that my husband was a Senator." The scenes were patriotic and moving, she wrote, because of, not in spite of, the individuals she had chosen to group together. To have reproduced a real scene, she huffed, would have been "absurd."

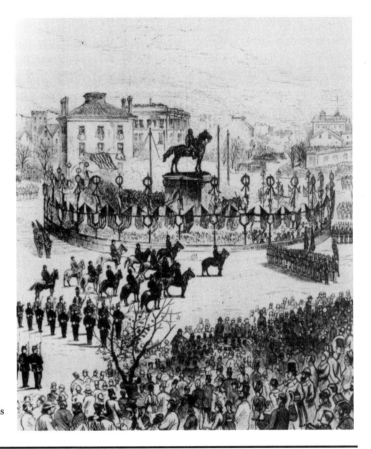

Trainloads of veterans pulled into Washington for the unveiling of the Thomas monument in 1879, among the earliest in a trend toward increasingly elaborate dedication ceremonies. Reprinted from Harper's Weekly, December 6, 1879.

16 MAJOR GENERAL GEORGE H. THOMAS

Thomas Circle, Massachusetts Avenue and 14th Street, N.W.

SCULPTOR: John Quincy Adams Ward

DATE: 1879

MEDIUM: Bronze

The national press converged on Washington to cover the dedication of John Quincy Adams Ward's equestrian statue of Major General George H. Thomas on November 19, 1879. *Harper's Weekly* dubbed the ceremony the grandest ever witnessed in the capital. The *New York Times* claimed that it drew the biggest turnout since the Grand Review of the troops in May 1865. Neither publication exaggerated: coming just fourteen years after the war's end, the elaborate dedication ceremony did indeed draw a huge crowd. Trainloads of veterans, eager to get rooms before the Wednesday ceremony, had begun arriving in the capital the previous week. Some came for the eleventh encampment of the Society of the Army of the Cumberland, which had commissioned the statue; others enjoyed impromptu reunions on sidewalks, in hotel lobbies, and in saloons. The entire federal government closed for the big event, and, noted the *Washington Star,* judging by the size of the crowd, every employee had decided to watch the parade that preceded the ceremony.

Second in size only to the Grand Review, the parade stretched on for two miles. Federal buildings and houses along the route vied with one another for the most elaborate display of bunting. Several thousand soldiers marched, their ranks interspersed with bands, Grand Army of the Republic units, chapters of the Society of the Army of the Cumberland, and hundreds of unaffiliated veterans who marched together as one, raising cheers from the spectators as they passed. A shower early in the day had dampened the decorations but not the spirits of the veterans, who pressed in close around Thomas Circle to see and hear the speakers. The circle itself was surrounded by banners bearing the names of the generals with whom Thomas had served. The statue was hidden from view by four huge American flags. Anticipation ran high, especially among the members of the Society of the Army of the Cumberland.

At the fourth reunion of the society in 1870, just after Thomas's death, the members had voted to erect a monument to their fearless, stubborn leader. A Virginian and a graduate of West Point, Thomas had served under Robert E. Lee in the West in the pre–Civil War army but in 1861 chose to cast his lot with the Union. The heroic stand of his troops during the Chattanooga campaign in 1863 earned him both the nickname "the Rock of Chickamauga" and the command of the Army of the Cumberland. Thomas became a major general after the rousing victory at Nashville, where he destroyed the Confederate Army of Tennessee.

The Society of the Army of the Cumberland had appointed a committee in each state to raise funds for the Thomas statue. By 1873, they had raised $10,000. The society then petitioned Congress to provide condemned cannon to be recast in Thomas's likeness, and Congress obliged with eighty-eight old bronze cannon and, in 1876, an appropriation of $25,000 for the statue's pedestal. The society also announced in 1873 that seven sculptors had submitted models in hopes of winning the prized commission. The society's officers didn't like any of them. They empowered the sculpture committee to go out and find a nationally recognized artist who would do General Thomas justice.

In 1874, the society signed a contract with New York sculptor John Quincy Adams Ward (1830–1910) for a 14-foot-high equestrian statue to be produced within three years in return for $35,000. Ward had found favor with the sculpture committee thanks to his Seventh Regiment Memorial in Central Park in New York and his 1872 portrait statue of Major General John Fulton Reynolds, commissioned by the First Corps of the Army of the Potomac for the spot where Reynolds had fallen on the Gettysburg Battlefield.

The Thomas statue was Ward's most important commission to date for two reasons: not only were commissions for equestrian monuments hard to come by, but a successful equestrian monument in the nation's capital might lead to future patronage, which, in fact, it

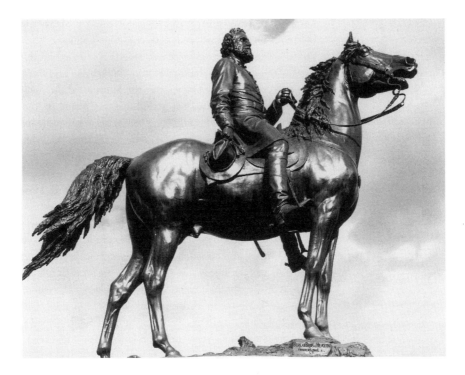

John Quincy Adams Ward's statue of Major General George H. Thomas, the "Rock of Chickamauga," is considered to be one of the best equestrian monuments in the capital.

did. So pleased was the society with the Thomas statue that its members chose Ward without competition a decade later to create their memorial to James A. Garfield. Pleased once again, they chose Ward in 1892 to create their third gift to the American people in Washington, another equestrian statue, this time of General Philip Sheridan. Unfortunately for Ward, this third commission broke the charm. The Sheridan commission proved disastrous all around and was finally taken away from him (see #28).

Ward set to work early in 1875. Mrs. Thomas supplied him with photographs of her late husband, his uniform, and his saddle and other equipment. By the spring of 1879, Ward had finished the plaster model; and he invited the press, officers of the Society of the Army of the Cumberland, Thomas's family, and several army officers to his New York studio to see it. They all loved the statue. The *New York Daily Tribune* described it for its readers on May 3, 1879: "The General in reconnoitering the position of the enemy has ridden his horse over the ground between, and brought him to a stand on the summit of a gently rising ridge. He holds the reins lightly in his left hand, and warmed by the brisk exercise has removed his hat and holds it in his

right hand." Having successfully piqued the public's interest, Ward put the Thomas statue under wraps again until the dedication day.

On November 19, 1879, President and Mrs. Rutherford B. Hayes, the cabinet, a host of congressmen, members of the military, other dignitaries, Ward, and past and present officers of the Society of the Army of the Cumberland crowded onto the platform in Thomas Circle facing the veiled statue. Senator Stanley Matthews of Ohio delivered the principal address, recounting Thomas's "conspicuous and unselfish devotion to public duty," and concluding with this hope: "When marble shall have crumbled to clay and brass become corroded by the rust of time, may the liberties of the people which he defended still survive, inspired to deeds of virtue and heroic duty by the memory of his example." Then Matthews, acting on behalf of the Society of the Army of the Cumberland, presented the statue to President Hayes, who accepted it on behalf of the American people. The huge flags parted and, said the *Star,* a roar of approval went up from the crowd as Thomas was revealed high (some said too high) on the pedestal silhouetted against the sky. Together horse and rider are one of Ward's most successful works, conveying power, strength, and action. The handsome horse exudes a nervous energy in sharp contrast with the calm confidence of its rider. With its four legs planted firmly on a slight incline, the horse sniffs the air with dilated nostrils. Its mouth is open, its head is tossed back, its ears are erect, and its mane and tail blow in a stiff breeze. Thomas sits easily on its back, relaxed, with his wide-brimmed hat in his hand at his side, a device Ward used to allow a good look at Thomas's face. The veterans in the crowd who had served under Thomas said that Ward had perfectly captured him. Critics regard this statue as one of the best equestrian statues in the city.

SOURCES

RG 66, Records of the Commission of Fine Arts, entry 4, John A. Logan, National Archives, Washington, D.C.

John Quincy Adams Ward Papers, Archives of American Art, Washington, D.C.

Wayne Craven, *Sculpture in America* (Newark, Del., 1984), 245–53.

Harper's Weekly, December 6, 1879.

New York Daily Tribune, May 3, 1879.

New York Times, November 20, 1879.

Lewis Sharp, *John Quincy Adams Ward: Dean of American Sculpture* (Newark, Del., 1985), 17, 57, 193–95.

Washington Star, November 17–19, 1879.

17 BRIGADIER GENERAL JAMES BIRDSEYE McPHERSON

McPherson Square, 15th Street between I and K Streets, N.W.

SCULPTOR: Louis Rebisso

DATE: 1876

MEDIUM: Bronze

Few Union officers rose through the ranks more quickly during the Civil War than James Birdseye McPherson. A first lieutenant of engineers in August 1861, by October 1862 he was a major general of volunteers and commander of a division of the 13th Corps. Within another year, he would be a brigadier general in the regular army, and, six months later, commander of the Army of the Tennessee.

Born on a farm near Clyde, Ohio, in 1828, McPherson received an appointment to West Point and graduated in 1853, first in a class that included Union and Confederate heroes Philip H. Sheridan and John Bell Hood. Eleven years after their graduation, Hood's battle orders would result in McPherson's death outside Atlanta.

From the spring of 1861, when he came back east from his post

in San Francisco, until his death in the summer of 1864, McPherson was in the thick of the action, during the Battles of Forts Henry and Donelson, Shiloh, and Corinth, and throughout the Vicksburg campaign, for which he won high praise from Generals Grant and Sherman. After Grant assumed direction of all the armies and Sherman succeeded him in command of the Military Division of the Mississippi, McPherson took over Sherman's Army of the Tennessee and fought all the way south to the outskirts of Atlanta.

On July 22, 1864, after receiving his orders at Sherman's headquarters and setting off with a single orderly to join his troops, McPherson ran into Confederate skirmishers. When he refused to surrender, he was shot from his saddle. It was said that Sherman's tears ran down and puddled on the floor when he saw the body of his favorite subordinate laid out on a door torn from its hinges to make an improvised bier.

A handsome, muscular bachelor with a thick, curly beard, McPherson had several months earlier applied for a leave, so he could go to Baltimore and marry the young woman to whom he was engaged. Sherman had refused the leave, because he believed McPherson would be indispensable during the hard fighting that lay ahead on the drive southward, but promised him he could head north as soon as Atlanta fell. Sherman wrote a touching letter to McPherson's sweetheart, explaining why her fiancé would not be coming after all.

A fearless commander, McPherson won the confidence and loyalty of his men and cemented it by living alongside them and sharing their hardships. After his death, Major General John A. Logan, who took over command of the Army of the Tennessee, rallied his men to push on to Atlanta with the cry, "McPherson and revenge, boys, McPherson and revenge."

At one of their first reunions, McPherson's "boys" of the Society of the Army of the Tennessee voted to honor him with a statue in the capital. Theirs would be the first of the bronze Civil War generals in Washington commissioned by a veterans' group. The society raised $23,500 for the equestrian statue, and, in 1875, Congress donated cannon captured in the Battle of Atlanta to be melted down and cast for the statue, and appropriated $25,000 for the base and pedestal.

When the first sculptor they chose proved unable to produce an acceptable model, the Society of the Army of the Tennessee turned to Italian-born Cincinnati sculptor Louis Rebisso (1837–99). Before his death in 1899, Rebisso would create two other mounted generals: William Henry Harrison in Cincinnati and Ulysses S. Grant in Lincoln Park, Chicago. Rebisso depicted McPherson surveying the battlefield. Alert, gazing into the distance, he holds binoculars in his right hand and his spirited horse in check with his left. His uniform is creased and rumpled from weeks on the move.

Plans for the society's monument incorporated a vault for McPherson's body, which had been buried near Clyde, Ohio. Just as the

The equestrian statue of Brigadier General James Birdseye McPherson, erected by the Society of the Army of the Tennessee in 1876, was the first memorial in Washington commissioned by one of the Civil War veterans' groups.

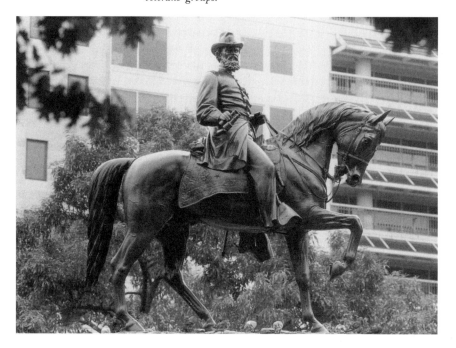

SOURCES

RG 42, Records of the Office of Public Buildings, entries 202 and 203, McPherson Monument, National Archives, Washington, D.C.

RG 66, Records of the Commission of Fine Arts, entry 4, McPherson Monument, National Archives, Washington, D.C.

Wayne Craven, *Sculpture in America* (Newark, Del., 1984), 525.

Harper's Weekly, November 11, 1876.

body was about to be exhumed, however, a group in Clyde, which was raising money for its own monument, got an injunction thwarting the society's plan.

The McPherson statue was unveiled on October 18, 1876, during the tenth reunion of the Society of the Army of the Tennessee. The dedication ceremonies, although modest, set the pattern for the more elaborate ones that followed in rapid succession: first a military parade featuring hundreds of veterans marching with their societies, with their G.A.R. units, and independently; followed by a host of dignitaries, usually including the President, taking their seats on the platform; then a series of patriotic speeches by high-ranking former comrades; and finally the actual unveiling of the statue. It was Sherman, Commanding General of the Army, who presided over the McPherson unveiling and Logan who delivered the chief address, which was on the theme of sacrifice. After more music and a prayer, the ceremony that would become the prototype for more than a dozen more ended, and "McPherson's boys" solemnly dispersed.

15th Street and Pennsylvania Avenue, N.W.

SCULPTOR: Carl Rohl-Smith

DATE: 1903

MEDIUM: Bronze

Next to Ulysses S. Grant, William Tecumseh Sherman is the most famous of the Union's generals. Next to the Grant monument, at the eastern end of the Mall, the Sherman Monument, behind the Treasury Building, with its equestrian statue, bas-relief panels and portrait medallions, sculpture groups, life-size soldiers, and lengthy inscriptions, is the largest and most complex of the capital's Civil War memorials. The dedication of the Sherman Monument, in 1903, was also second only to that of the Grant Memorial, in 1922, in elaborateness and in allusions to national strength and sacrifice. (See #6.)

Like Grant, Sherman had left the army and was floundering in the years before the war. His antebellum career gave little hint of the glory that lay in store for him. After graduating from West Point in 1840, Sherman served in the Mexican War. He resigned his commission in 1853 to enter the banking business, but first one and then another bank failed. When his attempts to return to the army were rebuffed, Sherman turned to law and lost the only case he tried. The beginning of the Civil War, in 1861, found Sherman serving as superintendent of a new military college in Louisiana. He turned down a commission in the Confederate Army. After the size of the regular army of the United States was increased that spring, Sherman was reappointed as colonel of the 13th Infantry. Finally, at age 41, he noted in his memoirs, there was purpose in his life.

The names of Sherman's battles, inscribed in the wide mosaic band around the base of the monument, chronicle the next four years: Bull Run, Shiloh, Corinth, Chickasaw Bluffs, Arkansas Post, Steeles Bayou, Jackson, Vicksburg, Colliersville, Griswoldville, Waynesboro, Fort McAllister, Capture of Savannah, Bentonville, Durham Station, Surrender of Johnson's Army, Chattanooga, Ringgold, Missionary Ridge, Relief of Knoxville, Meridian Expedition, Dalton, Resaca, New Hope Church, Dallas, Kulp's Farm, Kenesaw Mountain, Ruff's Mill, Peach Tree Creek, Atlanta, Ezra Church, Utoy Creek, Jonesborough, Capture of Atlanta, Allatoona. Made commander of the Army of the Tennessee in 1863, Sherman's "March to the Sea" in the winter of 1864–65 captured the imagination of the North. The press, whom Sherman mistrusted and who disliked him in return, grudgingly helped him become an immensely appealing hero.

Lieutenant general, then general and commander of the entire army from 1869 to 1883, Sherman was popular among veterans, whose welfare he looked after. Active in several veterans' organizations, he was in constant demand as a speaker at reunions, dedications, and encampments and rarely turned down an invitation to mix with the "boys." As soon as word of Sherman's death, in Febru-

ary 1891, reached the Society of the Army of the Tennessee, its officers began to plan a memorial honoring his memory. At the society's encampment that summer, members voted to raise "some suitable and permanent expression of the respect, admiration, and gratitude felt by the American people for the noble character, lofty patriotism, and invaluable services of General William Tecumseh Sherman" and to erect it in the nation's capital, the heart of the Union he had fought to save. They asked Congress to appropriate $50,000 toward their project and to establish the Sherman Monument Commission, both of which quickly came to pass.

For its part, the Society of the Army of the Tennessee established committees in each state to raise funds and wrote to the members of the Grand Army of the Republic, the Societies of the Armies of the Ohio, Potomac, and Cumberland, and the Military Order of the Loyal Legion, asking for their help. Every Union veteran was urged to contribute "so that when the statue is erected in Washington, every soldier who sees it will feel that it is a part of his effort." An emotional circular reminded the veterans of Sherman's concern for them:

> He of all the preeminently great commanders during the struggle for national unity . . . was superlatively one of us. At our camp fires and reunions . . . "Uncle Billy" was ever a prominent and welcome figure. His efforts for the welfare and pleasure of the "boys," no matter how arduous or how great a drain upon his time, were always deemed a labor of love and duty, to be fulfilled without abatement. No honors paid him abroad or at home ever tended to weaken his love and solicitous interest in those who "marched with him from Atlanta to the sea," or stood a bulwark between the nation and its foes on bloody, hard-fought fields.

Though, in the end, such appeals raised only $14,469.91, requiring Congress to double its contribution in order to complete the project, by 1895, the Society of the Army of the Tennessee was confident enough of success to announce a competition to select a design for the Sherman memorial. They wanted equestrian models only and only from American artists, either living in America or residing abroad. And they would select a winner with the help of a committee from the National Sculpture Society.

By April 1896, twenty-three sculptors had submitted models. Among them were Charles Niehaus, who had come close but failed to win several other federal commissions, including the one for the McClellan equestrian statue, and Danish-born Carl Rohl-Smith, who was working on the Soldiers and Sailors Monument for Des Moines, Iowa. Visitors flocked to the War Department where the models were displayed. The *Washington Star* reported that public sentiment favored the most elaborate of all the entries, Rohl-Smith's.

In mid-May, the commission announced the four finalists: P. W. Bartlett, John Massey Rhind (see #12), Niehaus, and Rohl-Smith. The National Sculpture Society sent a delegation of the nation's most prominent sculptors—John Quincy Adams Ward, Daniel Chester

French, and Augustus Saint-Gaudens—to evaluate their models. Rohl-Smith's design, which the three judges found ill-conceived and overdone, emerged at the bottom of their list, which was leaked to the newspapers. Two weeks later, the commission announced the winner: Rohl-Smith.

Niehaus and the other losers immediately cried foul. Given the commission's disregard for expert opinion, they claimed, no reputable artist would enter the upcoming competition for the Ulysses S. Grant monument commission. (Niehaus entered, lost, and complained bitterly.) The National Sculpture Society protested the decision in a strongly worded letter to the commission. The *Star* railed against the unfairness of the award, calling the competition a "bunko game . . . in which the aid of artists is solicited and the advice of competent judges is invited . . . only to be disregarded in favor of a preconceived opinion." Old soldiers, claimed the reporter, who had lobbied for the Rohl-Smith model, wouldn't know good art if they tripped over it.

In June, at the urging of the National Sculpture Society, Senator Edward Wolcott of Colorado, who claimed that the nation's capital was already disgraced by enough bad sculpture, offered a resolution for an inquiry into the awarding of the Sherman commission. The debate that followed revealed a vein of mistrust of "artistic experts" that ran deep among Wolcott's colleagues and reflected the prejudice of many of their constituents. Senator William Boyd Allison of Iowa claimed that, by choosing the model most pleasing to the general public, the commission was merely carrying out the public trust. Senator Joseph Hawley of Connecticut also opposed Wolcott. Hawley, who said he spoke for "the people," wanted "a popular statue of General Sherman—such a one as his old soldiers would recognize at half a mile distance; not a mere work of art, which might be entitled 'The American General,' but which was not a statue of 'Old Tecumseh.'" Senator Roger Mills of Texas agreed: the general's family and his men were the best judges, and they liked the Rohl-Smith model. "A committee of artists who aggregate to themselves an exclusive knowledge of art," he chided, would be the last people to whom he would refer such a subject.

Wolcott's resolution went down to defeat, but the story refused to die. Answering charges that he had used some sort of political influence to win the award, Rohl-Smith protested to reporters that he had no "pull" in Washington, only the best design. Calling allegations of favoritism a "libel and an insult," he ascribed the furor to professional jealousy. The National Sculpture Society continued to press the issue of the award into July, when its aggrieved members finally abandoned it, and Rohl-Smith set to work.

While choosing a sculptor to execute the Sherman Monument, the commission had also been busy selecting a site on which to put it, a process that was far less contentious. The West Plaza of the Capitol was rejected in favor of a site Sherman would surely have approved of,

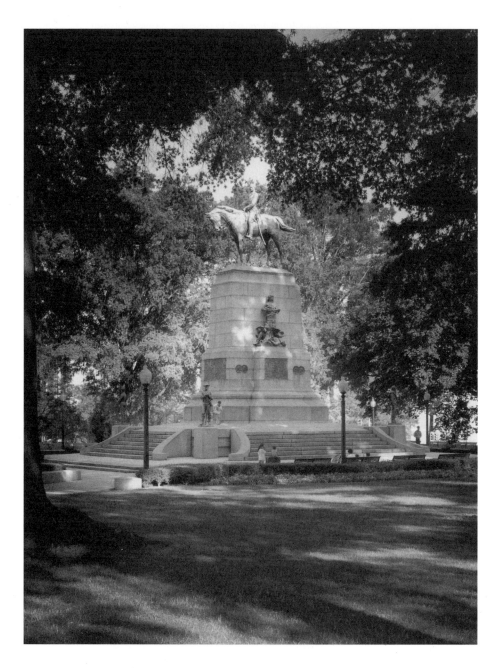

*The site of the Sherman Monument
is the spot from which Sherman
watched the Grand Review of the
Union Army in May 1865, an event
he called one of the happiest, most
satisfying moments of his life.*

the spot on the south side of the Treasury Building where he had watched the Grand Review of the Union Army. On May 23, 1865, the first day of the two-day Grand Review, Sherman had silently watched the Army of the Potomac march by in smart precision and worried that his own men, who would pass in review the next day, would not measure up. That evening, he rode across the Potomac River to the camp of the Army of the Tennessee and called together all of his commanding officers. He described in detail what a splendid figure the Army of the Potomac had cut and, trusting to their pride, told them to make their men aware of it.

The next day, Sherman rode out at the head of the Army of the Tennessee up Pennsylvania Avenue. The military bands played a new tune in their honor, "Marching Through Georgia." As he topped the rise near the Treasury Building, where he would pull aside to join President Johnson and the other dignitaries reviewing the troops, Sherman turned in the saddle to see his army marching down the avenue behind him. These men, said the *Star,* were taller, lankier, more sun beaten than those who had marched by the day before. Their strides were longer, more confident. They swung along with an easy grace and their spirits sky high. They were magnificent. The crowds that filled the streets cheered and pelted them with flowers. As he watched his men, Sherman was nearly overcome with emotion. It was, he recalled in his memoirs, one of the happiest, most satisfying moments of his life. The spot where he had reviewed his troops would be the site of Sherman's monument, and Sherman's pride in his men was the emotion Rohl-Smith would try to capture in his statue of the general.

In the fall of 1897, Rohl-Smith set up his studio in a large, barnlike structure that the Secretary of the Treasury built for him near the spot where the finished monument would stand. The building included an apartment where Rohl-Smith and his wife, Sara, lived while he worked. In 1900, having completed the models for the equestrian statue and three of the four soldiers who would stand guard at the monument's corners, Rohl-Smith sailed for Denmark for a visit. He died unexpectedly, at the age of 52, in Copenhagen.

Sara Rohl-Smith asked the commission for permission to make arrangements for the monument's completion. She knew best the young sculptors, mostly Scandinavians, who had been working with her husband on various sections of the monument. With the commission's approval, she successfully directed completion of the monument, using her late husband's original drawings.

In August 1903, the *Star* reported that the first cast sections of the 14-foot-tall equestrian statue were arriving at the site. Sherman's torso, hands, arms, shoulders, neck and head composed the largest piece. His legs and feet were cast with the horse's head, back, and tail. The four life-size soldiers representing the infantry, cavalry, artillery, and engineers took their places on the corners of the tiered platform. In a relief on the north side of the pedestal showing Sherman and his

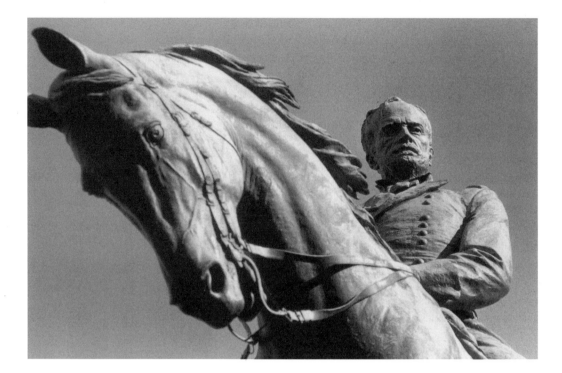

men marching through Georgia, slaves step from their quarters to watch them pass. The relief on the south side depicts the Battle of Atlanta, with Sherman and his staff at headquarters and smoke rising from the burning city in the distance. The reliefs on the west and east sides of the pedestal show Sherman walking among his men sleeping around a campfire, and the general with his officers on horseback before the Battle of Missionary Ridge. Pairs of medallions bearing bas-reliefs of Sherman's army and corps commanders—James Birdseye McPherson and Oliver O. Howard, John A. Logan and Francis Preston Blair, Grenville M. Dodge and Edward G. Ransom, and Benjamin Grierson and Andrew J. Smith—flank the larger reliefs on the east and west sides.

Large bronze groups installed halfway up on the monument's east and west sides depict Peace and War. Peace, on the east, consists of a graceful woman, holding an olive branch, and three happy children, one of whom is feeding a dove. War, on the west, is a horrible fury seething with rage and hatred, who tramples humanity in the form of a dead young soldier at her feet. Large bronze vultures perch on the body, about to feast on its flesh, graphically driving home Sherman's famous observation that "War is hell." Inscribed on the north facade

is another of Sherman's views of war: "War's legitimate object is more perfect peace."

The Society of the Army of the Tennessee made all of the plans for the dedication of the Sherman Monument. There would be special excursion trains to bring veterans to the capital, special hotel rates, and special activities for wives. As Thursday, October 15, 1903, approached, thousands of veterans poured into Washington. When the capital's hotels filled up, the overflow spilled into hotels in Baltimore, Alexandria, and Annapolis.

Miles of bunting and acres of flags decorated businesses, homes, and government buildings. The base of the monument was entwined with 400 feet of garland. At each corner stood wreaths 7 feet in diameter. On each side of the base, there was a 6-foot-high shield of red, white, and blue flowers, one for each of the four armies. The statue of Sherman himself was enfolded between two huge American flags suspended on wires. More flags covered the bronze soldiers at the corners.

The floor of the reviewing stand for the parade that preceded the ceremonies was covered with Turkish carpets. Overstuffed armchairs for President Theodore Roosevelt and other dignitaries lined the freshly painted white railings. More than a thousand folding chairs were arranged in a semicircle in front of the platform for the actual unveiling ceremony. Right at the base of the statue stood two hundred special chairs for the "veterans who had left limbs to rot on the battlefield." Tables were set aside for the press and for the Western Union telegraph operators.

The parade, which seemed to stretch for miles, began at two o'clock. President Roosevelt could hardly contain his excitement and kept leaping out of his chair to wave and shout to the passing units. The last tune played before the ceremony began was "Marching Through Georgia." General Grenville Dodge, president of the Society of the Army of the Tennessee, whose face graced a medallion on the monument, presided. At his signal, William Tecumseh Sherman Thorndike, the general's young grandson, pulled the cord that parted the flags. The crowd went wild.

The *Star's* reporter wrote, "A thousand throats cheered as a flag drew away from the tall, gaunt figure on the high pedestal, but tens of thousands of hearts echoed the sentiments of patriotism and loyalty expressed by the eloquent men who recited the deeds of Sherman and his army when the veil had been removed." The ceremony was, in fact, unusual among monument dedications for the eloquence of its speakers. Speeches at all such occasions were patriotic and sentimental, sometimes to the point of mawkishness, but the speakers at the Sherman dedication, most notably President Roosevelt, rose above saccharine nostalgia. The tone was set by the Reverend D. J. Stafford of Washington, D.C., with his invocation: "We thank Thee that in the hour of trial Thou didst raise up able leaders for Thy people—leaders who by courage, ability, and sacrifice saved the nation. Give us the

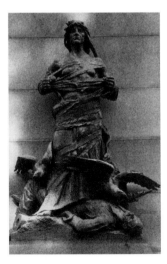

In the bronze group on the west facade, War, depicted as a horrible fury, stands astride a dead young soldier upon whose flesh vultures are about to feed.

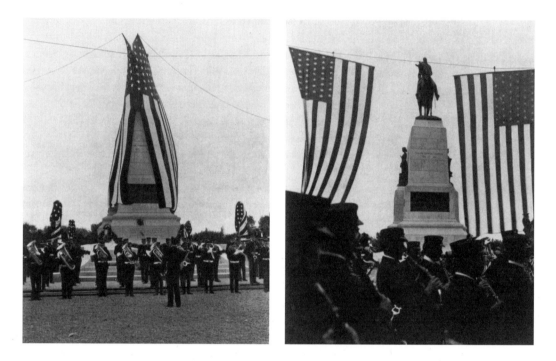

Two enormous American flags suspended from wires enfolded the Sherman statue until the moment of its unveiling. Smaller flags covered the bronze sentinels at the four corners. A military band played as Sherman's grandson pulled the cord that parted the flags, revealing the equestrian statue of Sherman. Reprinted from (left) Sherman: A Memorial in Art, Oratory, and Literature *By the Society of the Army of the Tennessee with the Aid of the Congress of the United States of America (58th Cong., 2d sess., 1904, Doc. 320), and (right)* Sherman: A Memorial in Art, Oratory, and Literature *(58th Cong., 2d sess, 1904, Doc. 320).*

grace to perpetuate the memory of great men, not only in monuments of stone and brass, but still more in our hearts, by the emulation of their example and the imitation of their virtues."

President Roosevelt's speech was filled with moving, challenging imagery. More than any previous President who had been called upon to speak at such an occasion, Roosevelt had an agenda, and he relished the pulpit afforded him by the Sherman dedication to move it forward. The nation, which had just put another war behind it and emerged as a fledgling international power, must be ever vigilant and always strong, the President warned the appreciative crowd of veterans, who roared their agreement. He used this opportunity to call for a strong national defense and to chide those who would thwart him: "No man is warranted in feeling pride in the deeds of the Army and Navy of the past if he does not back up the Army and Navy of the present."

Most of all, Roosevelt wanted no one to rest on the laurels of the past. Americans must be vigorous, rigorous, up and doing noble deeds, pursuing lofty goals. Heroes like Sherman should spur citizens on to similar acts. The President called for a new patriotism, for hon-

esty, and vigilance, all of the qualities Sherman and the other "great dead" had exhibited: "Their blood and their toil, their endurance and patriotism, have made us and all who come after us forever their debtors. . . . our homage must not only find expression on our lips; it must also show itself forth in our deeds."

The triumphs of the past, Roosevelt stressed, should be lessons that, if learned, would lead to victory in challenges yet to come: "It is a great and glorious thing for a nation to be stirred to present triumph by the splendid triumphs in the past. But it is a shameful thing for a nation if these memories stir it only to empty boastingsWe of the present, if we are true to the past, must show by our lives that we have learned aright the lessons taught by the men who did the mighty deeds of the past." The thousands of men who had done the "mighty deeds of the past," arrayed in front of the President, had grown accustomed to hearing speeches that looked backward and evoked the glorious past. Roosevelt's speech looked forward. He told these men, then in their seventies, their ranks thinning, that their hard-won victories would guide the nation into a glorious future that they would not live to see but the destiny of which they had guaranteed. His promise of a sort of immortality stirred their blood, and the men of the armies of the Tennessee, Cumberland, Ohio, and Potomac rose as one to give him ovation after ovation.

SOURCES

RG 42, Records of the Office of Public Buildings, entries 109, 351, 385, 397, 404, Sherman Monument, National Archives, Washington, D.C.

Michael Fellman, *Citizen Sherman: A Life of William Tecumseh Sherman* (New York, 1995).

Dennis R. Montagna, "Henry Mervin Shrady's Ulysses S. Grant Memorial in Washington, D.C.: A Study in Iconography, Content and Patronage,"

Ph.D. dissertation, University of Delaware, 1987.

Sherman: A Memorial in Art, Oratory, and Literature By the Society of the Army of the Tennessee with the Aid of the Congress of the United States of America, 58th Cong., 2d sess., 1904, Doc. 320.

Washington Star, May 28, 31, June 5, 9, 10, 1896; October 8, 1897; August 12, October 14–16, 1903.

19 LIEUTENANT GENERAL WINFIELD SCOTT

Scott Circle, Massachusetts Avenue and 16th Street, N.W.

SCULPTOR: Henry Kirke Brown

DATE: 1874

MEDIUM: Bronze

Two blocks west of the statue of Major General George H. Thomas, considered one of the city's best equestrian monuments, stands the statue of General Winfield Scott, one of the worst. Scott was the first of the bronze Civil War generals to take his stand in the new traffic circles arising in the postwar capital. He is also the only Civil War–era military man represented in Washington by two statues; a full-length statue of Scott was erected in 1873 at Soldiers' Home (see #32).

99 Winfield Scott, Scott Circle

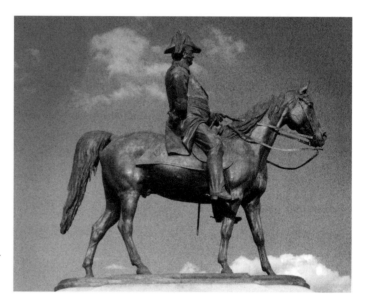

From the time this equestrian statue was erected in 1874, the sculpting of both Scott and the horse drew criticism.

Scott, who had resigned as General-in-Chief of the Army in October 1861 after a brilliant, fifty-year military career, died in May 1866, fifteen days before his eightieth birthday. In March 1867, amid a chorus of praise for one of the nation's most illustrious old soldiers, Congress authorized $35,000 for an equestrian statue to honor him. The commission went to New York sculptor Henry Kirke Brown (1814–86), whose 1856 equestrian statue of George Washington for Union Square in New York City had been widely praised.

Brown completed the model of the Scott statue around 1872. When it came time to cast it, the government contributed old bronze cannon captured during the Mexican War. The statue's base was carved from a single block of granite, the largest stone ever successfully quarried in America at the time. Erected in 1874, this Scott statue had no formal dedication.

The figure of Scott, with his hand on his hip as if irritated, quickly came in for a great deal of criticism. Critics complained that the statue portrayed him as too old, too fat, too stiff, too short-legged. Scott looked, said one wag, like an old sack of flour. Even greater ridicule was heaped on the horse. One reporter called it an "old Dobbin" that

looked like it was "suffering slightly from ringbone lameness and not daring to travel faster than a walk." Others complained that the horse was too light, too delicate, too thin, too timid, and dreadfully proportioned. General Philip Sheridan, who lived a few blocks up Massachusetts Avenue, is said to have begged his wife never to let him be immortalized on such a dreadful animal.

According to one story, the awful horse was not entirely Brown's fault. Brown had learned that, despite his broad girth, Scott's favorite mount had been a small mare, so that's what he placed the general upon. Just as casting was to begin, however, some of Scott's descendants saw the model and protested that a great general must ride a stallion, not a mare. Annoyed, Brown made only minimal accommodations. The result was the too-small horse with the head and body of Scott's little mare, but the external genitalia of a stallion. Since Brown's horse for the George Washington statue was quite good, this story might explain Scott's strange-looking mount, except for the fact that the horse Brown sculpted three years later for his Nathanael Greene equestrian statue in Washington, D.C., with its spindly legs and long, scrawny neck, was even worse.

Brown fared better with Civil War–era heroes when he stayed away from horses. Among his best-known works are his statues of President Lincoln, one for Union Square in New York and one for Prospect Park in Brooklyn, and his statue of dashing Major General Philip Kearny, commissioned by New Jersey for the Capitol's Statuary Hall.

SOURCES

RG 42, Records of the Office of Public Buildings, entry 204, Winfield Scott, National Archives, Washington, D.C.

RG 66, Records of the Commission of Fine Arts, entry 4, Winfield Scott, National Archives, Washington, D.C.

Architect of the Capitol, *Art in the United States Capitol* (Washington, D.C., 1976), 219–66.

Wayne Craven, *Sculpture in America* (Newark, Del., 1984), 144–58.

20 ADMIRAL DAVID FARRAGUT

Farragut Square, 17th and K Streets, N.W.

SCULPTOR: Vinnie Ream Hoxie

DATE: 1881

MEDIUM: Bronze

No sooner had Admiral David Farragut died, in August 1870, than memorials began to spring up in his honor. A crusty "old salt," Farragut was the navy's first admiral and much beloved. He had gone to sea at the age of 8. By the outbreak of civil war in 1861, Farragut had already served in the navy for forty-nine years. During the Battle of Mobile Bay, from up in the rigging of his flagship, the *Hartford,* he had barked to his men below, "Damn the torpedoes! Full speed ahead," assuring himself a prominent place in navy lore and in the hearts of Americans. (See also #14.)

In the winter of 1870–71, Representative Nathaniel P. Banks of Massachusetts introduced a resolution in Congress calling for a public monument to Farragut. The wording of Banks's resolution was important: the statue of Farragut was to be "after a design molded from life." Banks had chosen his words carefully; he already had in mind physician-sculptor Horatio Stone of Washington, who claimed to have met Farragut and received his permission to proceed with a statue on which he was already hard at work. Stone assumed that

he had clinched the commission by Banks's addition of this restrictive clause, but he was wrong. The story of the behind-the-scenes wrangling for the Farragut commission is a complicated one, and an ambitious young woman named Vinnie Ream, not Stone, emerged the victor.

Vinnie Ream (1847–1914) had captured the nation's imagination in 1866 when she received the first government commission ever granted a female artist. She was just 19 at the time. Ream was born in Wisconsin, and her family moved to Washington in the early years of the war. She had little formal education, but she secured a clerkship at the Post Office Department. Her horizons broadened in 1863 when she visited the Washington studio of sculptor Clark Mills. She later wrote, "I felt at once that I, too, could model and, taking the clay, in a few hours I produced a medallion of an Indian chief's head." Impressed, Mills took her on as a part-time pupil. Within a year, she was sculpting busts of such notables as George Armstrong Custer and winning a string of influential admirers.

In 1864, Ream's friends in Congress arranged for her to model a bust of President Lincoln. At first, Lincoln refused, but when he learned that she was a young girl trying to earn a living by her art, he relented. The resulting bust of Lincoln, completed in 1870 and lavishly praised by Ream's supporters, led to the $10,000 commission for a full-length statue of Lincoln for the Capitol Rotunda. That so important a commission should go to so young and inexperienced a sculptor sparked censure and incredulity. Mrs. Lincoln, jealous of Ream from the start, made her displeasure known. A sharp-tongued female journalist suggested that Ream's success had more to do with feminine wiles than with talent. Even an admirer found her "ingratiatingly coquettish towards anyone whose affection she wished to win." Strikingly pretty, petite, and flirtatious, Ream had beautiful brown eyes and a mass of thick, curly dark hair.

In early 1871, Ream began to work on a portrait bust of the late Admiral Farragut, whom she had met several times. There was speculation that she was hoping to repeat her Lincoln success and secure a second lucrative government commission. When Representative Banks introduced his resolution, she began mobilizing her forces.

Banks's resolution was referred to the Joint Committee on Public Buildings and Grounds. Much to sculptor Horatio Stone's disappointment, instead of immediately awarding him the commission, the committee decided to hold an open competition. At first, Stone could take comfort in the fact that artists were to be allowed only sixty days in which to submit models, an extremely short deadline only he and Ream could have met. But the resolution as amended and approved in April 1872, pushed the deadline ahead nine months to January 1, 1873, ample time for other artists to enter.

As she worked on her model, Vinnie Ream worked on her friends. Farragut's widow, who liked her bust of the admiral, became her champion. At Ream's urging, Mrs. Farragut bombarded the commit-

Strikingly pretty and "ingratiatingly coquettish towards anyone whose affection she wished to win," Vinnie Ream cultivated the friendship of prominent men in Washington. Courtesy of the Library of Congress.

tee with letters of endorsement. In the fall of 1872, as the first models began to arrive, Ream wrote to Mrs. Farragut asking for the names of friends of the admiral who might praise her work in letters to the committee. Mrs. Farragut supplied her with a long list of names, including the admiral's personal secretary and men who had served on the *Hartford.* Ream wrote to them all soliciting their support. Within weeks their warm letters of endorsement were on their way to Washington.

By January 1873, thirteen artists had submitted models or, in one case, a photograph of a model. Ream was the only woman. Most of the models were small, but Ream's and Stone's were 8 feet tall. Some models depicted Farragut in repose, some in a fury of activity. A model by J. Wilson MacDonald was one of the latter. Upon learning that some committee members found his proposed 12-foot-high statue too dramatic, MacDonald fired off a letter to the committee arguing that the Farragut statue should be more than a likeness. "The age and art," he protested, "demand something better than has been yet done in this country of our public men. We must have statues full of interest, works of art, immense and even grand." He went on to point out that some of the competitors, Ream for one, had already received a government commission, while he had received none, an unfair situation that the committee had a chance to set right. Small chance. The *Washington Star* ridiculed MacDonald's pose for Farragut as "grotesquely absurd," showing the "old sea king . . . in acrobatic position on the top of a column holding a rope in the attitude of throwing it to a trapeze performer."

Randolph Rogers's model was, in the eyes of most visitors to the Capitol basement, where the models were displayed, even worse than MacDonald's. Rogers wrote to the committee in November 1872, describing his animated interpretation of Farragut up in the *Hartford*'s rigging in Mobile Bay: "I have represented him as in the *top* and lashed to the mast, with speaking trumpet in his left hand and pointing the way with his right . . . his heart bared to the storm of shot and shell." The *St. Louis Times* found the pose "too dreadful to contemplate." To the *Washington Star's* reporter, it looked like "martyrdom at the stake . . . the Admiral being tied around the waist by a particularly heavy rope to the broken stump of a particularly stout mast."

Worst of all, most agreed, was the entry of Edward Watson, who submitted a photograph of his unfinished model. The photograph made clear enough Watson's lack of skill and preoccupation with pedestals rather than the person of Farragut, who looked like a badly molded, featureless, toy atop an enormous, ill-proportioned base. Observing that there was "a good deal of pedestal and precious little Farragut," one reporter likened the model to "one of those huge pyramid cakes that form center pieces for wedding and party supper tables. In fact, we have often seen genius of the confectioner's art that excelled it in grace, symmetry and delicate balance."

Both Stone's and Ream's models had their partisans. Several naval officers praised Stone's model as "true to life" and "unsurpassed by similar works." Ream's statue, newly repaired after being badly damaged while in transit from her studio to the Capitol, won praise for the naturalness of Farragut's watchful stance. One reporter wrote approvingly, "the face is alert, yet thoughtful, and the position erect with one foot resting on a coil of rope, is suggestive of both action and repose." President Ulysses S. Grant called Ream's model "first rate." After a visit to the Capitol, Admiral David Porter wrote the committee that the model "of Miss Vinnie Ream is the only likeness in the lot." Mrs. Farragut not only sent a letter supporting her young friend to the committee but personally lobbied its members on Ream's behalf.

In General William Tecumseh Sherman, Ream found her most ardent champion. There has been much speculation as to the intimacy of the relationship between the 53-year-old general and the 26-year-old artist, speculation fueled by their surviving letters, written in the effusive, flirtatious language of the nineteenth century and easily misconstrued by readers in the twentieth. What is clear is that Sherman, like Albert Pike and a number of other prominent men in Washington, was smitten with Vinnie Ream. (See #9.)

On Valentine's Day afternoon in 1873, Sherman went to the Capitol to view the Farragut models. Passing through the Rotunda, he ran into Ream, who had called at one of his wife's Friday evening receptions in January. Before they parted, Ream invited Sherman to visit her studio. That evening, he wrote her: "I will with the greatest pleasure take the earliest opportunity to call as promised, preferably Sunday, unless that day be regarded as too sacred."

On February 18, Sherman wrote the joint committee that "the plaster model of Vinnie Ream struck me decidedly as the best likeness, and recalled the memory of the Admiral's face and figure more perfectly than any other model there on exhibition." Sherman's correspondence makes clear that he had decided to make Ream's cause his own, and he began to plot a strategy designed to win her the commission. On February 20, he counseled her: "I think you had better finish the small clay model . . . by Monday next and then place it along with the models in the vestibule with a label 'Vinnie Ream.' Don't argue with any of the committee the reason why you add this small bust to the large model, because it is eloquent in itself and will silence anyone that may attempt to argue that a small model cannot express a likeness as well as a large one."

Meanwhile, the committee began deliberating. While Stone and Ream were regarded as the frontrunners, days, then weeks, passed with no decision. The newspapers speculated that all of the models might be rejected. Growing increasingly anxious, Ream urged Sherman to lobby two members of the committee, Vermont Senator Justin Morrill and crusty old Senator Simon Cameron of Pennsylvania. Sherman patiently wrote back that it "would hardly be right for me to seek out Mr. Cameron and urge him to any definite course of action;

but if I see him I will endeavor to do so in such a way as to make him feel that it is his own thought. Men don't like to be *advised,* unless they themselves seek it, but sometimes you can put the proposition so that the thought seems original and then they catch at it like a greedy fish at bait." Sherman also promised that he would try to enlist his brother, Senator John Sherman of Ohio, to speak to Cameron.

Despite Sherman's best efforts, when the committee voted on February 27, 1873, Vinnie Ream came up several votes short. With the committee deadlocked in a three-way tie among Ream, Stone, and MacDonald, Senator Morrill, co-chair, announced that "while the committee are ready to concede that there is considerable merit in many of the models presented, they have not been able to agree that any one is entirely worthy, and therefore . . . reject the whole."

There the matter rested for nearly a year until the next Congress convened in early 1874. In the interval, word leaked out that a second competition might be held. Sculptor Augustus Saint-Gaudens wrote the Architect of the Capitol to inquire. A highly placed friend, however, warned him away: "Don't waste any time modeling a statue of Farragut—nobody will get that to do except a man who can intrigue at Washington." Sound advice, although in this case a woman might "intrigue" as successfully as a man.

Vinnie Ream was, in fact, frantic with anxiety. Sherman wrote consolingly, "If you succeed I will rejoice with you: but even if you fail I will still be as ardent an admirer as ever." He also counseled her: "With each award the critics will be silenced of the charge that your success is due to your pretty face and childish grace. . . . If in your hard struggle for fame, you can keep a loving woman's breast you will have a double claim to the respect of true and brave men."

In February 1874, Congress took up the Farragut statue again. A proposal to make a direct award to MacDonald, who promised to have his statue finished in time for the Philadelphia Centennial Exposition in 1876, was rejected; but another, to leave the decision to Secretary of the Navy George Robeson, was gaining momentum. Such a plan was not acceptable to Ream, who had no influence with Robeson, and she urged her friends in Congress to come to her aid. In March, Representative Godlove Orth of Indiana wrote her that her "friends in the House" would add the names of the General of the Army, General Sherman, and Mrs. Farragut to the proposed decision makers.

Justifying this thinly veiled effort to stack the deck in Ream's favor, another friend in the House claimed that the committee had chosen Sherman "because he was so intimate with Admiral Farragut and knew him so well, and . . . Mrs. Farragut, for if any person on earth ought to know a statue that resembles our great Admiral it should be Mrs. Farragut." Not everyone was convinced. Skeptical Representative Samuel S. Cox of New York asked his colleagues: "Why should the Secretary of the Navy be an especial judge of art? Why should the honored widow of Admiral Farragut decide on the resemblance of a

stone statue to her husband, and call it art? Why should General Sherman, who is accomplished in many ways, be an especial judge of art?" Cox's suggestion that two artists be added to the judges fell on deaf ears.

After other efforts to modify it were beaten back, the resolution passed: Secretary Robeson, who would chair the trio, General Sherman, and Mrs. Farragut would award the commission. Robeson knew a set-up when he saw one and resented it. He refused to poll the committee, insisting that they deliberate and investigate further. Fearing that the Farragut commission might still slip away, Ream again appealed to her friends. She begged Senator John Ingalls of Kansas for help. Though he teasingly replied that she was "the biggest and most delightful fraud I ever met," Ingalls agreed to do what he could, reassuring Ream that "nobody eludes you but the laughing old sailor Robeson, and I have no doubt you will conquer that big three decker." Representative Orth, who had already gone to bat for her, however, demurred, politely explaining that he was unwilling to attempt to influence a cabinet member: "In endeavoring to serve, I might injure your case." Even Sherman, to whom she also appealed, warned her to go slow.

In November 1874, the committee of three held its first meeting. Robeson insisted that they tour the capital to inspect the public statues. He was especially fond of the statue of General Winfield Scott by Launt Thompson that had been erected at Soldiers' Home the previous year (see #32). Thompson was among the artists who had shown interest in the Farragut commission the second time around.

When Robeson finally took a vote of his committee in December, General Sherman and Mrs. Farragut voted for Vinnie Ream, Robeson for Thompson. Ream, having received the majority of the votes, had won, but Robeson would not yield. He tried his best to convince Mrs. Farragut to change her vote. Two full months passed before Robeson finally gave in and announced Ream the winner. The first woman to be awarded a government commission now became the first woman to receive a second.

With contract in hand guaranteeing her $20,000 for completing the Farragut monument, Ream set to work. She labored more than two years on the 10-foot-high model. Though some criticized her slow progress, Sherman urged caution. "Take your time," he counseled, and he urged her to consult Mrs. Farragut "on any and all occasions." Ream did consult Mrs. Farragut and incorporated her suggestions. By the fall of 1877, Ream was confident enough of her model that she sent out engraved cards inviting all "interested in observing the progress thus far attained in my statue of Admiral Farragut" to call at her Pennsylvania Avenue studio.

By the spring of 1878, the plaster model, depicting Farragut just before the capture of New Orleans, was nearly ready for casting. The *Star,* long in Ream's camp, judged it an excellent likeness: "The face and pose of the old hero combine to tell at once the story of his

Once work on the Farragut model was well under way, Ream sent out invitations to prominent Washingtonians, inviting them to her studio to observe "the progress thus far attained." Courtesy of the Historical Society of Washington, D.C.

Studio,
235 Pennsylvania Avenue,
WASHINGTON, D. C.

If you would be interested in observing the progress thus far attained in my statue of Admiral Farragut, I would be pleased to have you call, and at your early convenience.

VINNIE REAM,
SCULPTOR.

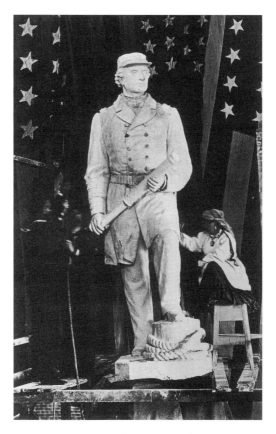

Vinnie Ream puts the finishing touches to the plaster model of Admiral Farragut, depicted just before the capture of New Orleans. Courtesy of the Library of Congress.

character and that of the great task before him, and which for the time being commands his soul and all his faculties."

Although most large bronze sculptures were sent to Europe for casting, "patriotic impulse prompts [Ream] . . . to have the work done in this country," wrote the *Star*. In the summer of 1879, Ream announced that the Farragut statue would be cast at the foundry at the Washington Navy Yard, which had never before cast so large an object. Love, as much as patriotism, lay behind her choice. On May 28, 1878, Vinnie Ream had married Lieutenant Richard Hoxie of the Corps of Engineers, a young man of whom Sherman approved and whose career Sherman furthered. Hoxie was assigned to Washington and, if his wife wished to stay by his side, she would have to finish her work in the capital. With the blessing of the new Secretary of the Navy, Richard W. Thompson, Vinnie Ream Hoxie moved her huge plaster model to the Navy Yard, where, to the delight of the sailors, she worked every day to complete the finishing touches.

The bronze for the statues of many of the military men in Washington came from captured enemy cannon. Thompson's statue of Scott, for example, was cast from cannon captured during the Mexican War. Admiral Farragut would no doubt have been pleased with

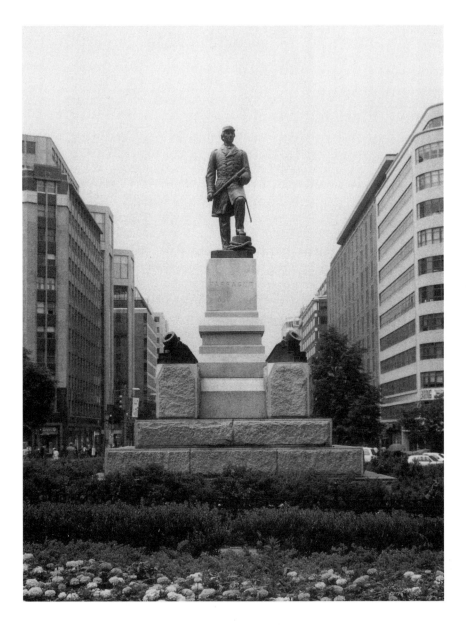

The 10-foot-tall statue of Admiral David Farragut and the four mortars at the corners of the pedestal were cast from the bronze propeller of his flagship, Hartford.

the source of the bronze for his statue. The engineer-in-chief of the Navy Yard had the *Hartford*'s bronze propellers removed and hauled to the foundry, where they yielded enough bronze not only for the 10-foot-high statue but for the four mortars at the corners of the pedestal as well.

While work on the statue progressed, work on the site also continued apace. Farragut Square, in the heart of the city's fashionable residential area, had been named for the admiral just after his death. The pedestal for the statue was placed in the center of the square and oriented so that Admiral Farragut would be facing the White House, two blocks away. Problems with the base pushed the dedication date back from March 4, 1881, when it would have coincided with President James A. Garfield's inauguration, to April 25, 1881, the anniversary of Farragut's great victory at New Orleans.

When the sculptor expressed dismay that the change might mean a smaller crowd, Admiral Porter wrote soothingly: "We don't want to make the ceremonies in honor of Admiral Farragut secondary to anything else. . . . Give yourself no uneasiness about your statue not being seen by an appreciative assembly. There will be one hundred thousand people to witness the ceremonies and the 25th of April will always be remembered as Farragut day."

As the date grew closer, excitement mounted. Both the *Star* and the *Washington Post* began running stories about Vinnie Ream Hoxie, Admiral Farragut, and the statue. The only cloud on the horizon was the base, which did not arrive until April 20, with just five days to spare. At this point, Lieutenant Hoxie stepped in with a crew of hand-picked men. Together they worked around the clock, completing the base and erecting the Farragut statue just hours before the ceremony. Into the pedestal's interior, Lieutenant Hoxie slipped a copper box containing an account of Farragut's long career and other papers, and a tiny bronze model of the *Hartford*'s propeller.

While it may not have numbered a hundred thousand, the crowd that began to line the sidewalks on dedication day in anticipation of the widely touted parade was already large when government clerks, who were dismissed at noon, swelled its ranks. The procession formed at the Navy Monument at the base of Capitol Hill and moved down Pennsylvania Avenue past the White House to Farragut Square in a sea of scarlet, blue, white, gray, black, and gold. Around one side of the Square, nearly four thousand invited guests filled the temporary stands and listened to John Philip Sousa conduct the Marine Band. Joining President and Mrs. Garfield in places of honor were Mrs. Farragut, the Farraguts' son Loyall, and Vinnie Ream Hoxie. The *Star* reported that the young artist was resplendent in "black brocaded silk and wore a straw bonnet ornamented with a white ostrich plume and a spray of pale roses."

Deafening cheers rose as two members of Admiral Farragut's crew on the *Hartford*, Quartermaster C. B. Knowles and Boatswain James Wiley, hoisted the flag that had covered the statue. There stood Admi-

ral Farragut, marine glass in his hand, 20 feet off the ground. Vinnie Ream Hoxie rose to acknowledge the crowd's applause. The moment stayed with her, she later wrote, as one of the proudest of her life. In the spectators' lusty approval, she read vindication of her talent. But Vinnie Ream Hoxie's statue of Admiral David Farragut is as much a testament to her political acumen as to her artistic ability.

SOURCES

RG 46, Records of the United States Senate, Committee Papers, Committee on Public Buildings and Grounds, SEN 42-A-E18, National Archives, Washington, D.C.

RG 66, Records of the Commission of Fine Arts, entry 4, Admiral David Farragut, National Archives, Washington, D.C.

RG 233, Records of the United States House of Representatives, HR 2017, 42d Cong., National Archives, Washington, D.C.

Vinnie Ream Hoxie Collection, Library of Congress, Washington, D.C.

William Tecumseh Sherman Papers, Library of Congress, Washington, D.C.

Ruth L. Bohan, "The Farragut Monument: A Decade of Art and Politics, 1871–1881," *Records of the Columbia Historical Society* (1973–74): 209–43.

Congressional Globe, 42nd Cong., 2d sess., 55, 1959–60, 2061, 2206; 42nd Cong., 3d sess., 294, 339, 2016.

Congressional Record, 43rd Cong., 1st sess., 2030–31.

Michael Fellman, *Citizen Sherman: A Life of William Tecumseh Sherman* (New York, 1995), 355–58.

Joan Lemp, "Vinnie Ream and Abraham Lincoln," *Woman's Art Journal* 6 (Fall 1985–Winter 1996): 24–29.

New York Times, April 25–26, 1881.

George Olszewski, *Farragut Square* (Washington, D.C., 1968).

Dawn Langley Simmons, *Vinnie Ream: The Story of the Girl Who Sculpted Lincoln* (New York, 1963).

Valerie Thompson, "Vinnie Ream: The Teen Who Sculpted Abe Lincoln," *Sculpture Review* 41 (1992): 32–33.

Washington Post, April 25–26, 1881.

Washington Star, February 3, 18, March 1, 1873; April 20, 1878; September 29, 1880; April 8, 25–26, 1881; May 3, 1931.

Thurman Wilkins, "Vinnie Ream," *Notable American Women 1607–1950,* vol. 3 (Cambridge, Mass., 1971), 122–23.

21 MAJOR GENERAL JOHN A. RAWLINS

Rawlins Park, 18th and E Streets, N.W.

SCULPTOR: Joseph A. Bailly

DATE: 1874

MEDIUM: Bronze

Born near Galena, Illinois, in 1831, John Aaron Rawlins was the second oldest of nine children of a poor Scotch-Irish lead miner. In 1849, his father joined the gold rush to California, leaving 18-year-old John behind to support the family and run a meager timber farm. As soon as he could, Rawlins left the farm and moved into town, where he read law, was admitted to the bar, and was elected city attorney at the age of 26. In Galena, he also met Ulysses S. Grant, nine years his senior and relatively new in town, who worked in a leather shop. The two men were drawn to each other and became friends.

On April 16, 1861, the day after news of the fall of Fort Sumter reached Galena, Rawlins addressed a mass meeting and argued for the strong prosecution of the war to preserve the Union. Grant was in the audience that night and again two nights later when the subject was recruitment of troops. By then the people of Galena all knew that Grant had gone to West Point. He was, in fact, the only man in town with professional military training, so he was elected to preside over

the meeting. From that moment on, wrote Rawlins, "I saw new energies in Grant." The rest of Rawlins's life was caught up in that of his rejuvenated friend. Within eight years, Grant would be President of the United States and Rawlins would be his Secretary of War.

After Grant reentered the army, he asked Rawlins to be his aide-de-camp. Rawlins accepted. A recent widower, he sent his three young children to live with relatives and for four years of war remained at Grant's side as his principal staff officer and most influential advisor. Grant appreciated Rawlins's sense of justice, editorial abilities, tireless energy, penetrating mind, and restraining hand. Having grown up with a drunken father, Rawlins abhorred alcohol and was an apostle of sobriety. He used all of his influence over Grant to keep him away from drink. Rawlins, wrote an officer who knew both men in camp, "became a living and speaking conscience for his general."

By 1864, it was clear that Rawlins was ill with what proved to be tuberculosis. When the war ended, he sought relief in the West, traveling the proposed route of the Union Pacific railroad with General Grenville Dodge, the company's chief engineer. Dodge later named the location of one of their camp sites in Wyoming in honor of Rawlins. Though feeling no better, Rawlins returned to the East for Grant's first election to the presidency. On March 4, 1869, Grant and Rawlins rode alone to the Capitol for Grant's inauguration. A week later, Grant named Rawlins his Secretary of War.

Just as Rawlins had played the part of Grant's private conscience during the war, in the cabinet he became the President's moral mentor in the public realm. Rawlins championed the freedmen and spoke eloquently of their suffering. As Secretary of War, he kept in check the officers known to treat Indians most cruelly. He tried to steer Grant clear of men who would lead him away from the straight and true. "He had blunt, wrathful words of objurgation," noted a cabinet colleague, "for those who put in Grant's way temptations that he knew to be dangerous."

By August 1869, Rawlins was gravely ill. Grant, who had watched a brother die of tuberculosis, knew that his closest friend hadn't long to live. On Sunday, September 5, on the way back from church in Saratoga Springs, New York, Grant received a message that Rawlins would not last the day. General William Tecumseh Sherman, at Rawlins's side in Washington, had cabled that Rawlins was asking for him and trying to hold out for a last visit with his friend. The President raced for the capital by train and boat. Grant arrived on September 6, an hour after Rawlins died. His death robbed Grant of an honest voice of conscience and the best friend he had ever had.

Within a year of Rawlins's death, efforts were under way to erect a statue in his memory. Congress went so far as to authorize the use of surplus bronze cannon for the planned equestrian statue, but then interest flagged and nothing happened. In May 1872, after inquiring of

The statue of Major General John Rawlins, General Grant's friend and conscience, was moved three times before coming back to its starting point.

Secretary of War William Belknap about the status of the Rawlins statue, Grant personally wrote a nudging letter "to respectfully call the attention of Congress" to the delay and to spur members to move ahead with the tribute to his friend. The President's letter had the desired effect. Within the month, Illinois Senator John A. Logan, who had served under Grant and admired Rawlins, introduced a bill appropriating $10,000 for a statue of Rawlins. Grant signed it into law two weeks later.

Though Washingtonian Theophilus Fisk Mills, sculptor of the John Rodgers Meigs monument, apparently had had good reason to believe he would be the one to sculpt an equestrian statue of Rawlins and had gone so far as to make a model, Logan's legislation set up a committee to solicit models and select an artist. Mills found himself one of eight artists seeking the prestigious commission. His competitors included another local sculptor, Lot Flannery, who had already produced monuments to Abraham Lincoln and to the victims of the Arsenal disaster (see #11 and #1).

On December 29, 1872, the *New York Times* took sarcastic and misinformed note of the competition:

We are to have a statue of Gen. Rawlins. Not satisfied with the superb treasures of the sculptor's art with which a Mills [*Clark* Mills, father of Theophilus] and a Ream [Vinnie Ream, see #20] have enriched the Capitol, Congress recently appropriated ten thousand dollars in order to awaken the creative genius of other eminent sculptors, and so to secure a statue of Rawlins which should be worthy to be ranked with the circus-riding Washington and the stiff-necked Lincoln. . . . The choice of the Committee is understood to have fallen upon Mr. Bailly; and certainly, as between Mills whom we do know, and the seven competitors whom we do not know, it is fortunate that the former will not be awarded the contract. Washington is a city covering a good deal of ground, but it is hardly large enough to contain another statue by Clark Mills.

While the *Times* had mistaken Theophilus Mills for his father, Clark, and the latter's Andrew Jackson, riding an implausibly rearing horse in Lafayette Square, for George Washington, it was correct in its understanding that Joseph Bailly (1825–83) had won the commission. Bailly reversed the more common flow of artists from America to Europe. Born in Paris in 1825, Bailly was a conscript during the French Revolution of 1848. After shooting at his own captain, he escaped to America and eventually settled in Philadelphia and opened a studio. Among his best-known public commissions prior to the Rawlins statue were statues of Benjamin Franklin and George Washington, both in Philadelphia.

Bailly's full-length bronze statue of Rawlins depicts him in uniform, with tall boots and full beard, his field glasses in one hand and the other resting on his sword. The Rawlins statue has led a peripatetic existence. When it was first placed in Rawlins Park in 1874, the area was unkept and remote. Nearby Octagon House, now the handsome headquarters of the American Institute of Architects, was in disrepair. When members of the Grand Army of the Republic visited the statue in 1880, they were dismayed by Rawlins's scruffy surroundings and asked that the statue be moved to a more respectable location. The statue was moved to 10th and D Streets, N.W., but when a newspaper plant was to be built there, it was moved again, first to one side of Pennsylvania Avenue between 7th and 9th Streets, N.W., and then, in 1886, to the other.

In 1931, construction of the National Archives building uprooted the Rawlins statue once again, and it was returned to Rawlins Park, where it had started. The site had been greatly improved during its absence and was improved still more in 1938 by the addition of a reflecting pool and walkways. In 1963, a Wyoming congressman unsuccessfully tried to have the statue moved once again, this time to Rawlins, Wyoming.

SOURCES

RG 42, Records of the Office of Public Buildings, entry 204, Major General John A. Rawlins, National Archives, Washington, D.C.

RG 46, Records of the United States Senate, Presidential Messages, U. S. Grant to Congress, May 31, 1872, National Archives, Washington, D.C.

RG 66, Records of the Commission of Fine Arts, entry 4, Major General John A. Rawlins, National Archives, Washington, D.C.

Author's correspondence with John Y. Simon, editor, *The Papers of Ulysses S. Grant*, Carbondale, Ill.

Congressional Globe, 42d Cong., 2d sess., 3538, 3870, 4173, 4184, 4458, 4461, 4503–4.

William S. McFeely, *Grant, a Biography* (New York, 1981), 84–99, 119–35, 145–48, 298–300, 323–31.

New York Times, December 29, 1872; January 6, 1873.

Washington Post, September 14, 1941.

This statue of Abraham Lincoln, which the American commissioner general of the 1939 New York World's Fair dubbed too "modern," inspired a battle of public opinion in the press and a lawsuit.

ABRAHAM LINCOLN, RAIL FENCE MENDER

Department of the Interior, Courtyard, C Street between 18th and 19th Streets, N.W.

SCULPTOR: Louis Slobodkin

DATE: 1940

MEDIUM: Bronze

For a statue that was once so controversial, Abraham Lincoln, Rail Fence Mender is now one of the most obscure in Washington. Tucked away in a courtyard adjacent to the Department of the Interior's cafeteria, which is open to the public, it has faded into the background. Employees, without seeing it, eat at its base, which bears no inscription.

In 1939, this unusual representation of Abraham Lincoln, an Art Deco Abe, sparked a battle waged on the pages of the *New York Times* and a lawsuit against the United States government. The year before, New York sculptor Louis Slobodkin (1903–75) and more than four hundred other artists had entered a national competition for the relief panel that would decorate the United States Building at the 1939 New York World's Fair. While Slobodkin did not win, the jury recommended that his model, which they called "a unique symbol of American unity," be enlarged and displayed as a free-standing piece

in the Federal Building's sculpture court. Slobodkin was thrilled. Though he had done work for the government of Argentina, Abraham Lincoln, Rail Fence Mender was one of his first public commissions in the United States, where he was well known as an illustrator of children's books.

Slobodkin finished his 15-foot plaster statue, which was placed on a small island in a pool at the Federal Building, in plenty of time, but then events went awry. According to newspaper accounts, on a visit to the Federal Building to show his wife his work before the fair opened, a guard informed Slobodkin that his statue was gone. It had vanished in the night. As the story unraveled, it turned out that the commissioner general of the World's Fair Commission had personally ordered the statue not only to be removed but to be broken up into small pieces. Abraham Lincoln, Rail Fence Mender was, he claimed, not right architecturally, too big, too high, and most important, too ugly. He found this "modern" image of a young, gaunt Lincoln in shirtsleeves ridiculous.

Slobodkin went to the press, noting that the government had destroyed both his creation and his reputation. The nation's art and sculpture societies rallied to his defense. After Slobodkin hired an attorney and threatened suit, government officials, unwilling to see the case go to court, approached him about a settlement. He wanted his small model back, and he wanted a new government commission for the same statue, this time in bronze. That's what he eventually got, along with vindication.

The new commission called for a "bronze statue seven and one-half feet high with black marble base." Slobodkin finished the new statue, for which he was paid $1,600, in the summer of 1939. It was exhibited at the Corcoran Gallery of Art in Washington that October, after which it was removed to the nearby courtyard where it now resides.

SOURCES

F. Lauriston Bullard, *Lincoln in Marble and Bronze* (New Brunswick, N.J., 1952), 317–20.

"Cromwellian Encore: Slobodkin's Lincoln Disappears from the New York Fair," *Art News* 13 (May 15, 1939): 5.

Department of the Interior, *The Interior Building: Its Architecture and Its Art* (Washington, D.C., 1986), 118–19.

Edward Steers Jr. and Joan Chaconas, *Everlasting in the Hearts of His Countrymen: A Guide to the Memorials to Abraham Lincoln in the District of Columbia* (Washington, D.C., 1984), 13–14.

Washington Post, July 28, 1939.

Washington Star, May 5, 1939.

West Potomac Park at Independence
Avenue and Ohio Drive, N.W.

SCULPTOR: James Earle Fraser

DATE: 1926

MEDIUM: Granite

While John Ericsson did not lead a nation in war, like Abraham Lincoln, whose memorial stands nearby, or lead men in battle, like the generals who dot the city's traffic circles, his contribution to the Union's victory was great. He contributed his genius for invention. His monument reads "John Ericsson A.D. 1803–A.D. 1889, Inventor and Builder of the Monitor, He Revolutionized Navigation by His Invention of the Screw Propeller." Actually, Ericsson perfected, rather than invented, the screw propeller for navigation; but he did unquestionably design the Union's first "ironclad," the *Monitor*.

As a little boy in Sweden, Ericsson studied machinery for hours. After studying engineering and serving in the Swedish army, he moved to London, where he worked on a wide array of projects, including development of the screw propeller. In 1839, Ericsson, who felt unappreciated wherever he was, visited the United States, where he believed there was more respect for innovative genius, and remained for the last fifty years of his life. The Civil War finally brought Ericsson the fame he felt he deserved. Early in the war, when informants revealed Confederate plans to build an armor-clad ship, Secretary of the Navy Gideon Welles called for proposals to build such a ship for the Union's fleet. None came from John Ericsson. Still bitter from earlier feuds with the navy, he sulked in New York until wealthy shipbuilders persuaded him to submit his striking proposal.

Ericsson's design called for a hull sheathed with iron plate overlaid with a low, flat deck whose perpendicular sides extended below the water line and were protected by more iron plate. The screw propeller, the anchor, and all other vital machinery would be housed within this protective shell. On deck was another of Ericsson's innovations: a heavily armored, revolving turret containing two 11-inch guns. The turret, shallow draft, estimated 8-knot speed, and armor would, Ericsson guaranteed, make his craft maneuverable, versatile, and invincible.

Senior navy officers scoffed at what they derisively dismissed as Ericsson's "cheese box on a raft," but Ericsson won over Welles with his supremely confident presentation. The keel for the first Union ironclad was laid in October 1861. With Ericsson supervising every aspect of construction, the vessel was launched just one hundred days later. Ericsson named it *Monitor,* one who admonishes and corrects wrongdoers. There was no time for trial runs. The *Monitor*'s trial would be by fire. The battle between the *Monitor* and the *Merrimack* (or the C.S.S. *Virginia*), off Hampton Roads, Virginia, on March 9, 1862, marked the beginning of a new epoch in naval operations. The *Monitor*'s victory, though not quite as decisive as Welles had hoped, more than justified his faith in Ericsson.

News of the dramatic battle between the two ironclads electrified the Union. Ericsson was feted with banquets. He received the thanks

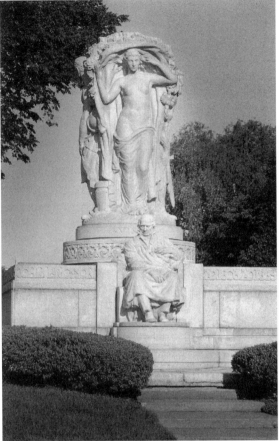

Swedish-born inventor John Ericsson, who designed the first ironclads for the Union navy, broods beneath the Yggdrasill, the tree of life of Norse mythology, and Vision, an embodiment of one of the traits that made him a great inventor.

of Congress. He was hailed as a hero and remained one long after his death in 1889. Statues commemorating his genius were erected in New Haven and New York, and Scandinavian Americans proud of the work of their countryman, scientists, engineers, and navy officers petitioned Congress to erect a monument to Ericsson in the nation's capital. In 1916, Congress appropriated $35,000 toward an Ericsson monument and established a commission to bring it to fruition. Although World War I intervened, the John Ericsson Memorial Committee raised an additional $25,000 and began working closely with the Commission of Fine Arts to select a site and an artist. A site in West Potomac Park, fittingly near the water, and sculptor James Earle Fraser (1876–1953), one of the best-known sculptors in America, emerged the winners.

As a boy in Minnesota, James Earle Fraser carved figures out of stone from local quarries. He studied sculpture in Chicago and, at 17, completed his most famous work, End of the Trail. The disconsolate Indian slumped on an exhausted horse registered Fraser's protest against the displacement of Native Americans. While studying in Paris, Fraser caught the eye of the preeminent American sculptor Augustus Saint-Gaudens, who took him on as his assistant. In 1913,

Fraser designed the American buffalo nickel. During his prolific career, Fraser created many outdoor sculptures in Washington, among them two massive seated figures at the Supreme Court and two on the Constitution Avenue side of the National Archives, pediments for the Commerce Building, statues of Albert Gallatin and Alexander Hamilton for the Treasury Department, and The Arts of Peace, a pair of gilded bronze statues near the Ericsson Monument at the entrance to Rock Creek Parkway.

For the Ericsson Monument, Fraser drew upon Scandinavian legends. The monument portrays Ericsson seated, enveloped in a cloak, lost in thought. Behind him rises the Yggdrasill, the tree of life of Norse mythology. Arrayed around the tree are three figures embodying the qualities that made Ericsson a great inventor: Vision, a woman with far-gazing eyes; Labor, a muscular American iron molder in work clothes; and Adventure, a Norse hero with shield, breast plate, sword, and helmet. The 50-by-50-foot base is inlaid with the points of the mariner's compass. For his efforts, Fraser was knighted by the King of Sweden.

In the winter of 1925–26, Fraser had a huge block of pink granite, which newspapers claimed was the largest single block of granite outside of Egypt, shipped to Washington, intending to carve the Ericsson monument on site that spring. However, a deadline was looming. Crown Prince Gustavus Adolphus, later King Gustavus VI, and the Crown Princess of Sweden were due to visit Washington in May 1926, and the dedication of the statue was to be the centerpiece of their visit. The local newspapers fretted that the statue would not be finished in time, and they were right. It wasn't. At the last minute, Fraser's full-size plaster model was tinted pink to look like the granite and placed on the pedestal for the unveiling on May 29.

President and Mrs. Calvin Coolidge, diplomats, congressmen, Supreme Court justices, members of the John Ericsson Memorial Committee, and Fraser joined the crown prince and princess on the platform. As the crown princess pulled the cord, dropping the drapery covering the statue, the navy and marine bands played the "John Ericsson Memorial March," composed for the occasion. A gunboat on the Potomac boomed out a twenty-one-gun salute, and carrier pigeons bearing messages of peace and prosperity fluttered into the sky. According to the newspapers, one of the dignitaries stepped over to Fraser and introduced himself. As a young Union officer, he said, he had been an eyewitness to the battle between Ericsson's *Monitor* and the *Merrimack*. The gentleman was 85-year-old Supreme Court Justice Oliver Wendell Holmes.

SOURCES

RG 42, Records of the Office of Public Buildings, entry 197, John Ericsson, National Archives, Washington, D.C.

RG 66, Records of the Commission of Fine Arts, entry 17, John Ericsson, National Archives, Washington, D.C.

William Conant Church, *The Life of John Ericsson* (New York, 1891).

Wayne Craven, *Sculpture in America* (Newark, Del., 1984), 492–94.

Loring Holmes Dodd, *Golden Moments in American Sculpture* (Cambridge, Mass., 1967), 38, 41.

J. Walker McSpadden, *Famous Sculptors of America* (New York, 1927), 277–303.

Washington Star, May 29–30, 1926.

West Potomac Park

SCULPTORS: Daniel Chester French,
statue; Ernest C. Bairstow, stonework

ARCHITECT: Henry Bacon

ARTIST: Jules Guerin

DATE: 1922

MEDIUM: Marble

The Lincoln Memorial has become deeply embedded in American iconography. The memorial seems timeless, perfect. Yet every aspect of a national monument to Abraham Lincoln was still being hotly debated in the first decades of the twentieth century. For a time, it looked as though an eight-lane highway might win.

While many towns began to lay plans for monuments to President Lincoln in the weeks immediately after his assassination in 1865, the first effort to erect a national memorial to his memory got under way two years later, in the spring of 1867, when Congress incorporated the Lincoln Memorial Association. (The memorial statue in Judiciary Square [see #11] was given by the citizens of Washington, D.C.) Though the Postmaster General sent out an appeal for subscriptions to postmasters, who were to act as agents for the Association, nothing came of their efforts and the grandiose plans withered away.

The next plan for a national Lincoln monument gained momentum in 1902, when, on the second try, Illinois Senator Shelby Cullom's bill to build a memorial to President Lincoln passed the Congress. The commission created by the legislation first met in 1904 and authorized Representative James McCleary of Minnesota, chairman of the House Committee on the Library, to travel through Europe, gather information on monuments, and report back in 1905. McCleary did go abroad, and he did study memorials. He also submitted a report, but four years late in 1909. His central proposal was an arresting one. As McCleary described it in popular articles, he envisioned a monumental highway, 72 miles long, 200 feet wide, running between the nation's capital and Gettysburg, Pennsylvania. Down the middle would run a 50-foot-wide greensward with gardens, fountains, and "other embellishments." McCleary pictured hundreds of thousands of Americans visiting the town of Gettysburg, the battlefield, and the national cemetery via this splendid highway and returning to Washington ennobled in spirit, with the flame of patriotism rekindled within their hearts.

Road construction interests, tire companies, automobile manufacturers, property owners along the route, and the townspeople of Gettysburg were enthusiastic about McCleary's plan. They lobbied Congress to move ahead quickly with the memorial highway, but as time passed, their hopes dimmed. In 1911, Senator Cullom and former House Speaker Joseph "Uncle Joe" Cannon, also from Illinois (as young men, both Cullom and Cannon had met Lincoln), pushed through Congress a bill calling for a Lincoln memorial commission, to fix a location and select a design for a memorial and appropriating $2 million, the largest amount ever set aside for such a project. President William Howard Taft chaired the new commission, and Cullom and Cannon were among its members.

When the Lincoln Memorial Commission decided to defer to the Commission of Fine Arts on the form the memorial should take, highway proponents lost all hope. The arts commission was made up of artists and architects, who could envision a memorial of marble or bronze far more easily than see dignity in an asphalt roadbed. The only real questions were where the memorial would be located, who would design it, and what it would look like.

While Fort Stevens, Capitol Hill, Meridian Hill, and Union Station all had their supporters, the arts commission strongly favored a site along the Potomac River west of the Washington Monument. Under the 1902 McMillan Plan for the capital city, this area was due for upgrading and enhancement, but in 1911 it was still barren and marshy. Where Cannon saw only "a God-damned swamp," the commission saw a *tabula rasa* with space enough for a large monument that would not compete with existing buildings and would provide a strong anchor for the west end of the Mall.

The Lincoln Memorial Commission asked architects Henry Bacon, a native of Illinois who had risen to prominence with his work on the Chicago World's Fair in 1893, and John Russell Pope, a rising star in American architecture, to submit designs for the different sites. Pope submitted ten dramatic drawings, including one for a massive funeral pyre from which a thin stream of smoke would perpetually waft. Bacon submitted one drawing of a dignified Doric temple. At the urging of the arts commission, the memorial commission chose the Potomac Flats site and the Bacon design.

Bacon's classical design was not without its critics. A Greek temple seemed to some "a bare-faced contradiction" of the life and character of Lincoln. Complained one critic, "Our national capital has Washington as a Roman general," referring to Horatio Greenough's much lampooned statue of a nearly naked George Washington. "Let us not add the more atrocious anachronism of Lincoln as Apollo."

Ground for the Lincoln Memorial was broken on February 12, 1914, the 105th anniversary of Lincoln's birth. The cornerstone was laid one year later. Inside the cornerstone lay two copper boxes, one inside the other, containing an array of items that included a Bible, a copy of the Constitution, a world atlas, maps of the United States, Alaska, the Philippines, and the District of Columbia, a small American flag, two issues of *National Geographic*, and 1914 coins.

In 1914, again without an open competition, the Lincoln Memorial Commission chose Bacon's longtime friend and frequent collaborator, sculptor Daniel Chester French (1850–1931), to execute the statue of Abraham Lincoln that would stand at the heart of the memorial. With the death of Augustus Saint-Gaudens, in 1907, French had become the preeminent American sculptor. French had grown up in Concord, Massachusetts. As a little boy, he had carved figures from turnips, and his family had encouraged his obvious talent. He had studied sculpture only briefly when, in 1873, Concord began planning

Sculptor Daniel Chester French working on a bust of Ulysses S. Grant in his studio, with the model of his seated Abraham Lincoln for the Lincoln Memorial in the background. Courtesy of the Library of Congress.

The twenty-eight pieces of white Georgia marble that make up the 170-ton statue of Lincoln had never been put together until they were assembled within architect Henry Bacon's Greek temple. Courtesy of the National Archives.

the centennial celebration of the first battle of the American Revolution. So great was the confidence of the townspeople in his abilities that they gave French his first commission, though he had never before done a full-length piece. The result was his famous Minuteman, which was an instant success.

Among French's best-known early public pieces were John Harvard, created for Harvard University, and Dr. Gallaudet Teaching a Deaf Mute for the Columbia Institute for the Deaf in Washington, D.C. French also won several commissions for works honoring Civil War heroes, among them the Rear Admiral Samuel Francis Du Pont Memorial Fountain in Washington (see #26) and two equestrian statues on which he collaborated with Edward Potter: General Grant for Fairmont Park in Philadelphia and General Joseph Hooker for the Massachusetts State House grounds in Boston.

French realized that his statue of Lincoln must harmonize with Bacon's Greek temple. He decided to concentrate on the dignity and force of character of Lincoln the statesman. French submitted a full-scale, 12-foot-tall model of his seated Lincoln in 1916, but he and Bacon already realized that it was far too small. Lincoln would look insignificant, dwarfed by the enormous columns. To decide just how

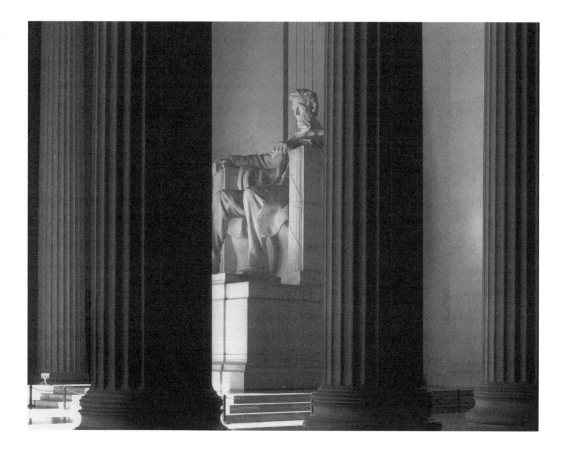

French and Bacon wrestled for years with the problem of proper lighting for the Lincoln statue. The original design of the building had included a skylight, which did not make it into the final version.

much larger the statue should be, French and Bacon made progressively larger solar prints and mounted them on wooden frames inside the roofed-in memorial. They tried 14 feet, 16 feet, 18 feet, but not until they got to 20 feet did the statue, which would sit atop a pedestal 11 feet high, seem properly proportioned. The memorial commission approved the larger, more expensive statue, and also approved French's request that it be carved from white marble, rather than cast in bronze as originally planned. Costs for the memorial were already inching toward $2,500,000. They would eventually exceed $3,000,000.

French turned the carving of the 170-ton statue over to Piccirilli Brothers, a family of noted marble carvers in New York City. The Piccirillis carved the statue from twenty-eight blocks of white Georgia marble. The pieces were never assembled until after they had all arrived in Washington. When they were finally put together on the pedestal, they fit so perfectly that the statue seems carved from a single huge block.

French, who had been traveling in Europe while the statue was assembled, was anxious to see his finished Abraham Lincoln. When he did, he was horrified. Lincoln's face looked out not with quiet

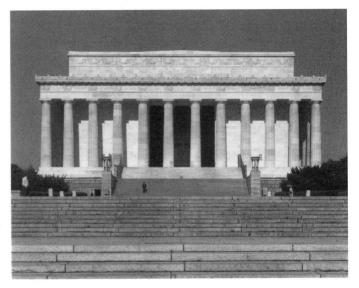

Bacon's temple of white Colorado marble rises along the Potomac River on land former House Speaker Joseph "Uncle Joe" Cannon once called "a God-damned swamp."

dignity but with a blank stare. His head rose up into darkness. His knees were far too prominent. Lighting was the problem. Bacon had designed the memorial with a glass skylight that would light the statue from above. French had carefully modeled Lincoln's features on that assumption. But the plans had changed. Slightly colored, translucent marble covered the ceiling, letting in little light. What light there was flooded in through the doorway, flattening Lincoln's face and highlighting his shins. The problem of proper lighting plagued French and Bacon for years. Again and again they experimented with artificial lighting before both were finally pleased.

Though French was far from satisfied with the presentation of his Abraham Lincoln, the Lincoln Memorial was declared complete late in 1921. The exterior of the building, carved of white Colorado marble, is a colonnade of 44-foot-high fluted Doric columns that tilt inward very slightly, to add to the feeling of height. The names of the forty-eight states at the time of the dedication carved into the top frieze, the thirty-six states in the Union at the time of Lincoln's death carved above the colonnade, and the swags, wreathes, and eagles that embellish the attic level are the work of Ernest C. Bairstow (1876–

1962), a Washington sculptor who specialized in architectural decoration.

Inside, the memorial is divided into three sections by 50-foot-high Ionic columns. The interior floors and wall base are of pink Tennessee marble; the walls of Indiana limestone; the ceiling of thin Alabama marble. The two side chambers contain murals by Jules Guerin and the words of Lincoln's most famous speeches: in the left chamber, the mural Emancipation is above the Gettysburg Address; on the right, a mural with allegorical figures portraying Unity flanked by Fraternity and Charity is above Lincoln's second inaugural address.

French's statue of Lincoln dominates the central chamber. Lincoln sits gracefully in a flag-draped chair, whose posts are formed by fasces. His coat unbuttoned, his powerful hands resting on the arms of the chair, his face, now properly lit, is strong but benign. On the wall behind Lincoln is the following inscription: "IN THIS TEMPLE AS IN THE HEARTS OF THE PEOPLE FOR WHOM HE SAVED THE UNION THE MEMORY OF ABRAHAM LINCOLN IS ENSHRINED FOREVER."

French and Bacon sat together on the platform at the dedication of the Lincoln Memorial on May 30, 1922, Decoration Day, later renamed Memorial Day. More than fifty thousand people attended the ceremony, including a complement of elderly Civil War veterans, who came straight from the annual Grand Army of the Republic services across the river at Arlington National Cemetery. This would be one of the last occasions when these survivors would gather to remember their youthful ordeal. The dedication ceremonies would be one of the first peacetime events photographed from the air and one of the first broadcast over radio nationwide.

Officiating was the Chief Justice, former President William Howard Taft, who had been chairman of the Lincoln Memorial Commission since its creation in 1911. Edwin Markham read a revision of his 1900 poem "Lincoln, the Man of the People," which included the lines:

The grip that swung the ax in Illinois
Was on the pen that set a people free.

Acknowledging those whom Lincoln had set free, the commission invited Dr. Robert Moton, successor to Booker T. Washington as president of Tuskegee Institute, to speak on behalf of twelve million African Americans. The ceremonies had been briefly delayed at the beginning, when black guests refused to be seated in a segregated section of the audience and left in protest. Most of the crowd were unaware of the incident, but Moton knew of it. He did not change his address, though the words may have sounded hollow to his ears: "As we gather in this consecrated spot, his spirit must rejoice that sectional rancors and racial antagonisms are softening more and more into mutual understanding and effective cooperation.".

Chief Justice Taft spoke of Lincoln's admirable qualities—justice, truth, patience, mercy, love, courage, sacrifice, honesty, and imagina-

tion—and told his listeners "here is a shrine at which all can worship." President Warren G. Harding delivered the chief speech, in which he spoke of Lincoln's trials: "His work was so colossal, in the face of such discouragement, that none will dispute that he was incomparably the greatest of our Presidents." "Today," Harding said, as he drew to a close, "American gratitude, love and appreciation, give to Abraham Lincoln this lone white temple, a parthenon for him alone."

SOURCES

RG 42, Records of the Office of Public Buildings, entry 195, Lincoln Memorial Commission Papers, National Archives, Washington, D.C.

Bruce Bustard, *Washington behind the Monuments* (Washington, D.C., 1990).

Allen C. Clark, "Abraham Lincoln in the National Capital," *Records of the Columbia Historical Society* 27 (1925): 167–74.

Edward F. Concklin, *The Lincoln Memorial* (Washington, D.C., 1927).

Wayne Craven, *Sculpture in America* (Newark, Del., 1984), 392–405.

Mrs. Daniel Chester French [Mary French], *Memories of a Sculptor's Wife* (Boston, 1928), 258–61.

James T. McCleary, "What Shall the Lincoln Memorial Be?" *American Review of Reviews* 38 (September 1908): 340–44.

J. Walker McSpadden, *Famous Sculptors of America* (New York, 1927), 115–46.

Myrtle Murdock, *Your Memorials in Washington* (Washington, D.C., 1952), 99–110.

Merrill D. Peterson, *Lincoln in American Memory* (New York, 1994), 206–17.

Michael Richman, *Daniel Chester French, an American Sculptor* (Washington, D.C., 1976).

Scott A. Sandage, "A Marble House Divided: The Lincoln Memorial, the Civil Rights Movement, and the Politics of Memory, 1939–1963," *Journal of American History* 80 (June 1993): 135–67.

Edward Steers Jr. and Joan Chaconas, *Everlasting in the Hearts of His Countrymen: A Guide to the Memorials to Abraham Lincoln in the District of Columbia* (Washington, D.C., 1984), 29–30.

Christopher A. Thomas, "The Marble of the Lincoln Monument," *Washington History* 5 (Fall–Winter 1993–94): 43–63.

Washington Star, February 12, 1914; February 12, 1915; June 21–23, 1921.

25 NUNS OF THE BATTLEFIELD

Rhode Island Avenue and M Street, N.W.

SCULPTOR: Jerome Connor

DATE: 1924

MEDIUM: Bronze

The Arsenal Monument and Nuns of the Battlefield are the only two Civil War–related monuments in the capital that suggest the role that women played in the conflict. The young women memorialized by the Arsenal Monument merited the memorial by dying horribly in an explosion while making shells (see #1). The women honored in Nuns of the Battlefield earned the tribute by ministering to the dying. Between eight hundred and one thousand women religious from twelve different orders nursed the wounded of both North and South on battlefields and in hospitals, wherever there was fighting, wherever they were needed.

The idea for a national monument honoring the nursing sisters originated shortly after the turn of the century with Ellen Jolly of Rhode Island, president of the Ladies' Auxiliary of the Ancient Order of Hibernians, who as a girl had heard vivid battlefield tales told by nuns. When she presented her idea to officials at the War Department, she was rebuffed and told it would not be considered without

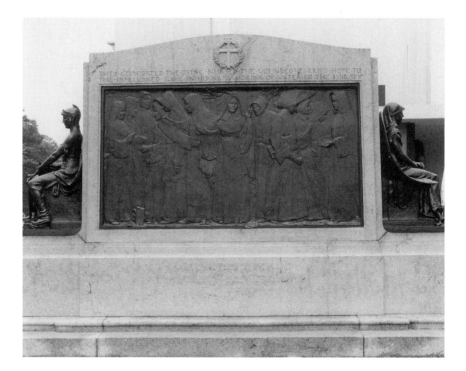

Twelve nuns, representing the different orders who nursed the wounded of both North and South, are depicted in this statue, erected by the Ladies' Auxiliary of the Ancient Order of Hibernians.

copious proof of their service. Jolly spent the next ten years amassing an amply convincing body of evidence. In 1918, Congress passed a resolution authorizing the erection of the monument on public ground, provided it be at no cost to the government and that the design be approved by the Commission of Fine Arts.

A committee of the Ladies' Auxiliary of the Ancient Order of Hibernians, chaired by Jolly, eventually raised $50,000 for the project and selected Washington sculptor Jerome Connor (1897–1943) to design the monument. Connor, himself an Irishman, specialized in Irish and Catholic themes, making him a natural for patrons such as these. His Washington works that no doubt recommended him to the Hibernians for the commission included statues of Bishop John Carroll at Georgetown University and Irish patriot Robert Emmet.

Connor was apparently a prickly character, who, like many artists, did not accept suggestions gracefully. While the Ladies' Auxiliary was pleased with his design from the first, the Commission of Fine Arts was not and, to his growing exasperation, sent him back to the drawing board several times, to rearrange the steps, to find a new site, to rework the inscription, and to infuse the figures with more vitality.

After a year of negotiations, the commission finally approved Connor's design in 1919, and he set to work.

Connor's large relief, 6 feet high and 9 feet wide, includes life-size figures of twelve nuns of all ages in the habits of the twelve orders they represent: Sisters of St. Joseph, Sisters of Our Lady of Mount Carmel, Sisters of St. Dominic, Sisters of St. Ursula, Sisters of the Holy Cross, Sisters of the Poor of St. Francis, Sisters of Mercy, Sisters of Our Lady of Mercy, Sisters of Charity, Sisters of Charity of Emmitsburg, Sisters of Charity of Nazareth, and Sisters of Divine Providence. Large bronze angels sit on either end of the relief. On the north end, the angel of Patriotism, wearing a helmet and armor but unarmed, is symbolic of the peaceful patriotism displayed by the nuns. On the south end sits the placid angel of Peace. The inscription above the panel reads: "They comforted the dying, nursed the wounded, carried hope to the imprisoned, gave in His name a drink of water to the thirsty." Below the relief are the following words: "To the memory and in honor of the various orders of sisters who gave their services as nurses on battlefields and in hospitals during the Civil War."

The monument, which sits opposite St. Mathew's Cathedral, was dedicated on Saturday, September 20, 1924, as part of a weekend-long meeting of Catholics from around the nation. One of the first speakers noted the poignancy of the fact that so many years had elapsed before the sisters were honored that not one who had nursed the Civil War soldiers remained to hear the tributes. Just then, reported the *Washington Star,* from out of the crowd of hundreds of nuns seated in front of the platform arose a "surviving nun of the battlefield," who "walked stooped and with head bowed up to the platform to thunderous applause." After a hurried consultation, Archbishop Curley of Baltimore announced that the elderly nun was Sister Magdeline of the Sisters of Mercy. She received a long ovation.

In his remarks, Archbishop O'Connell of Boston praised not only the nuns who nursed but all of the Catholic men and boys who fought and died in the Civil War. O'Connell also applauded the Ladies' Auxiliary of the Ancient Order of Hibernians for erecting a monument in the nation's capital, that all might know of the role Catholics played in the battle to save the Union. Then Jolly, proud to see her idea made real at last, slowly drew aside a huge American flag, revealing the monument. Sailors hoisted signal flags above the platform spelling out "faith, hope, and charity." A flock of white pigeons was released, and, as they soared upward, the ceremony ended.

SOURCES

Commission of Fine Arts, *Annual Report of the Commission of Fine Arts* (Washington, D.C., 1919).

Washington Star, September 20–22, 1924.

Dupont Circle, Massachusetts and
Connecticut Avenues, N.W.

SCULPTOR: Daniel Chester French

ARCHITECT: Henry Bacon

DATE: 1921

MEDIUM: Marble

*The three figures forming the foun-
tain's pedestal represent the Sea, the
Stars, and the Wind. The Sea cradles
a ship in one hand and caresses a
gull with the other.*

The fountain honoring Rear Admiral Samuel Francis Du Pont is actu-
ally the second memorial to the admiral to grace the traffic circle that
bears his name. Given Du Pont's tarnished reputation at the end of
the Civil War, it is surprising that even one was erected. The rehabili-
tation of his name is, in part, testament to the tenacity of his family.

Born into a branch of the famous Delaware chemical dynasty in
1803, Du Pont was appointed a midshipman in 1815 and went to sea
at the age of 14. He distinguished himself during the Mexican War
and was steadily promoted. When civil war broke out, he was com-
mandant of the Philadelphia Navy Yard. In September 1861, Du Pont
was named commander of the South Atlantic blockading squadron.
Within two months, he captured the Confederate fort at Port Royal,
South Carolina, handing the Union its first naval victory. Coming in
the midst of a string of misfortunes for the army, his was a sorely
needed triumph, for which he was appointed rear admiral and voted
the thanks of Congress. In Delaware, there was talk of sending Du
Pont to the White House. He continued to score success after success
along the Atlantic coast until he was ordered to attack Charleston,
South Carolina, in the spring of 1863.

After the victory of the *Monitor* over the *Merrimac* in 1862, Secre-
tary of War Gideon Welles put great faith in the new "ironclads" and
became convinced that a fleet of them could capture Charleston, de-
spite the formidable presence of Fort Sumter guarding its harbor.
Though Du Pont did not share Welles's faith in the new vessels, he
was ordered to take the city by sea, without the support of ground
troops. He reluctantly attacked in broad daylight on the afternoon of
April 7, 1863. After a terrible pounding that lasted two hours, Du Pont
ordered his ships to withdraw. His armored gunboat was sinking; five
monitors were out of action; for every projectile his ships got off, they
had been hit by three.

Welles was bitterly disappointed. The Northern press was highly
critical. Du Pont was humiliated and angry. Relieved of his command
in July, he hauled down his flag, ending not only his service during
the Civil War but also his almost fifty-year-long naval career. Du Pont
was convinced that he was being unfairly blamed for the disaster
at Charleston. He initiated a heated correspondence with Welles,
charging that the blame was partly his. A congressional investigation
proved inconclusive. Du Pont died two years after being relieved of
his command, from what his family claimed was a broken heart.

After his death, Du Pont's widow, Sophie, who was also his first
cousin, worked ceaselessly to burnish her husband's tarnished repu-
tation and convinced Delaware's congressional delegation to help her.
Eventually Congress authorized $20,000 for a bronze statue of Admi-

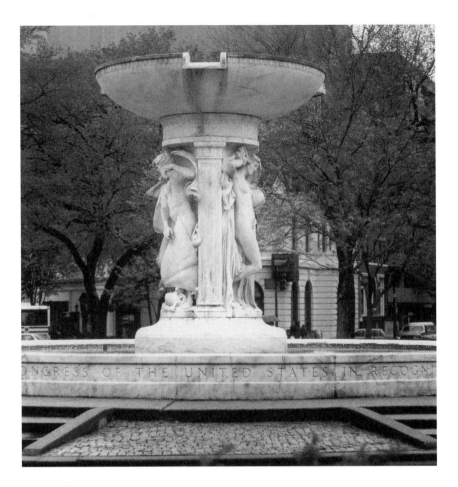

The family of Rear Admiral Samuel Francis Du Pont paid to have the government's poorly maintained portrait statue of their ancestor hauled away and replaced by a fountain with a nautical theme.

ral Du Pont to be erected in the newly fashionable "West End" of the capital city, in what had been called Pacific Circle and was renamed Dupont Circle. In May 1884, the War Department awarded the contract to New York sculptor Launt Thompson (1833–94) (see #32), who in just seven months produced a standing portrait statue of Du Pont holding binoculars and with his sword at his side. Dedicated in December 1884, the sculpture was almost immediately criticized for its blandness.

By 1909, the foundations of the statue had slipped so badly that Du Pont began to list, inciting nasty jokes about the sobriety of the admiral and of sailors in general. The Du Pont family grew increasingly annoyed, until finally, in 1916, May Du Pont Saulsbury, the admiral's niece and wife of Delaware senator Willard Saulsbury, proposed that the Du Pont family purchase and remove the Thompson statue and, at the family's expense, replace it with a more fitting and more attractive memorial, a fountain of continually flowing water. In 1916, Congress authorized the removal of the bronze statue, which was taken off to Rockford Park in Wilmington, Delaware, and authorized the erection of a marble fountain in its place. In its 1917 report, the Commission of Fine Arts noted, "The substitution of a fountain,

which is in itself an adornment to Washington, for a portrait statue is a step in the right direction."

The winning design among those submitted for the prestigious commission came from Daniel Chester French (1850–1931), one of the most prominent sculptors in America, whose work on the statue of Abraham Lincoln for the Lincoln Memorial was just beginning (see #24). The fountain consists of a large lower basin and smaller upper basin, joined by a pedestal composed of 8-foot-high figures symbolizing the Sea, the Stars, and the Wind, the three guardians of a ship's destiny, all in white marble. The Sea, a richly carved woman in wet, clinging robes, cradles a ship in one hand and caresses a gull with the other as a dolphin plays at her toes. The Stars are also represented by a woman, who holds a globe and gazes down into the eyes of passersby. The Wind, a male, is strategically draped by a ship's swelling sail and holds a large conch-shell horn.

The Du Pont family, who were paying for the fountain, agreed with the Commission of Fine Arts that French's model was a most fitting memorial to such a mariner as their seafaring relative. French, working with architect Henry A. Bacon, with whom he also collaborated on the Lincoln Memorial, began work in 1918. Three years later, at a cost of $77,521, the fountain was finished. At its dedication on May 17, 1921, Secretary of War John Wingate Weeks and Secretary of the Navy Edwin Denby paid tribute to Admiral Du Pont. The navy band played, and the Du Pont family looked on as three of the admiral's little nieces tossed laurel wreaths into the fountain's clear lower pool.

SOURCES

RG 66, Records of the Commission of Fine Arts, entry 4, Admiral Samuel Francis Du Pont, National Archives, Washington, D.C.

Commission of Fine Arts, *Annual Report of the Commission of Fine Arts* (Washington, D.C., 1916, 1917, 1918).

John Hayes, ed. *Samuel Francis Du Pont: A Selection from His Civil War Letters* (Ithaca, N.Y., 1969).

George Olszewski, *Dupont Circle* (Washington, D.C., 1967).

Robert Silver, *Outdoor Sculpture in Wilmington* (Wilmington, Del., 1987), 31–32.

27 MAJOR GENERAL GEORGE B. MCCLELLAN

Connecticut Avenue and Columbia Road, N.W.

SCULPTOR: Frederick MacMonnies

DATE: 1907

MEDIUM: Bronze

In the fall of 1861, after Major General George B. McClellan had helped push aside aging Lieutenant General Winfield Scott to become not only commander of the Army of the Potomac but general-in-chief of the army, President Lincoln suggested that the dual responsibility might be too great. Arrogant and ambitious, McClellan, who regarded Lincoln as low-born and crude, haughtily responded, "I can do it all." It soon became apparent that he could not. A year later, in 1862, McClellan's penchant for overestimating the enemy's strength and his refusal to move his army led to orders that he turn his command over to another and proceed to his home in Trenton, New Jersey, to await orders, which never came.

While McClellan exasperated the President and Congress, he inspired enormous affection among the men of the Army of the Potomac. During the summer of 1861, he had forged those green recruits into soldiers, and those soldiers into an army second to none. He instilled in his men discipline, pride, and confidence, and they repaid him with unyielding devotion. What others saw as excessive caution,

his men saw as concern for their welfare. Here was a general who would not send them into battle until conditions were just right.

McClellan's would be the first statue erected in Washington by the Society of the Army of the Potomac. Shortly after his death in 1885, the society's friends in Congress secured an appropriation of $50,000 for the statue and established the customary commission to select a site and choose a sculptor. In the spring of 1901, the McClellan Statue Commission requested artists to submit models for an equestrian statue. Thirty models arrived in Washington the following spring to be judged by an advisory committee composed of sculptors Augustus Saint-Gaudens and Daniel Chester French and architect Charles McKim. They quickly narrowed the field to four artists—Austin Hays, Charles Niehaus, Julian Story, and Furio Piccirilli—who were asked to enlarge their models.

Those four models were exhibited at the Corcoran Gallery of Art in the spring of 1903. McClellan's widow, Ellen Marcy McClellan, liked Story's model best. One "old cavalryman" wrote to the commission that all the horses but Story's were "seriously defective." Another complained that Hays had made McClellan look "French." Rumors circulated that the advisory committee favored the Niehaus model, but, in June 1903, the commission issued a terse statement declaring "no model submitted upon the competition is satisfactory" and rejecting them all. A month later, the commission decided "to invite some sculptor to submit a model for the McClellan equestrian statue, and to have no further competition." No doubt Saint-Gaudens had a hand in the letter the commission sent a few days later to his former pupil, Frederick MacMonnies (1863–1937), then in Paris, inviting him to design the equestrian monument of General McClellan.

The son of Scottish immigrants, MacMonnies began sculpting animals out of bread dough when he was 4 years old. At 16, he landed a job as chore boy in Saint-Gaudens's studio and stayed on as an assistant for four years before going to France, where his work quickly began to win prizes. His big break came when, at Saint-Gaudens's urging, he was awarded the commission for the central fountain for the Chicago World's Fair of 1893. MacMonnies's elaborately detailed fountain was the sensation of the fair, and commissions began to pour in. Among his best-known works with a Civil War theme are his sculpture groups for the Civil War Soldiers and Sailors Memorial Arch in Prospect Park in Brooklyn.

After a string of incredibly prolific years, MacMonnies suffered a breakdown, during which he gave up sculpture for painting. Perhaps it was to jog his former pupil out of his depression that Saint-Gaudens wanted to steer the McClellan project his way. French and McKim, both fond of MacMonnies, concurred. MacMonnies accepted the commission, and, in February 1905, sent photographs of his McClellan model back to America.

After the commissioners, McClellan's old friends, and Mrs. McClellan and their son George, who was mayor of New York City,

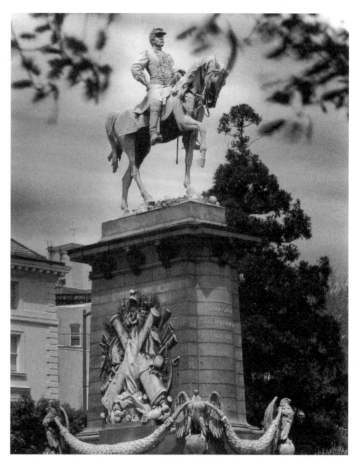

The site of the McClellan monument, at the crest of Connecticut Avenue, was a Union camp in the summer of 1861 when McClellan arrived in Washington.

examined the photographs, quibbles surfaced: the horse's body was too long, the curvature of its neck too sharp, its tail too "lively," McClellan's saddle and stirrups weren't right, his sword was improperly hitched, he should grip his horse with his knees and turn his toes in, not out. Though the commission instructed MacMonnies to incorporate as many suggestions as he could, he changed little.

Site selection proceeded apace. Members of the Society of the Army of the Potomac grumbled that all of the best spots in the capital had been preempted by statues of lesser men, though they had little to blame but their own sluggish fundraising for that. Eventually they settled on a small but prominent triangular lot amid fashionable houses and apartment buildings at the junction of Connecticut Avenue and Columbia Road. The fact that the site had been a Union camp in the summer of 1861 when McClellan arrived in Washington added to its appeal.

The small lot seemed to shrink even more when the pink granite pedestal began to rise up and up and up, stranding McClellan and his horse high above the line of sight of passersby. The pedestal includes bronze escutcheons bearing the names of McClellan's battles—Yorktown, Gaines Mill, Williamsburg, Antietam, South Mountain, Fair

Oaks, Malvern Hill—massed cannon, flags, munitions, and wreaths, and four large eagles supporting massive garlands of oak and laurel.

With the site selected and the statue being cast, the society began to plan the dedication ceremonies. While officers anticipated that this would be the easiest part of the project, they had not reckoned on the capriciousness of Mrs. McClellan. After consulting her throughout the process, they planned the ceremony for late May 1907. Preliminary announcements had already been mailed when Mrs. McClellan decided to go to Europe and requested that the date be changed, preferably to November. A member of the planning committee wrote to society president Horatio King in a rage: "It seems as if some friend of hers should be willing to advise her to postpone the advertisement of a selfishness that—I can think of nothing with which to conclude the sentence, my paper being inflammable." King sent back a wicked little poem:

> There was an old woman of leisure,
> And nothing on earth could e'er please her.
> She fussed and she fumed till she'd had her own way,
> And still kept on fussing, 'cause she'd nothing to say.

Mrs. McClellan had also written to Secretary of War William Howard Taft, telling him a November date would suit her better. To her annoyance, he had rebuffed her request. King wrote to Taft to commiserate: "By the way, I am in disgrace too for not consenting to murder the old Vets by having open air exercises in November."

The society reluctantly agreed to move the dedication ceremonies and the society's thirty-seventh reunion up to May 2. Thick packages of information, including special rail and hotel rates and descriptions of the weekend's banquets and excursions to Mount Vernon and Jamestown, went out to the aging membership.

Bunting bloomed all over the city for the military parade that preceded the dedication ceremonies. Hundreds of veterans from all of the Union's armies marched with their G.A.R. posts, and veterans unable to march filled the reviewing stands. The handsome commemorative booklet each member of the Society of the Army of the Potomac received that day enumerated the varieties of old soldiers "who came to do honor to the hero who brought into formation the renowned army which they helped to its glorious record . . . : Some bowed by the weight of years, others disfigured by the casualties of war. Many wear honorable scars, carry an empty sleeve, a vacant trouser's leg, a sepulchral eye-pit, some struggle along on the helping crutch or the artificial limb, a reminder of that of nature buried among the debris of carnage."

Mrs. McClellan and her son, Secretary Taft and other cabinet members, congressmen and diplomats joined King and other officers of the society and President Theodore Roosevelt on the main platform. As he had at the dedication of the Sherman statue in 1903, the President seemed to be having the time of his life (see #18). If he was

annoyed that the society rebuffed his idea of having his young son Archie pull the cord unveiling the statue he did not let on. Mc-Clellan's son pulled the cord that swung apart the two enormous American flags enfolding the statue.

The veterans in the crowd listened with tears in their eyes to the tributes to McClellan, but their own chests swelled with the praise heaped on each one of them by speakers who articulated the meaning of their youthful sacrifice. Brigadier General Henry C. Dwight best tapped this vein:

> Statues may crumble to dust. Veterans' graves will be obliterated by time, but the grandest monument of the service of valor of the soldiers and sailors of the Civil War, the United States of America, the hope and joy of the world, consecrated to liberty by the blood and treasure of the nation, the undying testimonial of the patriotism of her people, will continue years and years.

SOURCES

RG 42, Records of the Office of Public Buildings, entries 381–86, Major General George B. McClellan, National Archives, Washington, D.C.

RG 66, Records of the Commission of Fine Arts, entry 4, National Archives, Washington, D.C.

Wayne Craven, *Sculpture in America* (Newark, Del., 1984), 419–26.

Loring Holmes Dodd, *Golden Moments in American Sculpture* (Cambridge, Mass., 1967), 63–65.

J. Walker McSpadden, *Famous Sculptors in America* (New York, 1927), 73–111.

Washington Star, May 2, 1907.

28 GENERAL PHILIP H. SHERIDAN

Sheridan Circle, Massachusetts Avenue and 23rd Street, N.W.

SCULPTOR: Gutzon Borglum

DATE: 1908

MEDIUM: Bronze

According to family legend, shortly before his death, General Philip Sheridan paused while out walking with his wife to look at the equestrian statue of one of his Civil War comrades, which decorated a Washington park. The overweight bronze general sat stolidly astride a timid, too-small mount. "Whatever you do after I am gone," the general told Mrs. Sheridan, "don't put me on a horse like that."

No general who had captured the public's imagination as Sheridan had could escape being immortalized, and, as the North's most famous cavalry hero, his would certainly be an equestrian statue. And when the time came for a monument to be erected in her husband's honor, Mrs. Sheridan made sure the horse was as proud and courageous as its rider. Most equestrian statues in Washington stand quietly atop tall pedestals, forcing viewers to gaze at the horse's underbelly. Sheridan and his horse, Rienzi, look as if they have just come galloping down Massachusetts Avenue, sending dirt flying as they skid to a halt. Set low to the ground, Sheridan looks the viewer right in the eye. This animated statue of the charismatic general is by a

flamboyant sculptor, Gutzon Borglum (1867–1941), who, when his work was criticized as unconventional, snapped that Washingtonians had gotten used to "ridiculous clothespin men on wooden horses."

Washingtonians got their first look at Philip Sheridan in the spring of 1863. The son of Irish immigrants, Sheridan was 33 years old but looked younger. He was small and bandy-legged, with wide shoulders and a florid complexion. Sheridan had graduated from West Point in 1853, where he had been suspended for a year after chasing with fixed bayonet a superior he believed had mistreated him. His only distinctions in the prewar army were pugnacity and a handlebar mustache. During the first year of the war, Sheridan languished as a quartermaster captain in Missouri. In the spring of 1862, he obtained a field command of a cavalry regiment, by a fluke, and within weeks proved himself so bold and so able that he was promoted to brigade command, then division command, and, after Stone River, to major-general of volunteers. At the Battle of Chattanooga, Sheridan caught the attention of Ulysses S. Grant, who gave him command of the cavalry of the Army of the Potomac. In 1864, when Sheridan was appointed Chief of Cavalry, he carried out with a vengeance Grant's orders to lay waste to the Shenandoah Valley.

"Little Phil," as Sheridan was fondly known to his men, and his favorite horse, Rienzi, rode into history on October 19, 1864. While Sheridan was away in Winchester, Virginia, his men were surprised and all but routed by Jubal Early's Rebels at Cedar Creek, twenty miles away. When news of the attack reached Sheridan, he threw himself into the saddle and raced for the front. Finding most of his men in full retreat, Sheridan rode among them, swinging his hat and shouting, "There's lots of fight in you men yet! Come up, God damn you! Come up!" And come up they did, turning and following Sheridan by the dozens and then the hundreds to return to Cedar Creek and snatch victory from defeat.

"Sheridan's Ride" was quickly immortalized in a rousing poem by Thomas B. Read, to the pounding meter of a galloping horse:

> Be it said in letters both bold and bright:
> Here is the steed that saved the day
> By carrying Sheridan into the fight
> From Winchester twenty miles away.

Gutzon Borglum tried to capture Sheridan at the moment he rallied his men on the Winchester road. Borglum had grown up in the American West, in Idaho Territory, and, though he studied sculpture in France and Spain, his early themes were almost always cowboys and Indians and almost always involved spirited horses like Rienzi. A few years after he completed the Sheridan equestrian statue, when a group of Southerners invited him to carve a huge head of General Robert E. Lee onto the side of Stone Mountain near Atlanta, Borglum somehow convinced them to fund instead a colossal procession of Confederate soldiers led by Lee, Jefferson Davis, and Stonewall Jack-

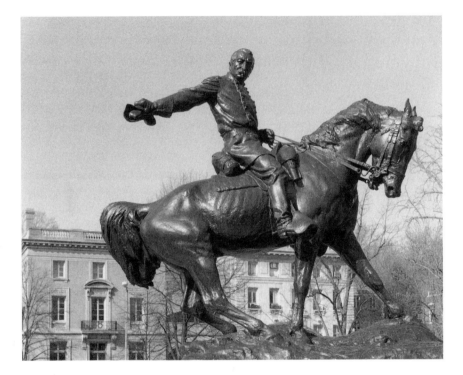

Sculptor Gutzon Borglum captured the moment on October 19, 1864, when "Little Phil" Sheridan, riding his horse Rienzi, rallied his scattering men on the Winchester road in Virginia's Shenandoah Valley.

son, all on horseback. Though Borglum was eventually fired by the Stone Mountain Monument Association and had to flee the state, a group of South Dakotans, undeterred by his growing reputation as a difficult artist, invited Borglum to carve a massive "shrine of democracy" on the side of Mount Rushmore. Again he clashed with authorities, but Borglum had roughed in all four presidents by the time of his death in 1941.

During his long, prolific, and controversial career, Borglum created several Civil War–related pieces in addition to the Confederate triumvirate at Stone Mountain and the Sheridan statue: a huge marble head of Lincoln in the Capitol Rotunda, a statue of Lincoln sitting alone on a bench for Newark, New Jersey, another equestrian of Sheridan, for Chicago, and the North Carolina Memorial for the Gettysburg Battlefield. His Sheridan statue in Washington, however, stands out among his work as one of his best and one of his favorites. The Sheridan commission, however, was originally awarded to another sculptor, and Borglum had to use all of his considerable charm and guile to win it away for himself.

When Sheridan died in August 1888, the Society of the Army of the Cumberland asked prominent sculptor John Quincy Adams Ward

to prepare an equestrian model of "Little Phil." As a leading member of the society, Sheridan had worked with Ward on his well-received statues of General George H. Thomas and President James A. Garfield that the society had commissioned (see #16 and #5). In 1892, the society and Ward signed a contract calling for completion of a Sheridan equestrian statue by 1898.

To the society's surprise, 1898 came and went, and Ward had nothing to show for six years' work. By 1903, he had produced only a life-size study of Sheridan's head. The Society of the Army of the Cumberland, Congress, which had appropriated $50,000 for the statue, and Mrs. Sheridan, who took extreme interest in the project, were growing exasperated. Mrs. Sheridan did not like the direction in which the model seemed to be heading at all. Ward wanted to depict Sheridan as a senior officer in the final years of his life. This was definitely not what she had in mind. Mrs. Sheridan wanted her husband portrayed as a dashing young officer astride Rienzi on their famous ride. She refused to let Ward borrow the stirrups, saber, belt, and spurs he had requested.

Hoping to salvage the project, Ward invited Mrs. Sheridan and her son, Lieutenant Philip H. Sheridan Jr., to his New York studio. Mother and son hated Ward's model: General Sheridan was too portly, too old, his horse too wooden. In 1905, the society canceled its contract with Ward, who sued and lost. Thirteen years after it had started, the society found itself back where it had begun. (After his death, Ward's Sheridan model was cast and erected in Albany, New York.)

The saga of Ward and the Sheridan statue was closely followed by the art world and by none more eagerly than Gutzon Borglum. He and Ward had tangled before when Ward had criticized the rough energy of his work. Borglum wanted to best Ward; always short of funds, he also needed the $50,000; and he was confident that he could create an exciting horse for Sheridan to ride. A few years earlier, he had entered the competition for the Grant Memorial and lost, so this time he laid his groundwork carefully. He read Sheridan's memoirs and biographies. He got himself invited to a Washington dinner party and seated next to Mrs. Sheridan, whom he invited to his New York studio. The visit went far better for Borglum than it had for Ward. Mrs. Sheridan was charmed by how much he knew about her husband and by the models of horses he had casually set out. At her urging, in 1907 the society and Borglum entered into a contract for an equestrian statue of General Sheridan.

As he worked, Borglum talked to Sheridan's friends and comrades. He visited Mrs. Sheridan often and sketched her husband's artifacts. And, when he was almost through, the army gave Lieutenant Sheridan, who bore a remarkable resemblance to his father, leave to visit his studio and pose for the finishing touches. Borglum's attention to detail paid off. Mrs. Sheridan, her son, and her three daughters all loved his statue of General Sheridan. So did the Society of the Army

of the Cumberland, and so, apparently, did almost everyone at the statue's dedication on November 25, 1908.

Sheridan was clearly a favorite with the press and with the crowds. The dedication of his statue in Sheridan Circle, just two blocks from the home where Mrs. Sheridan and their daughters still lived, drew bigger crowds and more newspaper coverage than had the dedication of the statue of General George McClellan the previous spring. The prededication publicity that Borglum had helped to generate by inviting reporters into his New York studio hadn't hurt.

President Theodore Roosevelt spoke fondly at the dedication of Sheridan and his mad dash down the Shenandoah Valley, no doubt recalling his own charge up San Juan Hill. Mrs. Sheridan beamed as her son pulled the cord that parted the flags covering his father's statue. The crowd cheered long and lustily, said the *Washington Star,* for this was an exuberant statue that excited the imagination and exuded action and bravery from every angle. Everyone in the audience, noted the *Star,* knew the poem about Sheridan's ride. Many could and did recite it from memory that day—"Here is the steed that saved the day . . . "—and there Rienzi was, right in front of them, a touchstone reminding them all of both the horse and rider who had hurled back the enemy at Cedar Creek.

SOURCES

Rg 42, Records of the Office of Public Buildings, entries 351, 394–96, General Philip H. Sheridan, National Archives, Washington, D.C.

RG 66, Records of the Commission of Fine Arts, entry 4, General Philip H. Sheridan, National Archives, Washington, D.C.

Wayne Craven, *Sculpture in America* (Newark, Del., 1984), 488–91.

Loring Holmes Dodd, *Golden Moments in American Sculpture* (Cambridge, Mass., 1967), 28–32.

"Gutzon Borglum," *Literary Digest* (March 14, 1925): 27–29.

J. Walker McSpadden, *Famous Sculptors of America* (New York, 1927), 213–44.

Myrtle Murdock, *Your Memorials in Washington* (Washington, D.C., 1952), 25–27.

Willadene Price, *Gutzon Borglum: Artist and Patriot* (privately printed, 1961), 73–79.

Lewis Sharp, *John Quincy Adams Ward: Dean of American Sculpture* (Newark, Del., 1985), 84–87, 266–67.

Washington Post, November 24–26, 1908.

Washington Star, November 25, 1908; January 23, 1943.

29 **25TH NEW YORK VOLUNTEERS MONUMENT**

Battleground National Cemetery, 6625 Georgia Avenue, N.W.

SCULPTOR: Unknown

DATE: 1914

MEDIUM: Granite

After two sweltering days of fighting on the open fields in front of Fort Stevens on July 11 and 12, 1864, Confederate General Jubal A. Early pulled back his men and retreated across the Potomac River into Virginia. Fort Stevens was all that had lain between Early and the federal capital, and the battle there was the only one of the Civil War fought within the District of Columbia. (See also #30.) As news of Early's defeat spread, a host of sightseers headed out to the northern

edge of town, where the full impact of the battle sank in. Bodies lay all about—some two hundred Union dead and wounded, about twice that many Confederates. As night fell, the official reports noted, the dead were "gathered in from the fields where they had fallen, wrapped in blankets and many laid in graves near Fort Stevens. With the rude tenderness of soldiers, they were covered with earth, and their names marked with pencil on the little headboards of pine."

By the end of July 1864, Quartermaster General Montgomery Meigs had appropriated just over an acre of land close by Fort Stevens for a small cemetery. In this little plot, designated Battleground National Cemetery, one of the smallest national cemeteries in the nation, forty of the Union dead from the Battle of Fort Stevens were laid to rest in a tight circle. In March 1936, 92-year-old Major Edward R. Campbell, who had defended Fort Stevens seventy-two years earlier, died and was buried with his comrades. (Further up Georgia Avenue, at the intersection of Grace Church Road, stands a granite shaft erected to the memory of the seventeen unknown Confederate dead from the battle.) Most of the soldiers in the circle at Battleground National Cemetery were privates, most from New York; but the dead included sergeants, corporals, and a lieutenant, and men from Pennsylvania, Ohio, and throughout New England.

Today twin cannon guard the entry to this tiny cemetery. In addition to the graves, the site includes a cemetery lodge erected in 1871, a Doric-style rostrum added in 1920–21, a flagstaff, plaques, and four large granite monuments honoring units that participated in the Battle of Fort Stevens. The first of these to be dedicated was the tall granite column inscribed with the names of the dead and wounded of the 98th Pennsylvania Volunteers, erected by the Commonwealth of Pennsylvania in 1891. The granite column with a bronze plaque inscribed with the names of the battles and men of the 122nd New York Volunteers from Onondaga County, New York, was dedicated in 1904, a gift from the State of New York. In 1907, the State of Ohio erected a granite column to the infantrymen of the 150th Ohio National Guard, Company K, who died in the defense of Washington.

The only sculpture among the four monuments, and the most recent, was dedicated with the most elaborate ceremony. A simple, watchful granite soldier stands atop the State of New York's monument honoring the dead of the 25th New York Volunteers, which is inscribed "Sacred to the memory of our comrades who gave their lives in defense of the national Capitol."

Hundreds of similar "lone sentinels," infantrymen at parade rest, appeared in cemeteries, courthouse lawns, and town squares across the North and, with a change of uniform, the South in the decades after the war. Mass-produced by memorial companies, foundries, and quarries (this one by McGibbon and Curry) relatively inexpensive figures such as this one, which cost $7,500, as well as Union and Confederate soldiers in different poses and with different hats, filled catalogues sent to Grand Army of the Republic posts, civic associa-

The bodies of the Union soldiers who died in the Battle of Fort Stevens, many of them from the 25th New York Volunteers, were initially buried near the battlefield but were later moved to Battleground National Cemetery, where this statue honors their gallant defense of the nation's capital.

tions, and Confederate Women's organizations, who had abundant zeal but limited funds with which to honor the dead.

The dedication of the 25th New York Volunteers monument on September 19, 1914, drew a crowd of several hundred onlookers to Battleground National Cemetery. The event was covered by the *Washington Star* in a front-page story headlined "Unveil Monument to Capital Savers." The New York G.A.R. had played a major part in fundraising for the statue, and G.A.R. units were well represented. Twenty-some survivors among the 25th New York Volunteers who had staved off Early's men in the summer of 1864 were also in the audience. They were assured by speaker after speaker that the citizens of Washington welcomed them, "then, and today."

The *Star* noted that "there was no lack of Confederate representatives" in the crowd, and it claimed that the day represented "a joining of North and South, when Union and Confederate veterans clasped hands in tribute to bravery." The theme of unity pervaded most of the speeches. The 1914 ceremony took place in the midst of a new war, this one raging in Europe, and the speakers made much of the strong, united front a mended America presented in that new battle for freedom. Most explicit was Representative Daniel J. Griffin of New York:

"A half century has rolled by since those brave New York lads went gallantly to their death. No scars remain from that fratricidal strife. North, South, East and West are united inseparably under the starry emblem of freedom and humanity."

After several speakers reminisced about the events of July 11 and 12, 1864, one of the veterans read a poem he had written about those dramatic days, entitled *That Thin Blue Skirmish Line,* which included these words:

> The Empire State's Twenty-fifth, this was their name.
> And well had their courage been tried;
> And each soldier felt, as he thought of their fame,
> 'Twas well for such fame to have died.
> And when the great Lincoln said, "Boys, hold them back!
> This duty to you I assign."
> Each soldier was ready to die in his track,
> In that thin blue skirmish line.

SOURCES

RG 79, Records of the National Park Service, entries 119, 120, 2700:0–31, Battleground National Cemetery, National Archives, Washington, D.C.

Author's conversations with Benjamin Franklin Cooling III, Alexandria, Virginia, regarding Fort Stevens and Battleground National Cemetery.

Benjamin Franklin Cooling III and Walton H. Owen II, *Mr. Lincoln's Forts: A Guide to the Civil War Defenses of Washington* (Shippensburg, Pa., 1988), 163–65.

Stephen Davis, "Empty Eyes, Marble Hand: The Confederate Monument and the South," *Journal of Popular Culture* 16 (Winter 1982): 2–21.

Michael Wilson Panhorst, "Lest We Forget: Monuments and Memorial Sculpture in National Military Parks on Civil War Battlefields," Ph.D. dissertation, University of Delaware, 210–15.

Washington Post, September 19, 1914.

Washington Star, September 19, 1914.

30 LINCOLN UNDER FIRE

Fort Stevens, Georgia Avenue and 13th Street, N.W.

SCULPTOR: Attributed to James E. Kelly

DATE: 1920

MEDIUM: Bronze

In July 1864, Confederate leaders in Richmond were desperate to ease the pressure that Union forces were slowly applying to their entrenched army at Petersburg, Virginia. On July 7, Confederate General Jubal Early ordered his fourteen thousand men across the Potomac River and headed toward Frederick, Maryland. Two days later, Frederick was ransomed for $200,000, and Early turned south toward Washington, hoping General Ulysses S. Grant would pull large numbers of troops away from his siege lines and hurry them north to protect the capital. Panic spread through Washington with news that the Rebels had reached Rockville, Maryland. A trickle of refugees from nearby Maryland towns fueled residents' fears. They knew that at that moment all that lay between Early and the capital

were a few raw recruits and convalescents. Some rumors claimed that reinforcements were being rushed to the city, but others had Lee's entire army at the capital's doorstep.

By the morning of July 11, it was clear that Fort Stevens, on the northern edge of the city's defenses, would bear the brunt of Early's attack. From within the fort, the dust of Early's advance was visible. Soon a fan-shaped line of Confederate skirmishers moved into the valley before the fort, confident that they would face only feeble resistance. And at first it was feeble, but then Early's men felt resistance stiffen, and they caught sight of faded blue uniforms. These weren't local militia; these were veterans. Nearly six hundred of them rushed to the scene, mostly from the 25th New York Volunteers, but some from the 150th Ohio National Guard and a company of the Second Division. Early drew back to wait out the night.

The next morning, Early found the Union lines thick with troops. Several thousand reinforcements from the 6th and 19th Corps had arrived under darkness. Skirmishing began early in front of the fort. Washingtonians awoke to the sound of artillery and saw puffs of white smoke rising from the direction of Fort Stevens. President Lincoln, congressmen, and cabinet members drove out to the fort for a better look. About midafternoon, Major General Horatio Wright of the 6th Corps gave the order to push back the Confederate skirmish line. At his signal, the charge from the parapet began. Early's men held their ground and sharp fighting ensued. Lincoln clambered to the parapet to watch, oblivious to the balls landing all around him. A surgeon was hit in the leg within 5 feet of the President. Wright was nearly apoplectic that snipers might find such a tempting target, and he strongly urged Lincoln to seek cover. Finally, Wright's aide, Lieutenant Colonel Oliver Wendell Holmes, is said to have shouted, "Get down you fool!" and the President did.

As dusk fell, Early's men pulled back. That night he ordered them to retreat into Virginia, and by morning they had vanished. Fort Stevens had held. The threat to the capital evaporated. The cost of the Union victory was high: of the one thousand men in the charging brigade, some two hundred were killed or wounded, including every regimental commander. The scattered dead were gathered and laid in rude graves to await more ceremonious burial in the tiny federal cemetery established nearby (see #29).

Like the other forts surrounding the capital, Fort Stevens was abandoned after the war. Weeds and litter filled its trenches and the earthworks slowly eroded until several veterans of the Battle of Fort Stevens banded together in 1900 to rescue it from oblivion. In 1911, the Fort Stevens Lincoln Memorial Association erected a 3-ton boulder, dug up from the battlefield, on the top of the parapet at the spot where Lincoln had stood. At each corner of its base are cannon balls plowed up from nearby farms.

Some five hundred men and women turned out for the November 7, 1911, dedication ceremony, including many from the Association of

On July 12, 1864, President Lincoln, who had climbed atop the parapet at Fort Stevens for a better look at the battle below, was finally convinced to remove himself from the line of fire when young Oliver Wendell Holmes shouted, "Get down you fool!"

the 6th Army Corps and the Grand Army of the Republic. Among the crowd were several dozen aging Confederate veterans. The principal orator, in fact, was former Louisiana congressman Floyd King, who had commanded the artillery division that had attacked Fort Stevens. In rhetoric becoming more common by the turn of the century, King eulogized Lincoln as a staunch friend of the South and declared himself "heartily glad" that Early's men had retreated. The roll of the dead, both Yankee and Rebel, was read, followed by "America," sung by a choir of schoolchildren.

On July 12, 1920, the fifty-sixth anniversary of the Battle of Fort Stevens, the Associated Survivors of the 6th United States Army Corps placed on the big boulder a vivid bas-relief showing Lincoln, the only sitting President to come under enemy fire, atop the parapet. Dedicated to the memories of Lincoln, Wright, and all the men who fell at Fort Stevens, the panel was unveiled by two of Wright's great-grandchildren.

As speakers emotionally recounted the events of July 11 and 12, 1864, the veterans in the audience relived them, too. Though the Civilian Conservation Corps would restore part of the fort in 1937–38, in July 1920 there were few physical reminders to jog the veterans'

memories save the same awful heat and bugs. The occasional farm-house had long since vanished in a blur of dense development. As Wright had noted a few years before, "Hardly a man in the 6th Corps who came here on double quick to the help of comrades in arms would recognize the place." The last of the men who had defended the nation's capital and the men who had tried to capture it in the summer of 1864, however, reported that they had no trouble recalling the Battle of Fort Stevens.

SOURCES

RG 66, Records of the Commission of Fine Arts, entry 17, Fort Stevens, National Archives, Washington, D.C.

Author's conversations with Benjamin Franklin Cooling III, Alexandria, Va., about the Battle of Fort Stevens.

Benjamin Franklin Cooling III, *Jubal Early's Raid on Washington 1864* (Baltimore, 1989).

Benjamin Franklin Cooling III and Walton H. Owen II, *Mr. Lincoln's Forts: A Guide to the Civil War Defenses of Washington* (Shippensburg, Pa., 1988), 156–61.

"Commemorative Ceremony on the One Hundredth Anniversary of the Battle of Fort Stevens," booklet published for the ceremony in 1964, lent to the author by David Langbart.

William V. Cox, "The Defenses of Washington: General Early's Advance on the Capital and the Battle of Fort Stevens, July 11 and 12, 1864," *Records of the Columbia Historical Society* 4 (1901): 135–65.

Margaret Leech, *Reveille in Washington, 1860–1865* (New York, 1941), 336–43.

Edward Steers Jr. and Joan Chaconas, *Everlasting in the Hearts of His*

Countrymen: A Guide to the Memorials to Abraham Lincoln in the District of Columbia (Washington, D.C., 1984), 11–13.

Washington Post, October 7, 1902; July 12, 1920; July 12, 1996.

Washington Star, November 7, 1911; July 12, 1920.

31 THE AFRICAN-AMERICAN CIVIL WAR MEMORIAL: SPIRIT OF FREEDOM

10th and U Streets, N.W.

SCULPTOR: Ed Hamilton

DATE: 1997

MEDIUM: Bronze

In late May 1865, just weeks after the Confederate surrender at Appomattox, the Grand Review of the Union troops galvanized the nation. Over the course of two days, some 200,000 Union soldiers marched in wide, even rows down Pennsylvania Avenue from the Capitol Building to the White House. The Grand Review was, however, incomplete. Not one of the 166 regiments of the United States Colored Troops (U.S.C.T.), regiments made up of African Americans, had been invited to participate in the victory parade. Their absence went unnoticed by most in the enormous crowds that thronged the streets, but not by all. An observant reporter for the *Philadelphia Inquirer* wrote of the black soldiers, "Their time will yet come."

Though long overdue, recognition of the black soldiers and sailors of the Civil War has indeed come. The most recent of the Civil War–related monuments in the nation's capital is the first in the United States to honor the African American troops who fought not only for

an abstract concept of freedom and to preserve the Union but literally for their own liberation.

Although the movie *Glory* first introduced many viewers to the idea of the African American as Civil War soldier, few realize the extent of their involvement. In fact, some 178,000 African American troops from eight Northern states, seven Southern states, and the District of Columbia fought in more than four hundred engagements, of which thirty-nine were major battles, in every theater from 1863 through 1865 except Sherman's March to the Sea. About 37,000 African American members of the military died in the war. Sixteen black soldiers and seven black sailors received the Medal of Honor for bravery.

African Americans volunteered to fight for the Union almost as soon as the Confederate cannons fired on Fort Sumter. Federal law, however, prevented them from serving in state militias, and they had little success getting into the Union army. (The navy did not exclude blacks, and more than 19,000 served as sailors during the course of the war.) As the war continued, mounting pressure came from abolitionists, including prominent African American orator Frederick Douglass, to allow African Americans into the army, where they could fight to destroy slavery.

In September 1862, after a major Union victory at Antietam, President Lincoln issued a preliminary emancipation proclamation, paving the way for African American enlistment. After New Year's Day in 1863, when the Emancipation Proclamation became law, African Americans enlisted in droves.

Many Northerners doubted the ability of former slaves to fight effectively, but from the first major battle in which they fought (two regiments of Louisiana's Corps d'Afrique took part in an assault on Port Hudson, Louisiana, on May 27, 1863), African American soldiers proved the doubters wrong. After two regiments of newly recruited freedmen beat back a Confederate attack on Milliken's Bend, a Union outpost on the Mississippi River, in June 1863, Assistant Secretary of War Charles Dana wrote that "the bravery of the blacks . . . completely revolutionized the sentiment of the army with regard to the employment of negro troops. I heard prominent officers who formerly in private had sneered at the idea of the negroes fighting express themselves after that as heartily in favor of it." Later that summer came the charge on Fort Wagner, outside of Charleston, led by the most famous of the African American regiments, the 54th Massachusetts, under the command of the young Boston abolitionist Colonel Robert Gould Shaw. Immortalized by both *Glory* and Augustus Saint-Gaudens's beautiful statue on Boston Common, the battle on July 18, 1863, claimed the lives of nearly half of the 600 men in the regiment, including Shaw.

Among those touched by *Glory*'s depiction of the heroism of the 54th Massachusetts and eager to learn about the United States Colored Troops was District of Columbia Councilman Frank Smith,

himself a veteran of the civil rights movement of the 1960s. The more he learned, the more convinced Smith became of the appropriateness of a memorial in Washington honoring the valor of all African Americans who took up arms and fought for their freedom.

In 1991, Smith's resolution proposing such a monument was approved by the city council, and, the following year, President George Bush signed into law an act officially establishing the African-American Civil War Memorial. Incorporated in 1992, the African-American Civil War Memorial Freedom Foundation, working with the National Park Service, the National Archives, the Washington Metropolitan Area Transit Authority, the Commission of Fine Arts, the National Capital Planning Commission, and the National Capitol Memorial Commission, began to plan the new monument.

From the start, Smith had envisioned a memorial not on the Mall but in an inner-city neighborhood with strong historic ties to the capital's black community. The site selected at 10th and U Streets, Northwest, is doubly appropriate. Not only is it in the midst of a vibrant African American neighborhood, but the area is known as Shaw, having long ago been named for Colonel Robert Gould Shaw. Because the neighborhood had been extensively disrupted by subway construction, the city transit authority became one of the memorial's major supporters.

The collaborative efforts of Devrouax and Purnell, Architects, and Ed Dunson and Associates resulted in a design concept for the site that was approved by all of the arts agencies: a wide stone plaza whose centerpiece is a sculpture partially enclosed within a long, low semicircular wall. Affixed to the stone wall will be stainless steel panels inscribed with the names of the more than 178,000 African American soldiers and sailors who fought in the Civil War and of the approximately 7,000 white officers who led the Colored Troops. J. Carter Brown, chairman of the Commission of Fine Arts, applauded "the design of the memorial . . . with the whole of 185,000 inscribed names underscoring the overwhelming commitment of African-Americans participating in the war. This impression will be the strength and the single most important contribution of the memorial."

More than twenty designs were submitted for the competition, open to artists of African American descent, to select the sculpture that would be the centerpiece of the memorial. Louisville, Kentucky, sculptor Ed Hamilton, whose work includes statues of boxer Joe Louis in Detroit, Booker T. Washington for Hampton Institute in Hampton, Virginia, and the Amistad Memorial in New Haven, Connecticut, emerged the winner. Three black infantrymen and a sailor guardedly look out in high relief from the convex side of a 12-foot-high wall. On the concave side, an African American man bound for war is bid farewell by his wife, their young children, and his elderly parents. Above them all hovers the hooded Spirit of Freedom. The

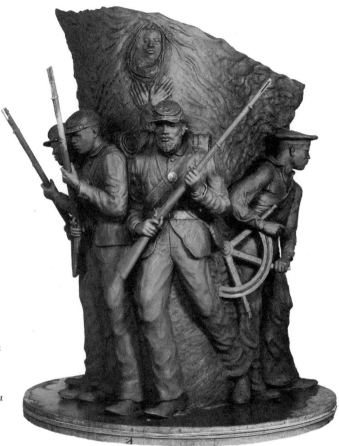

The Spirit of Freedom hovers over three African American soldiers and a sailor, who represent the more than 178,000 black troops who fought for their freedom during the Civil War and whose names will be inscribed on panels that will accompany the sculpture. Photograph by William Sheets, used by permission.

Commission of Fine Arts wrote that Hamilton's sculpture conveyed "the sense that they were fighting for the protection of their families from the slave trade . . . and for equal protection under the law."

Hamilton's sculpture makes tangible the sentiments of African American soldiers like Samuel Cabble, who escaped from a slave-master in Missouri and made his way to Massachusetts, where he joined the 55th Massachusetts Colored Infantry and marched off to fight in North Carolina. Cabble's letters make it clear what he was fighting for. He was, he wrote, fighting for his wife, still enslaved in Missouri, and, as he wrote her, "against that very curse that has separated you and me."

Samuel Cabble's letter to his wife and many other letters were found in the compiled service records of the U.S.C.T., by volunteer members of the Civil War Conservation Corps of the National Archives. The National Park Service, together with the National Archives and leading genealogical organizations, is making the names of the U.S.C.T. soldiers, as well as those of white Civil War soldiers both Union and Confederate, available on the World Wide Web in a project called the Civil War Soldiers and Sailors System. This and

other data bases and exhibits will be located across the street from the memorial in the Family History and Visitors Center, which will be in Garnet-Patterson Middle School.

On a warm September day in 1996, some 300 African American Civil War reenactors clad in blue Union uniforms strode down Pennsylvania Avenue to martial tunes like "Marching Through Georgia," the same tunes to which the white troops had marched in the Grand Review 131 years earlier. As they passed, they accepted the accolades of onlookers which had been denied the original Colored Troops in 1865. Several direct descendants of soldiers from the Colored Troops marched that day, including Kevin Douglass Greene, great-great-grandson of Frederick Douglass and great-grandson of Charles Douglass, who had volunteered with the 54th Massachusetts.

This long overdue parade acknowledging the African Americans who fought for freedom opened a five-day celebration organized by the African-American Civil War Memorial Freedom Foundation, which culminated in the dedication of the site of the first national memorial honoring these gallant troops. As the *Philadelphia Inquirer* reporter had predicted, indeed their time has come at last.

SOURCES

Press releases, fact sheets, fundraising material, and brochures regarding the Memorial were provided by the African-American Civil War Memorial Freedom Foundation and project director Lyndia Grant.

Baltimore Sun, September 9, 1996.

Ira Berlin et al., *Free at Last: A Documentary History of Slavery, Freedom, and the Civil War* (New York, 1992).

Boston Globe, September 11, 1996.

Compiled Military Service Records of Volunteer Union Soldiers Who Served With the United States Colored Troops: 55th Massachusetts Infantry (Colored), National Archives Microfilm Publications, pamphlet describing M1801 (Washington, D.C., 1996).

Courier-Journal (Louisville, Ky.), August 29, 1993.

Joseph T. Galatthaar, *Forged in Battle: The Civil War Alliance of Black Soldiers and White Officers* (New York, 1990).

James M. McPherson, *Battle Cry of Freedom* (New York, 1988), 563–67, 634–38, 686–87, 740–48, 792–96.

James M. McPherson, *The Negro's Civil War* (New York, 1965).

Linda Rancourt, "Fighting for Freedom," *National Parks* (September/October 1996): 24–29.

Washington Afro-American, June 29, 1996.

Washington Post, August 9, 1991; September 3, 7, and 9, 1996.

32 LIEUTENANT GENERAL WINFIELD SCOTT

United States Soldiers' Home, 3700 North Capitol Street, N.W.

SCULPTOR: Launt Thompson

DATE: 1873

MEDIUM: Bronze

The heroic bronze at the Soldiers' Home was the first of two statues of Lieutenant General Winfield Scott erected by the federal government to honor the memory of one of the army's oldest old soldiers. The second, an equestrian statue, stands in Scott Circle (see #19). In this statue, Scott, who at 19 stood 6 feet 5 inches tall and weighed 230 pounds and always seemed larger than life, stands 10 feet tall, his right hand in the breast of his dress uniform, with his flowing cape, saber, epaulets, braid, embroidery, and buttons rendered realistically. Punc-

tilious in dress and decorum, "Old Fuss and Feathers" would have appreciated their elaborate detail.

Scott's Civil War service represents only a small fraction of his brilliant, 58-year military career. General-in-chief of the Army when the war he tried to avert finally came in 1861, Scott was nearly 75 years old and quite fat. He suffered from gout, dropsy, and vertigo, was no longer able to mount a horse, and fell asleep during conferences. It was difficult for young recruits to see in this vain, exacting, irascible old man the dashing officer who had once inspired such deep devotion among his men that it moved them to legendary feats of bravery.

Scott was born on a farm in Virginia in 1786. Appointed to the army in 1808 by President Thomas Jefferson, he had served every subsequent President through Abraham Lincoln, including some he disliked and some who disliked him. By 1861, he had been involved in not only a score of successful military campaigns, starting with the War of 1812, but in almost as many political skirmishes, in which he had been far less successful. The acknowledged military genius of the Mexican War, Scott ran as the Whig presidential nominee in 1852 and was soundly drubbed. As civil war threatened at the beginning of 1861, his fellow Virginians urged Scott to defect to the Confederacy, but he rebuffed their overtures, telling them, "I have served my country, under the flag of the Union, for more than fifty years, and so long as God permits me to live, I will defend that flag with my sword, even if my native State assails it." When his refusal was publicized in Southern newspapers, Scott's mail grew heavy with threats of assassination. The Virginia legislature denounced him. He was burned in effigy at the University of Virginia. But Scott's loyalty to the Union never failed, though after the First Battle of Bull Run Northern newspapers questioned its depth.

Although he remained loyal to the Union, Scott's ability to take the field to save it was gone, and he knew it. Ambitious young officers like George B. McClellan, who ridiculed the old general, were champing at the bit for him to step aside. Scott requested retirement in October 1861, citing his infirmities, but he lived long enough to see the Union triumph. At the end of the war, when presenting a gift to Ulysses S. Grant, who had been one of his subalterns in the Mexican War, Scott inscribed it "from the oldest general to the greatest." Scott died at West Point in 1866, just fifteen days shy of his eightieth birthday.

While occupying Mexico City during the Mexican War in 1848, Scott sent back to the War Department in Washington the $118,000 tribute levied on the Mexican capital, with the suggestion that it be used to establish an "army asylum." Thanks to the efforts of Senator Jefferson Davis of Mississippi, who introduced the bill establishing the first "army asylum" in the country, Soldiers' Home, soon to be a haven for Union veterans, opened in the mid-1850s on 225 acres that had been the country estate of Washington banker George Washington Riggs. The original main building at Soldiers' Home was named

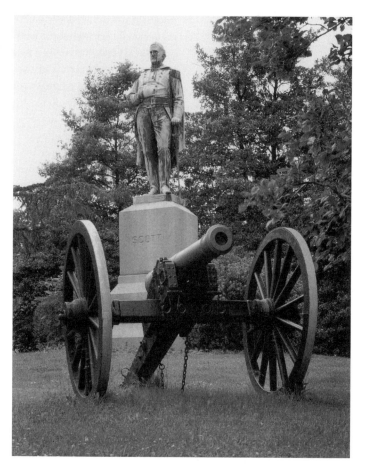

Lieutenant General Winfield Scott, who served in the army under every President from Thomas Jefferson to Abraham Lincoln, was responsible for the establishment of Soldiers' Home, where his statue stands on a rise.

Scott Hall in honor of the Home's benefactor. Remodeled and enlarged several times, Scott Hall, which still stands, was renamed the Sherman Building in 1954. President Lincoln took up residence at the Soldiers' Home during the Civil War summers to escape the city's heat and drafted the Emancipation Proclamation there in 1862.

In the early 1870s, the government authorized a statue of General Scott for the Soldiers' Home, and the larger-than-life likeness, resplendent in all his trappings, was installed on the bluff in the midst of the grounds with a sweeping view of the city in 1873. The artist, Launt Thompson (1833–94), and his widowed mother immigrated from Ireland to the United States in 1847 and settled in Albany, New York, where he studied anatomy and sculpture. By 1857, he had his own studio in New York City. Members of the wealthy Astor family were among his patrons. Thompson married into the old New York elite and traveled in the city's highest social circles.

Thompson's statue of General John Sedgwick, at West Point, and the Scott statue for the Soldiers' Home were his first government commissions. In 1884, he won another, for a second statue in Washington, this one of Rear Admiral Samuel Francis Du Pont, which, when completed, was soundly criticized as wooden and lifeless (see

#26). According to his friends, a change came over Thompson sometime in the early 1880s, after a trip to Italy. Although he completed an equestrian statue of General Ambrose Burnside for Providence, Rhode Island, in 1887, he had begun drunken ramblings through New York. Finally, his family confined him to an asylum for the insane, where he died in 1894.

SOURCES·

Annual Report of the Board of Commissioners of the Soldiers' Home, Washington, D.C. (Washington, D.C., 1883–90).

Wayne Craven, *Sculpture in America* (Newark, Del., 1984), 237–39.

Col. Paul R. Goode, *The United States Soldiers' Home: A History of Its First Hundred Years* (Richmond, 1957).

33 ABRAHAM LINCOLN

Fort Lincoln Cemetery, 3401 Bladensburg Road, Brentwood, Maryland

SCULPTOR: Andrew O'Connor

DATE: 1947

MEDIUM: Bronze

When the heroic bronze statue of a pensive, seated Abraham Lincoln was finally installed at Fort Lincoln Cemetery, just over the District of Columbia border in Prince George's County, Maryland, in April 1947, it marked the final chapter in a story that had begun thirty-three years earlier in Rhode Island. In 1914, the Rhode Island Sons of Veterans Association proposed that a memorial to Abraham Lincoln be placed on the State House grounds in Providence. Nothing happened for sixteen years, but the idea was revived in early 1930, and the newly created Lincoln Memorial Commission began aggressively raising funds. Schoolchildren all across the state contributed to penny drives that helped raise money for the statue.

Within just four months, the commission had raised $9,000 of the estimated $20,000 necessary to complete the monument. Buoyed by this encouraging start, the commission forged ahead and awarded the commission for the memorial to American sculptor Andrew O'Connor (1874–1941), who began work immediately. The son of a carver of cemetery monuments, O'Connor had studied with his father, then in Paris. By 1930, he had already completed one statue of Abraham Lincoln, a standing figure of a young, gaunt, beardless Lincoln, for the State House grounds in Springfield, Illinois.

The spurt of fundraising success proved short-lived. The campaign faltered and was finally abandoned. Apparently no one thought to inform O'Connor, who finished his statue of Lincoln, seated and lost in thought, in 1931; nor did they tell the Gorham Manufacturing Company in Providence, with whom the commission had also contracted, which went ahead and cast the statue the same year. All was ready for placement of the statue on the State House grounds but the money to pay for it. Gorham waited for its final payment of $5,000 and O'Connor for his of $4,500. O'Connor died in 1941, still waiting. The Gorham Company waited for fifteen years before giving up. In 1946, Gorham management began to survey organizations, chambers

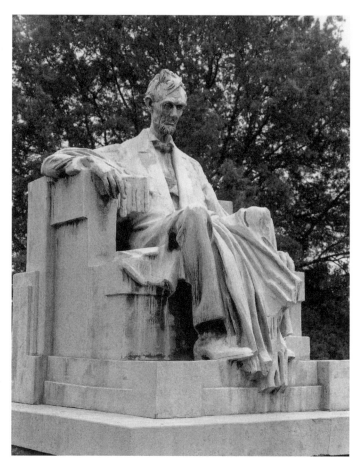

Artist Andrew O'Connor died without being paid for his statue of Abraham Lincoln, which languished at the foundry for fifteen years before it found a home at Fort Lincoln Cemetery.

of commerce, and cemeteries around the country to see if a buyer for the piece could be found.

The cemetery on the site of Fort Lincoln, built in the summer of 1861 as one of the circle of forts thrown up to defend the nation's capital, responded that it was indeed interested. Abraham Lincoln had visited the fort and, legend had it, conferred with his generals under a large oak tree and cooled himself with water from a spring on the cemetery grounds. The Lincoln statue was moved from the Gorham warehouse, where it had languished for a decade and a half, to Maryland and was installed without fanfare in April 1947.

SOURCES

Fort Lincoln Cemetery Records, Fort Lincoln Cemetery, Brentwood, Md.

F. Lauriston Bullard, *Lincoln in Marble and Bronze* (New Brunswick, N.J., 1952), 249–53.

Benjamin Franklin Cooling III and Walton H. Owen II, *Mr. Lincoln's Forts: A Guide to the Civil War*

Defenses of Washington (Shippensburg, Pa., 1988), 183–86.

Edward Steers Jr. and Joan Chaconas, *Everlasting in the Hearts of His Countrymen: A Guide to the Memorials to Abraham Lincoln in the District of Columbia* (Washington, D.C., 1984), 35–36.

A small bronze bas-relief embedded in a rough-hewn granite gravestone marks the grave of Colonel Royal Emerson Whitman.

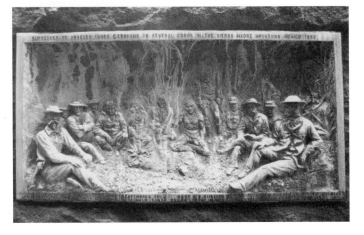

The grave of General George H. Crook is marked by a bas-relief of the surrender of Geronimo in 1883.

Arlington, Virginia

DATE: 1864

The slopes of the oldest sections of Arlington National Cemetery are thick with the graves of the Civil War dead. Many are marked with sculpture that ranges from the large equestrian statue of dashing, one-armed Philip Kearny, whose horse seems frozen in mid-charge, to the small, unsettling tomb effigy of 22-year-old John Rodgers Meigs, depicted as he was found, lying dead on his back in the dust (see #37 and #35). Fame was not a prerequisite for having a striking marker. Not too far from the large bas-relief of swashbuckling General Philip Sheridan is the beautiful, small bas-relief by Gutzon Borglum (see #28), of Mount Rushmore fame, of Colonel Royal Emerson Whitman, one of hundreds of little-known Union cavalry captains. Some men, like Kearny and Meigs, gave their lives for the Union. For others, like Henry Lawton, whose unusual marker evokes his later military career in the Philippines (see #40), and George H. Crook, whose bas-relief depicts the surrender of Geronimo, the Civil War was just the beginning of their military careers.

Hundreds of Confederate dead, thousands of Union dead, lie

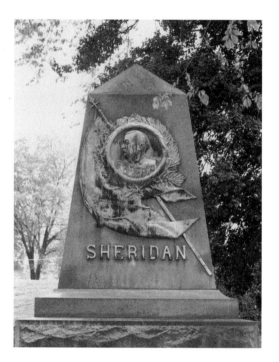

A large monument to General Philip H. Sheridan stands close to the Custis-Lee Mansion in Arlington National Cemetery.

in simple graves. The Civil War was this cemetery's raison d'être. In April 1861, these acres on the Virginia heights overlooking the Potomac River and Washington, D.C., were not planted with the dead but with crops. Robert E. Lee was doing his best to make the Arlington estate his wife had recently inherited a model farm.

Mary Anne Custis Lee inherited Arlington in 1857 upon the death of her father, George Washington Parke Custis, the adopted grandson of George Washington. She had grown up in Arlington House, now known as the Custis-Lee Mansion. After her wedding there in 1831, to recent West Point graduate Robert E. Lee, scion of an equally august Virginia family, she continued to live at Arlington while Lee, an engineering officer, traveled all over the country. Six of their seven children were born in the house. Mrs. Lee's pride was her beautiful rose garden to the east of the mansion.

When Lee turned down General Winfield Scott's offer of the field command of the United States Army and resigned his commission in April 1861, he knew he might be signing away his wife's inheritance. When he left for Richmond, he urged her to prepare to leave as well. He felt certain that strategically located Arlington would soon be occupied by Union troops. Within weeks, Mrs. Lee received word that

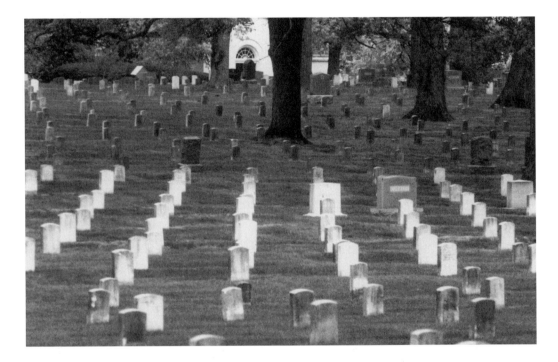

More than ten thousand Union graves cover the acres closest to the Custis-Lee Mansion.

federal troops would arrive shortly. Taking away whatever precious George Washington relics she could and storing the rest in the attic and cellar, she and her daughters headed south. Neither she nor her husband would ever live at Arlington again.

In 1862, Congress levied taxes on real estate in the "insurrectionary" districts. Since the aim was the confiscation of Southerners' property rather than raising revenue, a clause directed tax collectors to accept payment from none but the owner himself or herself. When Mrs. Lee, who was an invalid confined to a wheelchair, sent a cousin with her payment, it was refused. With uncommon speed, the 1,100-acre Arlington estate went on the auction block for default of taxes, and the United States government purchased it for $26,800.

By the time the government became the owner of Arlington, the war had created an urgent need for national cemeteries, especially in Washington. After each major battle in the surrounding countryside, thousands of the dead and dying were brought into the capital. Scores of soldiers died every week in the makeshift hospitals that filled the city. Authority for military hospitals, supplies, and cemeteries rested with Quartermaster General Montgomery C. Meigs. Although he had been raised in Georgia and owed his promotions to the sponsorship

In 1866, the remains of 2,111 unknown soldiers were gathered from Bull Run and the battlefields near Washington and buried in a common grave marked by a large granite monument.

of Jefferson Davis and other Southern friends in Congress, once the war began, Meigs became virulently anti-Southern. He denounced all Southerners, including his brother, who remained in the South, but saved his most heated diatribes for his old commander, Robert E. Lee. When, in 1864, Secretary of War Edwin Stanton ordered Meigs to do something about creating a national cemetery near Washington, he did. Meigs ordered no surveys of other sites but immediately recommended that the Arlington estate, Lee's home, be quickly transformed into a burying ground for the Union dead.

Meigs ordered the first soldiers' graves dug in Mrs. Lee's rose garden, practically at the doors of the mansion. By the end of 1864, more than seven thousand graves spread across the area that became known as the Field of the Dead. Among them was the grave of Meigs's only son, John Rodgers Meigs, killed by Confederate guerrillas in October 1864. Montgomery Meigs could hardly endure the loss, which only further hardened his heart. Eventually, in excess of ten thousand more Union graves would be dug into the acres closest to the house.

In April 1866, a year after the war's end, Meigs ordered a huge vault dug in what was left of Mrs. Lee's rose garden. Into the 10-

foot-deep and 20-foot-wide pit went the skeletal remains of all of the unidentified war dead gathered up from Bull Run and other battle-fields near Washington. Though Meigs was loathe to admit it, among the skeletons of the 2,111 or more bodies in the common grave under the huge granite marker, some Confederate bones almost certainly commingled with Union bones.

By the end of the war, several hundred Confederate dead, most-ly prisoners of war who had died in local hospitals, lay in graves scattered about Arlington. Meigs refused to let their relatives visit their graves. On the first Decoration Day (now Memorial Day) in 1868, when Southern women asked permission to place flowers on the Confederate graves, Meigs ordered them turned away. Not until Meigs passed from the scene, not until a new generation of leaders took up the reins of power, and not until another war intervened would the situation of the neglected Confederate dead at Arlington be recognized.

In 1898, President William McKinley, speaking in Atlanta, extolled the Southern and Northern men who had fought side by side in a new, foreign war. Many Confederate veterans had rallied to the flag in the Spanish-American War. Old differences should be buried, McKinley told the crowd, and the bravery and sacrifice of all the dead should be recognized. "Every soldier's grave made during the unfortunate Civil War," he claimed, "is a tribute to American valor." In 1900, Congress authorized a Confederate section within Arlington National Cem-etery. More than four hundred Confederate dead were gathered up from all over the cemetery and from graves in Alexandria and at the Soldiers' Home Cemetery and reinterred in the Confederate section to rest together. And in 1906, Secretary of War William Howard Taft permitted the United Daughters of the Confederacy to erect a memo-rial in the midst of the dead. The Confederate Monument (#38) takes its theme of peace and unity from the verse from Isaiah carved around the pedestal: "They shall beat their swords into plowshares, and their spears into pruning hooks."

Each of the cemetery's Civil War–related sculptures has a story to tell. Those described in the following six entries are but a few ex-amples.

SOURCES

Cemetery Files, Historical Office, Arlington National Cemetery, Arling-ton, Va.

Montgomery C. Meigs Papers, Library of Congress, Washington, D.C.

Brent Ashabranner, *A Grateful Nation: The Story of Arlington National Ceme-tery* (New York, 1990).

Federal Writers' Project, *The WPA Guide to Washington, D.C.: The Federal Writers' Project Guide to 1930s Washington* (New York, 1983), 440–45.

John Vincent Hinkle, *Arlington: Monument to Heroes* (Englewood Cliffs, N.J., 1970).

James Mayo, *War Memorials as Political Landscape: The American Experience and Beyond* (New York, 1988).

Myrtle Murdock, *Your Memorials in Washington* (Washington, D.C., 1952), 63–96.

35 MAJOR JOHN RODGERS MEIGS

Meigs Drive, Arlington National Cemetery, Arlington, Virginia

SCULPTOR: Theophilus Fisk Mills

DATE: 1865

MEDIUM: Bronze

The tomb effigy of Major John Rodgers Meigs is one of the most poignant and striking monuments within Arlington National Cem-etery. A bereft, embittered father's tribute to his young son, the monu-ment, sculpted in high relief and vivid detail, is also eerily unsettling. Just 39 inches in length, the effigy looks distressingly like the body of a dead child, an effect heightened by the fact that Meigs, though 22 years old at his death, looked little older than a boy.

The West Point class of 1863, probably taken in 1862. The bare-headed cadet sitting in the center of the front row is 20-year-old John Rodgers Meigs. Courtesy of the Library of Congress.

John Rodgers Meigs was the only surviving son of Major General Montgomery C. Meigs, quartermaster general of the United States Army throughout the war. Like his father, John Rodgers Meigs attended West Point. He was head of his class of 1863, but even before graduation he had seen action. While on leave from the academy in 1861, he had volunteered for service and distinguished himself at the Battle of Bull Run.

After graduation, he was appointed a first lieutenant of engineers and sent to the field. In early 1864, he joined Major General Philip Sheridan in the Shenandoah Valley, where, after being cited for gallantry in several actions, he was awarded the ranks of brevet captain and brevet major within a two-week period. On October 3, 1864, while within his own lines, John Rodgers Meigs was shot and killed by Confederate guerrillas near Harrisonburg, Virginia.

Montgomery C. Meigs wanted his son portrayed exactly as he was found in the field. On his back, bareheaded, his pistol at his side, every detail of his uniform clearly portrayed, John Rodgers Meigs lies in the bronze dust stamped with hoof prints on both sides of his body. To create exactly what he wanted, Montgomery C. Meigs chose Theophilus Fisk Mills, the son of Washington sculptor Clark Mills, whom he knew quite well from prewar days when Clark Mills's bronze foundry had cast the statue Freedom for the Capitol dome.

Montgomery Meigs also chose the site for his son's burial, and for his own, which is just behind his son's grave and is marked by an enormous granite monument that shelters the small effigy. The irony of his only son's final resting place was not lost on Meigs. It was, after all, at his urging, fueled by his hatred of the South and especially of his old commander Robert E. Lee, that Arlington National Cemetery had been created from Lee's own Virginia estate, just four months before John Meigs's death. (See #34.)

SOURCES

Cemetery Files, Historical Office, Arlington National Cemetery, Arlington, Va.

Montgomery Meigs Papers, Library of Congress, Washington, D.C.

Mary Giunta of the National Historical Publications and Records Commission of the National Archives, Washington, D.C., who is preparing a documentary edition of John Rodgers Meigs's papers, graciously shared her research.

Wayne Craven, *Sculpture in America* (Newark, Del., 1984), 172.

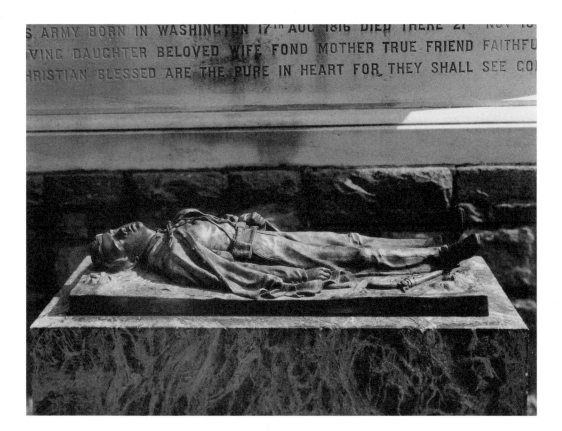

Montgomery C. Meigs wanted the
tomb effigy of his son to portray him
exactly as he was found in the field:
bareheaded, on his back, with his
pistol at his side.

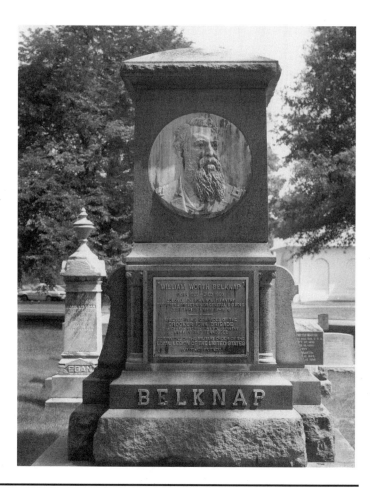

This imposing monument to William Worth Belknap, who resigned from Grant's cabinet in disgrace, was erected by his "Companions of the Military Order of the Loyal Legion of the United States and Other Friends."

36

MAJOR GENERAL
WILLIAM WORTH BELKNAP
MONUMENT

Meigs Drive near the Custis-Lee Mansion, Arlington National Cemetery, Arlington, Virginia

SCULPTOR: Carl Rohl-Smith

DATE: 1891

MEDIUM: Bronze

The large bronze medallion of William Worth Belknap is typical of several tributes to Civil War dead erected by family or veterans' groups in the oldest parts of the cemetery. The Belknap Monument was erected in 1891, a year after his death, by "Companions of the Military Order of the Loyal Legion of the United States and Other Friends." The "other friends" must have been old friends, because, in the years after he resigned in disgrace in 1876 from the cabinet of President Ulysses S. Grant, the friends Belknap had made in Washington were nowhere to be seen.

Born in Newburgh, New York, in 1829, Belknap attended Princeton, studied law at Georgetown University in Washington, and was practicing law in Keokuk, Iowa, in 1861 at the outbreak of the Civil War. He volunteered for service and was commissioned a major in the 15th Iowa Infantry. Cited for gallantry at Shiloh and Corinth, Belknap

caught General William Tecumseh Sherman's eye and under his patronage rose to brigadier general in 1864 and major general in 1865. Belknap served under Sherman during the March to the Sea and the Carolina campaign and was repeatedly cited for bravery and personal disregard of danger.

After the war, Belknap went back to Iowa. Upon the death of Secretary of War John Rawlins in 1869 (see #21), at Sherman's urging Belknap was plucked from obscurity to become President Grant's Secretary of War. During seven years in the cabinet, Belknap accomplished little save not getting at loggerheads with Sherman, the commanding general of the army. A big, handsome, genial man, Belknap was usually quiet at cabinet meetings.

On the morning of March 2, 1876, Washington official society was shocked to learn that Belknap had resigned suddenly. That afternoon, when he was unanimously impeached by the House of Representatives for "malfeasance in office," it became clear why. An investigation revealed that Belknap had accepted more than $24,000 over several years from a deal involving the post tradership at Fort Sill, Oklahoma. He narrowly escaped conviction in the Senate only because there was a question about whether Congress had authority over a cabinet member who had already resigned. Belknap practiced law in Philadelphia and later in Washington but never got over the humiliation of his exposure. His death in 1890 was rumored to be a suicide.

Belknap's companions in the Military Order of the Loyal Legion turned to Danish-born sculptor Carl Rohl-Smith, who had recently set up his studio in Washington, for the likeness of Belknap to grace their monument. Not surprisingly, the inscription they chose focused only on the military aspects of Belknap's career. Five years after completing the Belknap medallion, Rohl-Smith won the competition for the monument honoring General Sherman, Belknap's patron (see #18).

SOURCES

Cemetery Files, Historical Office, Arlington National Cemetery, Arlington, Va.

William McFeely, *Grant, A Biography* (New York, 1981), 427–28.

New York Times, October 15, 1890.

Washington Post, October 14, 1890.

Washington Star, October 13, 1890.

3 7 MAJOR GENERAL PHILIP KEARNY

Intersection of Lee, Meigs, and Wilson Drives, Arlington National Cemetery, Arlington, Virginia

SCULPTOR: Edward Clark Potter

DATE: 1914

MEDIUM: Bronze

One of only two equestrian statues in Arlington National Cemetery (the other is of Sir John Dill, 1881–1944), the monument to Philip Kearny is as handsome and bold as Kearny himself. Born into a wealthy and distinguished New York family in 1814, Kearny grew up under the strong influence of his maternal grandfather, millionaire John Watts. Though horses and military tactics were all that interested him, his grandfather refused to let him apply to West Point. For his part, Kearny refused to enter the ministry, even though his grandfather offered him $1,500 a month as an inducement. As a compromise, he studied law. As soon as his grandfather died in 1836, however, leaving him more than a million dollars, Kearny immediately applied for and received a commission in the army with the cavalry.

After service on the frontier, Kearny was sent to France in 1839 to study military tactics at the French cavalry school at Saumur. While there, he enlisted in the French army and took part in the Algerian campaigns. Returning to the United States in 1840, Kearny became aide-de-camp to General Winfield Scott. When the Mexican War began, Kearny recruited men for his 1st Dragoons and bought ninety dapple gray horses for his men with his own money. While leading a charge at Churubusco, Kearny's left arm was so badly shattered by grape-shot that it had to be amputated.

Shortly after the Mexican War, Kearny resigned his commission and settled down on his estate in New Jersey. Domestic life, he found, held little appeal. If there was no war at home, he would find one abroad. In 1859, he returned to France and joined the Imperial Guards of the French army. During the Italian campaign, he took part in every cavalry charge of the Battles of Solferino and Magenta. For his bravery, Napoleon III awarded him the Cross of the Legion of Honor.

With the outbreak of civil war at home, Kearny hurried back to the United States. Commissioned a brigadier general of the 1st New Jersey Brigade and soon promoted to major general in command of the 3rd Division United States Volunteers, he fought throughout the Peninsula campaign. As the Union army withdrew after the Second Battle of Manassas, or Second Bull Run, on September 1, 1862, Kearny inadvertently rode into a nest of Rebel skirmishers near Chantilly, Virginia. Though surrounded, he refused to surrender and, while trying to fight his way out, he was hit, dying instantly. General Robert E. Lee, who had known Kearny in Mexico, ordered his remains returned to Union lines under a flag of truce and ordered his horse, saddle, and sword returned as well.

Learning of his former aide's death, General Scott called Kearny "the bravest man I ever met, and a perfect soldier." Kearny's daring and bravery were legendary. "No one," said General John Pope, "could fail to admire his chivalric bearing and supreme courage." Tall, lean, and handsome, his reddish beard clipped to a point, his kepi always slanted in the French manner, and an excellent horseman, Kearny cut a dashing figure galloping into battle. During any cavalry charge, he was always in the front, the reins clenched between his teeth, his good right arm free to wave his men on. His men revered him and willingly followed. Other officers marveled how they cheered Kearny every time he rode down their lines. To set them apart and build their morale, Kearny's men always wore a patch of scarlet, a "Kearny patch," on their uniforms. "You are marked men," Kearny told them, "You must be ever in the front." They always were, and so was he.

Kearny liked to be on the move in life, and his remains moved around quite a bit in death. His body was first buried at Trinity Church in New York City, but in 1912, at the urging of the State

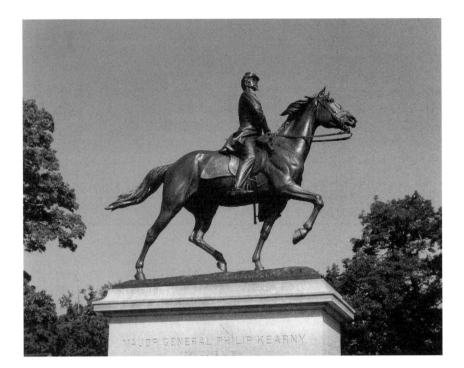

Major General Philip Kearny, who lost his left arm in the Mexican War, was always in the front of every cavalry charge, reins clenched between his teeth, his good right arm free to wave his men on.

of New Jersey, his remains were moved to Arlington National Cemetery. A squadron of the 15th Cavalry escorted the caisson bearing the casket from Union Station to Arlington, where President William Howard Taft spoke at the reinterment. Two years later, in 1914, when the equestrian statue of Kearny that New Jersey had commissioned was finished, Kearny's body was disinterred a second time and moved to a more prominent spot. This time, President Woodrow Wilson spoke. The inscription on the south end of the Kearny monument reads: "GAVE HIS LEFT ARM AT CHURUBUSCO, MEXICO AUGUST 18, 1847 AND HIS LIFE AT CHANTILLY, VIRGINIA SEPTEMBER 1, 1862."

The statue of Kearny, who looks jaunty and proud as he sits tall in the saddle, and his spirited horse is the work of Edward Clark Potter (1857–1923), who specialized in equestrian statues. Many of Potter's most famous works were collaborations with Daniel Chester French, with whom he studied, who sculpted the Du Pont Memorial Fountain and the statue of Lincoln in the Lincoln Memorial. French modeled the riders and Potter the horses for their General Grant in Philadelphia, their George Washington statues in Paris and Chicago, and General Devens in Worcester, Massachusetts. Potter's finest individual

equestrian works include the Kearny statue, General McClellan in Philadelphia, General Custer in Monroe, Michigan, and, considered his very best work, General Slocum on the Gettysburg Battlefield. Potter's best-known pieces are not of horses, however, but of lions. Potter created the famous lions at the entrance of the New York Public Library.

SOURCES

RG 66, Records of the Commission of Fine Arts, entry 17, National Archives, Washington, D.C.

Cemetery Files, Historical Office, Arlington National Cemetery, Arlington, Va.

Wayne Craven, *Sculpture in America* (Newark, Del., 1984), 398–400, 541–42.

J. Watts De Peyster, *Personal and Military History of Philip Kearny* (New York, 1869).

Irving Werstein, *Kearny, the Magnificent: The Story of General Philip Kearny, 1815–1862* (New York, 1962).

38 CONFEDERATE MONUMENT

Jackson Circle, Arlington National Cemetery, Arlington, Virginia

SCULPTOR: Moses Jacob Ezekiel

DATE: 1914

MEDIUM: Bronze

The 32-foot-tall Confederate Monument is one of the largest memorials at Arlington and one of the most elaborate, with symbols and allegorical figures encircling every tier. The sculptor, Moses Jacob Ezekiel (1844–1917), is equally complex. Of all the artists who created statues honoring the men, women, and events of the Civil War, Ezekiel is one of the very few who actually fought in the war. For him, sacrifice and bravery were not abstract ideals to be translated into bronze or stone but very real qualities that he not only experienced and possessed but had had tested under fire.

After a section of the cemetery was set aside in 1900 for the burial of the Confederate dead, the women of the United Daughters of the Confederacy (UDC) began to lay plans for a monument to stand in the center of the concentric circles of graves. In 1906, with the help of Mississippi senator John Sharp Williams, the UDC received approval from Secretary of War William Howard Taft to erect a Confederate monument at Arlington. The women knew exactly which sculptor they wanted for the job: Moses Jacob Ezekiel. Ezekiel was a Southerner and a Confederate veteran, in addition to being a world-famous sculptor, and his fame rested in part on a bust of the UDC's hero and his, General Robert E. Lee, and a group entitled *Virginia Mourning Her Dead*, which had recently been dedicated at the Virginia Military Institute (VMI).

The problem was that the women of the UDC weren't quite sure how to approach this eminent man. By 1906, Ezekiel, who lived and worked in Rome, had been knighted by three European rulers—

Emperor William I of Germany and King Humbert I and King Victor Emmanuel II of Italy. They had heard that Sir Moses Ezekiel was temperamental. They had also heard that he refused to enter competitions or submit designs to potential patrons. Having entered and lost a number of federal competitions for Civil War monuments as a young man, most notably the Farragut contest, he had declared himself above such demeaning exercises. With their minds made up in advance to leave the design in his hands and counting on his demonstrated love of the South, the women determined to approach him on his next visit to the United States.

Moses Jacob Ezekiel was born in Richmond, Virginia, the son of Sephardic Jews. Overcoming his parents' objections, he entered VMI in 1861, becoming the institution's first Jewish cadet. In his memoirs, Ezekiel described the morning in May 1864 when the cadets were awakened by a drum roll and ordered to go to the aid of Confederate General John C. Breckinridge, who was facing strong Union forces not far away in the Shenandoah Valley. As he and the other 15-, 16-, and 17-year-olds marched through Staunton, Ezekiel recalled how the town's young ladies met them with buckets of lemonade and baskets filled with sandwiches and cakes. Ezekiel took part in the cadets' spirited charge at the Battle of New Market that became immortalized in Southern legend.

Ezekiel graduated from VMI in 1866 with honors. After studying anatomy at the Virginia Medical School for a year, he joined his parents, who had moved to Cincinnati, and studied art there briefly before traveling to Germany to study sculpture in Berlin. In 1873, his bas-relief Israel won the prestigious Prix de Rome, awarded by the Berlin Royal Academy of Art. The prize was two years of study in Rome, all expenses paid. Ezekiel fell in love with Rome. For nearly forty years, he made it his home. His studio in the picturesque Baths of Diocletian became a popular salon, hosting some of the world's most famous writers, artists, and musicians.

Ezekiel was one of the first Southerners and one of the first American Jews to become a sculptor. Two themes, Southern chauvinism and religious pride, are reflected in much of his work. The works for which he had earned praise before he tackled the UDC's project included Religious Liberty, a large group commissioned by the Independent Order of B'nai B'rith for the Philadelphia Exposition in 1876, a bust of Rabbi Isaac Mayer Wise, the Lee bust, and Virginia Mourning Her Dead. When the women of the UDC approached him, he was working on a bronze statue he called Southern for the Confederate cemetery at Johnson's Island on Lake Erie, a work commissioned by the Cincinnati chapter of the UDC, for which he accepted no fee, and a statue of "Stonewall" Jackson, commissioned by a UDC chapter in Charleston, West Virginia.

Ezekiel wrote that when he first met with the women of the UDC they seemed a bit nervous. He immediately put them at ease. "I had

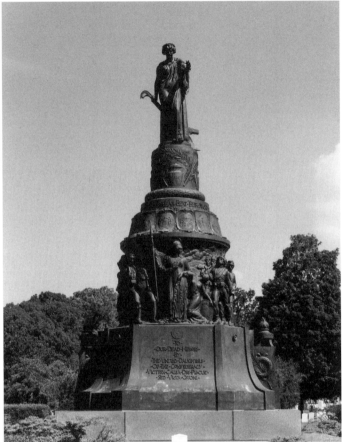

The Confederate Monument, one of the tallest memorials in Arlington National Cemetery, is crowned by the South, a woman who wears a crown of olive leaves and holds a laurel wreath and a plowstock on which there is a pruning hook.

been waiting forty years to have my love for the South recognized," he wrote, and he didn't mind letting his enthusiasm for the Arlington project show. When they asked if he had any ideas, he took out a pencil and paper and made a hurried sketch. "I told them I would like to make a heroic bronze statue representing the South, a standing figure, dignified and sorrowful with her right hand resting on the handle of the plough and her left hand extended holding out a laurel wreath." He made it clear that, if they commissioned him to create their monument, he would do it in Rome, and they would have to trust him as to the design. He wanted no suggestions. The women eagerly agreed to all of Ezekiel's demands and promised to make none of their own. In his memoirs, however, Ezekiel noted that before long curiosity got the better of them, and they began to make gentle inquiries, asking for hints, which he never gave. He telegraphed them that work had progressed far enough that the cornerstone could be laid in 1912.

When the pieces of the monument, which Ezekiel always called New South, arrived by ship and were assembled on the rise in the Confederate section of the cemetery, it was everything the women of the UDC had hoped it would be. It was huge, and it was intensely

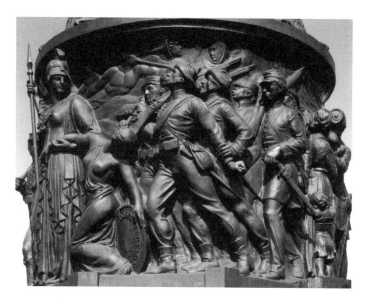

The South, supported by Minerva, goddess of wisdom, sinks to the ground as her loyal sons rush to her aid.

dramatic and not a little sentimental. From top to bottom, its symbols, inscriptions, and allegorical figures told the story of sacrifice and gallantry they wished the world to know.

Crowning the monument is a heroic woman in a flowing gown who represents the South. Her head is crowned with olive leaves, a symbol of peace. In her left hand she holds a laurel wreath to crown her fallen sons and honor their heroism. Her right hand rests on a plowstock on which there is a pruning hook. Around the plinth on which she stands are four bas-relief cinerary urns, one for each year of the war, and encircling its base are the words from the prophet Isaiah from which Ezekiel took his inspiration: "And they shall beat their swords into plowshares and their spears into pruning hooks." The plinth is supported by a frieze of fourteen richly detailed shields, one for each of the thirteen states of the Confederacy plus one for Maryland, acknowledging its contributions of money and troops.

Below the shields is the focal point of the monument, a frieze almost 8 feet tall, containing nearly three dozen life-size figures, that is rich in detail, dense with symbols, and borders on the maudlin. In the forefront is the dramatic figure of Minerva, goddess of war and wisdom. Minerva is holding up by the arm a woman depicting the South,

1 6 7 Confederate Monument

An officer kisses his baby goodbye while another child hides tears in the skirts of a slave.

A clergyman and his wife bless the son they are sending off to defend the South.

A belle binds a sword and sash around the waist of her handsome sweetheart.

who is sinking to the ground almost helpless but still clinging to her shield bearing the inscription "The Constitution." Behind her, the spirits of war sound their trumpets in every direction, calling on all Southerners to come to the aid of their struggling mother. Also in the background are the Furies, one carrying a cinerary urn and another, Tisiphone, with snakes in her hair.

Stretching out to the right and left of the flagging South, her sons and daughters answer the call and prepare to come to her defense. Miners leave their camps, carrying their picks on their shoulders. Faithful slaves follow their young masters in new Confederate uniforms. A handsome officer kisses his little baby, who reaches out to him from the arms of a black mammy, while his little daughter hides her face in the slave's full skirts. A muscular blacksmith, determination in his eyes, buckles on his sword, while his sorrowful wife, her hand on the anvil, gazes into an uncertain future. An elderly clergyman, in high collar and robes, and his wife hold the hand of their son, no more than a schoolboy, as he takes his leave to go off to war. A beautiful belle with downcast eyes, dressed in a wide, ruffled hoop skirt, binds a sword and sash around the waist of her virile sweetheart, who seems impatient to be off.

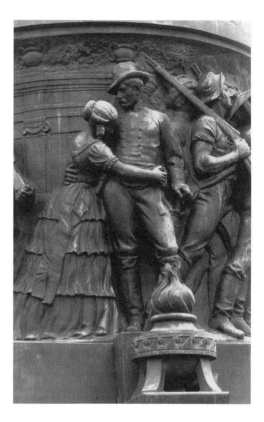

The front of the monument bears the seal of the Confederate States of America and the inscription: "TO OUR DEAD HEROES BY THE UNITED DAUGHTERS OF THE CONFEDERACY, VICTRIX CAUSA DIIS PLACUIT SED VICTA CATON" (the victorious cause was pleasing to the gods but the lost cause to Cato).

On the rear of the monument is an inscription written by the Reverend Randolph Harrison McKim, long-time pastor of Epiphany Church in Washington, D.C., and a Confederate veteran:

NOT FOR FAME OR REWARD

NOT FOR PLACE OR FOR RANK

NOT LURED BY AMBITION

OR GOADED BY NECESSITY

BUT IN SIMPLE

OBEDIENCE TO DUTY

AS THEY UNDERSTOOD IT

THESE MEN SUFFERED ALL

SACRIFICED ALL

DARED ALL—AND DIED

The Confederate Monument was dedicated on June 4, 1914, the anniversary of the birthday of Jefferson Davis, president of the Confederacy. An early summer thunderstorm threatened to shorten the carefully planned ceremony, but it held off until moments after the benediction.

Hundreds of elderly Confederate veterans in their faded gray uniforms, joined by several elderly Union veterans in faded blue, stood among the gravestones as a procession of dignitaries, preceded by the flag of the United States and the Confederate stars and bars, slowly walked to the foot of the monument. The veterans were joined by hundreds of women of the United Daughters of the Confederacy in large summer hats. These, wrote the *Washington Star*, were "the mothers who sent their sons into battle for principle, brides who buckled on their young husband's swords," anxious to witness the dedication of this monument "erected by loving thousands not to a president, not to a great general, not to the soldiers of any state, but to all the soldiers who fought in a 'lost cause.'"

The theme of the speeches that afternoon was one of common sacrifice and a common glorious future. Colonel Robert E. Lee, General Lee's grandson, told the crowd, "There is room in the hearts of the people of all the land for cherished recollections of the valorous dead." The commander of the United Confederate Veterans and the commander-in-chief of the Grand Army of the Republic spoke, and both men evoked images of a reunited brotherhood ready to "fight shoulder to shoulder against all the world for country's sake." Their children, the two veterans reminded one another, and their children's children "today wear a common uniform."

For a few moments midway through his speech, it appeared that General Bennett Young, commander of the United Confederate Veterans, had forgotten himself and was about to reopen old wounds. His beginning was conciliatory enough: "Nothing more strange and unwonted has ever happened in national life than the exercises of this afternoon. Its happening marks another step in the complete elimination of sectional passions, suspicions or prejudice." But then his rhetoric began to heat up.

> I come without apologies or regrets for the past. Those for whom I speak gave the best they had to their land and country. They spared no sacrifice and no privation to win for the southland national independence. . . . That for which they suffered and laid down their lives was just. . . . The sword said the South was wrong, but the sword is not necessarily guided by conscience and reason. The power of numbers and the largest guns cannot destroy principle nor obdurate truth. Right lives forever. It survives battles, failures, conflicts and death. There is no human power, however mighty, that can in the end annihilate truth.

As his speech concluded, Young pulled back again and ended with a plea for unity and a common front: "May the hands that fought be

At the end of the dedication cere-monies for the Confederate Memorial in 1914, elderly Confederate veterans walk down paths over what had once been the grounds of Robert E. Lee's home. Courtesy of the Library of Congress.

the hands that clasp, and the hearts that bled be the hearts that re-joice."

As the sky darkened ominously, President Woodrow Wilson, the first Southern-born President since the Civil War and the final speaker, accepted the statue from the UDC on behalf of all of the people of the United States. After a hasty benediction, the crowd hurried down the long paths, just ahead of the rain. The *Star* com-mented on the Confederate veterans leaning on canes, the Union vet-erans hobbling along minus legs, and sometimes a Union and a Con-federate veteran supporting each other.

In 1921, a fresh grave in the Confederate section received another son of the South. Sir Moses Jacob Ezekiel had requested to be buried at the foot of the monument that he considered his greatest achieve-ment. Although he had died in Rome in 1917, his remains could not be returned to the United States until after World War I. The Italian ambassador and a host of other dignitaries spoke at the reinterment at Arlington, but it was Colonel Robert E. Lee's moving tribute to Ezekiel's love of the South, made tangible by the huge monument in whose shadow he lay, that would have pleased him most.

SOURCES

Cemetery Files, Historical Office, Arlington National Cemetery, Arling-ton, Va.

Moses Ezekiel Papers, Archives of American Art, Washington, D.C.

Stanley F. Chyet, "Moses Jacob Ezekiel: Art and Celebrity," *American Jewish History* 35 (April 1983): 41–51.

Wayne Craven, *Sculpture in America* (Newark, Del., 1984), 312, 337–38.

Moses Ezekiel, *Moses Jacob Ezekiel: Memoirs from the Baths of Diocletian,* edited by J. Gutmann and S. F. Chyet, (Detroit, 1975).

Hilary A. Herbert, *History of the Arlington Confederate Monument at Arlington, Virginia* (Richmond, 1915).

Zebulon Vance Hocker II, "Moses Jacob Ezekiel: The Formative Years," *Virginia Magazine of History and Biography* 60 (April 1952): 241–54.

National Museum of American Jewish History, *Ezekiel's Vision: Moses Jacob Ezekiel and the Classical Tradition* (Philadelphia, 1985).

Washington Post, June 4, 1914; March 31, 1921.

Washington Star, June 4 and 5, 1914; March 30, 1921.

After Vinnie Ream Hoxie's death in 1914, her husband ordered a copy of Sappho, one of her earliest works, cast in bronze to mark her grave.

39 BRIGADIER GENERAL RICHARD L. HOXIE AND VINNIE REAM HOXIE MONUMENT

Miles Avenue, Arlington National Cemetery, Arlington, Virginia

SCULPTOR: Vinnie Ream Hoxie, statue; George Julian Zolnay, relief panel

DATE: Erected in 1915

MEDIUM: Bronze

In 1880, after completing the statue of Admiral David Farragut (see #20), a commission for which she had fought hard, Vinnie Ream Hoxie (1847–1914) gave up sculpting for many years. Although she was just 33 years old, her statues of Abraham Lincoln in the Capitol Rotunda and of Admiral Farragut had won her respect as an artist and some degree of notoriety in Washington, where she curried favor with powerful men in government.

In 1878, Vinnie Ream had married Lieutenant, later Brigadier General, Richard Hoxie, a handsome West Point graduate stationed in Washington with the army engineers. Hoxie's military service had begun when he enlisted as a 16-year-old bugler in the opening months of the Civil War. By the time he retired, in 1908, Hoxie was regarded as a leading authority on fortifications.

After her marriage, Ream Hoxie deferred to her husband's wishes and devoted herself to domesticity. Their home on Farragut Square, from whose doorway she saluted Admiral Farragut's statue every morning, became one of the capital's prominent salons, always offering good music (she played the guitar and harp) and an interesting assortment of congressmen, cabinet members, military men, and staff from the foreign legations whom Ream Hoxie had met and charmed when studying in Europe.

In 1906, after her son had grown up and with her husband's blessing, Ream Hoxie came out of retirement when the State of Iowa commissioned her to sculpt Civil War governor Samuel Kirkwood for Statuary Hall in the Capitol. Suffering from kidney disease, she used a rope hoist and a boatswain's chair, rigged up for her by her husband, to complete the 7-foot-tall statue.

She lived to finish the model of her last commission—from the State of Oklahoma for a statue of the Cherokee leader Sequoya for Statuary Hall—before her death in Washington in 1914, but the work was cast by sculptor George Julian Zolnay (1863–?), an emigré from Bucharest.

After Ream Hoxie's death, her husband gave the original of one of her earliest ideal works, a 7-foot-tall marble statue of Sappho, to the Smithsonian Institution's National Collection of Fine Arts. Before he parted with it, he had a copy made in bronze to mark her grave at Arlington National Cemetery, beside which his would eventually lie, and he commissioned Zolnay to create the bronze low-relief portrait of Vinnie Ream Hoxie that graces the monument's base.

The bas-relief portrait of Vinnie Ream Hoxie on the Hoxie Monument was commissioned of George Julian Zolnay by Brigadier General Richard L. Hoxie, her husband.

SOURCES

Cemetery Files, Historical Office, Arlington National Cemetery, Arlington, Va.

Vinnie Ream Hoxie Collection, Library of Congress, Washington, D.C.

Joan Lemp, "Vinnie Ream and Abraham Lincoln," *Woman's Art Journal* 6 (Fall–Winter 1985): 24–29.

Dawn Langley Simmons, *Vinnie Ream: The Story of the Girl Who Sculpted Lincoln* (New York, 1963).

Valerie Thompson, "Vinnie Ream: The Teen Who Sculpted Abe Lincoln," *Sculpture Review* 41 (1992): 32–33.

Thurman Wilkins, "Vinnie Ream," *Notable American Women 1607–1950* (Cambridge, Mass., 1971), 3:122–23.

Washington Post, November 21, 1914.

Washington Star, November 20, 1914.

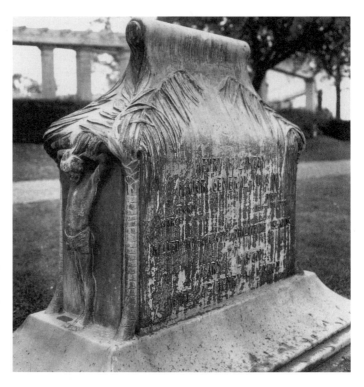

Henry Lawton's long military career lasted from his enlistment in 1861 at the age of 18 during the Civil War until his death in the Philippines during the Spanish-American War in 1899. The latter venue provided the theme for his monument.

40

MAJOR GENERAL HENRY W. LAWTON MONUMENT

Near intersection of Sheridan Drive and Sherman Avenue, Arlington National Cemetery, Arlington, Virginia

SCULPTOR: Myra Reynolds Richards

DATE: 1922

MEDIUM: Bronze

Major General Henry W. Lawton was typical of several soldiers buried in this section of the cemetery for whom the Civil War was only the beginning, not the end, of their military careers. Lawton's monument, however, is unique.

Just 18 years old when he enlisted in the 9th Indiana Infantry in 1861, Lawton served in the western armies throughout the war. He received the Medal of Honor for gallantry at Atlanta and was mustered out with the brevet rank of colonel in the fall of 1865. After a brief period studying law at Harvard, Lawton reentered the army in 1867 and spent two decades fighting Indians in the West. In 1886, he and his men pursued Geronimo for 1,300 miles over the Sierra Madre until the Apache leader surrendered. During the Spanish-American War, Lawton served first in Cuba as brigadier general and major general of volunteers and then in the Philippines. Lawton was a hero to

the men in his command, who appreciated the truth in the saying, "Lawton always leads his men; he doesn't send them." On December 18, 1899, while positioning his troops for an attack outside San Mateo, he was shot through the heart, and died almost instantly.

Lawton's family chose to evoke his last years of military service in the tropics in their unusual memorial. A 3-foot-tall hut of bronze palm branches is supported by muscular Filipinos, who serve as atlantes, at either end. The monument is the work of Myra Reynolds Richards (1882–1934), an Indianapolis sculptor who studied under George Julian Zolnay.

SOURCES

Cemetery Files, Historical Office, Arlington National Cemetery, Arlington, Va.

O. O. Howard, "General Henry W. Lawton: A Sketch of His Long Service," *Review of Reviews* 21 (February 1900): 184–86.

P. McQueen, "General Henry W. Lawton," *Outlook* 64 (January 6, 1900): 55.

41 ALEXANDRIA CONFEDERATE MEMORIAL

Prince and South Washington Streets, Alexandria, Virginia

SCULPTOR: Caspar Buberl, after a design by John A. Elder

DATE: 1889

MEDIUM: Bronze

On May 23, 1861, Virginia voted to ratify the ordinance of secession. All through that night, Union troops crossed the Potomac River, in boats and over the Long Bridge, to occupy Northern Virginia. By the next morning, some two thousand men of the 11th New York Infantry, known as the Fire Zouaves, and the 1st Michigan Infantry had arrived in Alexandria, where their officers ordered the city's military forces to either evacuate or surrender. Alexandria's garrison of about eight hundred troops chose the former. They mustered at the intersection of Prince and South Washington Streets and marched out of town to form the 17th Virginia Infantry. Most of them were gone from home for the next four years.

Twenty-four years later, in 1885, Alexandria's R. E. Lee Camp of the United Confederate Veterans voted to erect a monument to the city's Confederate dead on the spot where their comrades had assembled. A committee put out a call for designs. When Virginia artist John A. Elder (1833–95) heard of the competition, he promptly submitted a clay statuette of a pensive Confederate private, modeled from his popular painting *Appomattox*. The committee loved it and just as quickly adopted it.

Born in Fredericksburg, Virginia, Elder worked as a cameo carver before studying painting in Germany and opening a studio in New York. By 1861, he was back in Virginia, and he joined the Confederate army as a draftsman with the Ordnance Department. He was present at Petersburg when a Union mine exploded within Confederate fortifications—the Battle of the Crater—and quickly painted the horrific

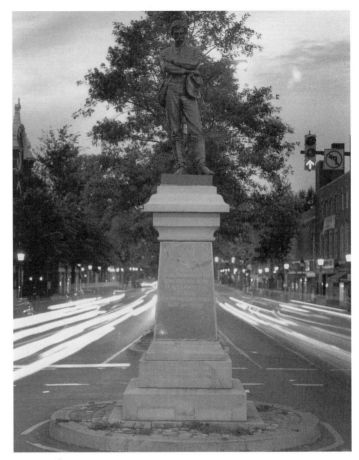

Once a large park with cast iron fences and lampposts, the area around the Alexandria Confederate Memorial has been whittled down to a small island amid a sea of traffic.

scene in graphic detail. After the war, Elder established his studio in Richmond and began painting the portraits of Robert E. Lee, "Stonewall" Jackson, and Jefferson Davis, and the poignant battle scenes, like *Appomattox*, that were extremely popular throughout the South.

Elder was a painter, not a sculptor. Though his model won the committee's admiration, he hadn't the skills to transform it into a large bronze. Probably at Elder's suggestion, committee members chose New York sculptor Caspar Buberl (1834–99) to create the life-size soldier after Elder's model. Buberl had already demonstrated his gift for realism with his detailed frieze commemorating the men of the Union army and navy, created for the Pension Building and completed in 1882 (see #10).

Once the R. E. Lee Camp had their design and their sculptor, the next thing they needed was money: $2,000 for the figure and $1,200 for the base of Georgia granite. To raise funds, they initiated a lecture series featuring Confederate leaders guaranteed to draw large audiences: Colonel Arthur Herbert of the 17th Virginia Infantry, Major General William Henry Fitzhugh "Rooney" Lee, second son of Robert E. Lee, and the wildly popular "Gray Ghost," Colonel John S. Mosby. The wives of camp members formed the Women's Auxiliary

Members of the R. E. Lee Camp of the United Confederate Veterans lined up in front of the monument they had just dedicated on May 24, 1889. Courtesy of the Alexandria Library, Lloyd House.

of the Lee Camp to help with fundraising by staging fairs with booths selling candy, ribbons, and flowers. Brigadier General Montgomery D. Corse, a commander of the 17th Virginia Infantry, announced with a flourish his own unique contribution to the campaign. As a veteran of the Mexican War, Corse received a pension from the federal government. He donated his entire pension to the monument fund and never tired of pointing out that, thanks to him, Yankee dollars had helped to pay for the Confederate statue.

In 1888, the Alexandria City Council granted permission to the camp to erect its statue on the spot from which the city's soldiers had marched out of town. May 24, 1889, the twenty-eighth anniversary of their departure, was set for the monument's dedication. Banks, schools, and the city government were closed. The *Alexandria Gazette* reported that, "in addition to the extraordinarily large number landed by boat, parties from the neighboring counties in carriages and all sorts of vehicles poured into the streets from early morning and by noon the neighborhood of the statue was packed by a huge mass of humanity." A long procession featuring mounted police, local fire company bands, veterans of the 17th Virginia Infantry led by General Corse, and scores of other Confederate veterans, who were tirelessly cheered by the crowds, wound through the town and stopped at the statue's base.

The conciliatory invocation concluded, "May the memory of our departed heroes inspire us with patriotic devotion; may all hatred and strife be buried in their graves." This was followed by a remarkable speech by Captain R. Travers Daniel, a friend of Elder's. Daniel quickly moved on from extolling the bravery of the Confederates who slept "in the bivouac of the dead" to excoriating their Yankee enemies. As he concluded, Daniel laid on the North the entire burden of binding up the wounds it had so maliciously inflicted: "It remains for the people of the North to make this a homogeneous and harmonious nation. Let us hope then that in the near future impertinent intermeddling of one section with the domestic affairs of another will cease—that all vindictive legislation will be wiped from the statute book." Just

how many in the audience still shared Daniel's fiery passion is unknown, though reporters noted that approving shouts punctuated his oration. By 1889, the younger members in the crowd were hearing less and less of this sort of inflammatory rhetoric.

The statue was unveiled by Miss Virginia Corse, General Corse's daughter. So ardent a Rebel and so proud an Alexandrian was Corse that some joked that his daughter's name was really 17th Virginia. Many in the crowd were moved to tears by the statue standing before them. The handsome, life-size, Confederate private, with his thick hair and broad shoulders, faces south, his back turned toward the Yankees. His arms are folded across his chest, one hand clasps his rumpled hat, his sad eyes are cast down. The north face of the pedestal bears Robert E. Lee's tribute to his men: "They died in the consciousness of duty faithfully performed." The south face reads: "Erected to the memory of the Confederate dead of Alexandria, Va., by their Surviving Comrades, May 24, 1889" and "This monument marks the spot from which the Alexandria troops left to join the Confederate forces May 24, 1861." The east and west faces bear the names of the ninety-nine Alexandria soldiers, most with the 17th Virginia Infantry, who were killed in battle.

An additional name, that of James W. Jackson, was added to the east side in 1900. Jackson, a civilian, was actually Alexandria's first Civil War casualty, dying before any of the soldiers with whose names his is inscribed. An ardent secessionist, Jackson was the innkeeper of the Marshall House Hotel. In April 1861, he had hoisted Alexandria's first Confederate flag over his establishment and vowed to blow to bits any Yankee who interfered with it. On the morning of May 24, 1861, as 24-year-old Colonel Elmer Ellsworth of the 11th New York Infantry marched through the occupied town, he noticed the flag. With a detail of comrades, he left the column, entered the hotel, climbed the stairs, and tore it down. True to his word, Jackson shot Ellsworth dead, only to be killed himself by another Zouave. It was said that Ellsworth's and Jackson's blood ran together down the steps. Today a bronze plaque on the southeast corner of Pitt and King Streets, just a few blocks from the Confederate statue, marks the spot where both men died.

When it was dedicated in 1889, the Confederate statue stood in the middle of a grassy park measuring 40 feet by 60 feet and graced at various times by ornate iron fences and gas lamps topped with eagles. Over the years, the park has been whittled down to a tiny island on which the statue stands marooned amid a sea of cars. In 1988, one of those vehicles smashed into it, knocking the soldier completely off his pedestal and touching off a round of arguments over whether or not he should be put back up again.

Perhaps sensing that their bronze private might not always be viewed with the same enthusiasm they felt for him, the members of the R. E. Lee Camp had had legislation introduced in the Virginia House of Delegates in 1890 protecting the statue and requiring it to

"remain in its present position as a perpetual and lasting testimonial to the courage, fidelity and patriotism of the heroes in whose memory it was erected." Efforts in the 1930s to move the statue to relieve traffic congestion had run up against this law, as have more recent efforts, beginning in the 1970s, that were based on moral, rather than pragmatic, grounds. Leaders of Alexandria's African American community seek the statue's removal, arguing that to them it is not a testimonial to "courage, fidelity and patriotism" but a reminder of a time that for them held only misery.

SOURCES

Confederate Monument file, Lloyd House, Alexandria Public Library, Alexandria, Va.

Alexandria Gazette, April and May, 1889.

James G. Barber, *Alexandria and the Civil War* (Alexandria, 1988), 13–14, 26–27, 105.

"The Confederate Statue," Office of Historic Alexandria, n.d.

Margaret Coons, "A Portrait of His Times: John Elder's Paintings Reflect People and Events During a Critical Period in Virginia History," *Virginia Cavalcade* (Spring 1967): 15–31.

APPENDICES

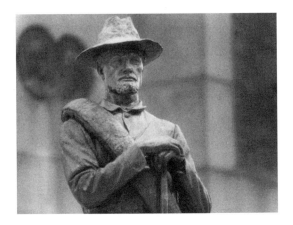

Illustration: *Life-size infantryman guarding a corner of the Sherman Monument*

1863 Freedom
1865 Arsenal Monument
 Major John Rodgers Meigs
1868 Abraham Lincoln, Judiciary Square
1873 Lieutenant General Winfield Scott, Soldiers' Home
1874 Lieutenant General Winfield Scott, Scott Circle
 Major General John A. Rawlins
1876 Emancipation
 Brigadier General James Birdseye McPherson
1877 Peace Monument
1879 Major General George H. Thomas
1881 Admiral David Farragut, Farragut Square
1882 Pension Building
1887 James A. Garfield Memorial
1889 Alexandria Confederate Memorial
1891 Major General William Worth Belknap Monument
1896 Major General Winfield Scott Hancock
1901 Albert Pike Memorial
 Major General John A. Logan
1903 General William Tecumseh Sherman Monument
1907 Major General George B. McClellan
1908 General Philip H. Sheridan
1909 Benjamin Franklin Stephenson and the Grand Army of the
 Republic Memorial
1914 Major General Philip Kearny
 Confederate Monument
 25th New York Volunteers Monument
1915 Brigadier General Richard L. Hoxie and Vinnie Ream Hoxie Monument
1920 Lincoln under Fire
1921 Rear Admiral Samuel Francis Du Pont Memorial Fountain

1922 Ulysses S. Grant Memorial

Lincoln Memorial

Major General Henry W. Lawton Monument

1924 Nuns of the Battlefield

1926 John Ericsson Monument

1927 Major General George Gordon Meade Memorial

1940 Abraham Lincoln, Rail Fence Mender

1947 Abraham Lincoln, Fort Lincoln Cemetery

1976 Veterans of Foreign Wars Tribute

1987 Admiral David Farragut, United States Navy Memorial

1998 African-American Civil War Memorial

APPENDIX B ALPHABETICAL LIST OF MONUMENTS WITH SCULPTORS

African-American Civil War Memorial (Ed Hamilton)

Alexandria Confederate Memorial (Caspar Buberl after design by John A. Elder)

Arsenal Monument (Lot Flannery)

Major General William Worth Belknap Monument (Carl Rohl-Smith)

Confederate Monument (Moses Jacob Ezekiel)

Rear Admiral Samuel Francis Du Pont Memorial Fountain (Daniel Chester French, sculptor; Henry Bacon, architect)

Emancipation (Thomas Ball)

John Ericsson Monument (James Earle Fraser)

Admiral David Farragut, Farragut Square (Vinnie Ream Hoxie)

Admiral David Farragut, United States Navy Memorial (Robert Summers)

Freedom (Thomas Crawford)

James A. Garfield Memorial (John Quincy Adams Ward, sculptor; Richard Morris Hunt, architect)

Ulysses S. Grant Memorial (Henry Merwin Shrady, sculptor; Edward Pearce Casey, architect)

Major General Winfield Scott Hancock (Henry Jackson Ellicott)

Brigadier General Richard L. Hoxie and Vinnie Ream Hoxie Monument (Vinnie Ream Hoxie, statue; George Julian Zolnay, relief panel)

Major General Philip Kearny (Edward Clark Potter)

Major General Henry W. Lawton Monument (Myra Reynolds Richards)

Abraham Lincoln, Fort Lincoln Cemetery (Andrew O'Connor)

Abraham Lincoln, Judiciary Square (Lot Flannery)

Abraham Lincoln, Rail Fence Mender (Louis Slobodkin)

Lincoln Memorial (Daniel Chester French, statue; Henry Bacon, architect; Ernest Bairstow, stonework; Jules Guerin, artist)

Lincoln under Fire (James E. Kelly)

Major General John A. Logan (Franklin Simmons)

Major General George B. McClellan (Frederick MacMonnies)

Brigadier General James Birdseye McPherson (Louis Rebisso)

Major General George Gordon Meade Memorial (Charles Grafly)

Major John Rodgers Meigs (Theophilus Fisk Mills)

Nuns of the Battlefield (Jerome Connor)

Peace Monument (Franklin Simmons)

Pension Building (Caspar Buberl)

Albert Pike Memorial (Gaetano Trentanove)

Major General John A. Rawlins (Joseph A. Bailly)

Lieutenant General Winfield Scott, Scott Circle (Henry Kirke Brown)

Lieutenant General Winfield Scott, Soldiers' Home (Launt Thompson)

General Philip H. Sheridan (Gutzon Borglum)

General William Tecumseh Sherman Monument (Carl Rohl-Smith)

Benjamin Franklin Stephenson and the Grand Army of the Republic
Memorial (John Massey Rhind)

Major General George H. Thomas (John Quincy Adams Ward)

25th New York Volunteers Monument (unknown)

Veterans of Foreign Wars Tribute (Felix de Weldon)

APPENDIX C　　　ALPHABETICAL LIST OF SCULPTORS
WITH MONUMENTS

Bacon, Henry (Rear Admiral Samuel Francis Du Pont Memorial Fountain;
Lincoln Memorial)

Bailly, Joseph A. (Major General John A. Rawlins)

Bairstow, Ernest (Lincoln Memorial)

Ball, Thomas (Emancipation)

Borglum, Gutzon (General Philip H. Sheridan)

Brown, Henry Kirke (Lieutenant General Winfield Scott, Scott Circle)

Buberl, Caspar (Alexandria Confederate Memorial; Pension Building)

Casey, Edward Pearce (Ulysses S. Grant Memorial)

Connor, Jerome (Nuns of the Battlefield)

Crawford, Thomas (Freedom)

de Weldon, Felix (Veterans of Foreign Wars Tribute)

Elder, John A. (Alexandria Confederate Memorial)

Ellicott, Henry Jackson (Major General Winfield Scott Hancock)

Ezekiel, Moses Jacob (Confederate Monument)

Flannery, Lot (Arsenal Monument; Abraham Lincoln, Judiciary Square)

Fraser, James Earle (John Ericsson Monument)

French, Daniel Chester (Rear Admiral Samuel Francis Du Pont Memorial
Fountain; Lincoln Memorial)

Grafly, Charles (Major General George Gordon Meade Memorial)

Guerin, Jules (Lincoln Memorial)

Hamilton, Ed (African-American Civil War Memorial)

Hoxie, Vinnie Ream (Admiral David Farragut, Farragut Square; Brigadier
General Richard L. Hoxie and Vinnie Ream Hoxie Monument)

Hunt, Richard Morris (James A. Garfield Memorial)

Kelly, James E. (Lincoln under Fire)

MacMonnies, Frederick (Major General George B. McClellan)

Mills, Theophilus Fisk (Major John Rodgers Meigs)

O'Connor, Andrew (Abraham Lincoln, Fort Lincoln Cemetery)

Potter, Edward Clark (Major General Philip Kearny)

Rebisso, Louis (Brigadier General James Birdseye McPherson)

Rhind, John Massey (Benjamin Franklin Stephenson and the Grand Army of the Republic Memorial)

Richards, Myra Reynolds (Major General Henry W. Lawton Monument)

Rohl-Smith, Carl (Major General William Worth Belknap Monument; General William Tecumseh Sherman Monument)

Shrady, Henry Merwin (Ulysses S. Grant Memorial)

Simmons, Franklin (Major General John A. Logan; Peace Monument)

Slobodkin, Louis (Abraham Lincoln, Rail Fence Mender)

Summers, Robert (Admiral David Farragut, United States Navy Memorial)

Thompson, Launt (Lieutenant General Winfield Scott, Soldiers' Home)

Trentanove, Gaetano (Albert Pike Memorial)

Ward, John Quincy Adams (James A. Garfield Memorial; Major General George H. Thomas)

Zolnay, George Julian (Brigadier General Richard L. Hoxie and Vinnie Ream Hoxie Monument)

Other Sources Consulted

In addition to the works cited at the conclusion of each section, several other sources provided context and reference information and informed the Introduction and the discussions of the individual monuments.

The brief biographies of generals, admirals, political figures, and sculptors in the ten-volume *Dictionary of American Biography*, edited by Dumas Malone in the 1930s, provided concise information and helpful bibliographies.

Especially useful were the collections of three Washington repositories. The Washingtoniana Division of the Martin Luther King, Jr., Public Library maintains subject files and houses the clipping morgue of the defunct *Washington Star*. Among the library's extensive local history holdings is a set of scrapbooks labeled "Monuments and Memorials," into which clippings, invitations, and press releases spanning at least three decades were pasted. The holdings of the Historical Society of Washington, D.C., include excellent subject files, plus scrapbooks of clippings and a well-indexed photograph collection. The best source of information on sculptors proved to be the outstanding files, arranged by artist, at the National Museum of American Art / National Portrait Gallery Library, which yielded a wealth of information on even the most obscure sculptor.

The books, articles, and dissertations that proved most helpful are:

Bishir, Catherine W. "Landmarks of Power: Building a Southern Past, 1885–1915," *Southern Culture* 1 (1993): 5–45.

Bogart, Michele H. *Public Sculpture and the Civic Ideal in New York City, 1890–1930.* Chicago: University of Chicago Press, 1989.

Craven, Wayne. *Sculpture in America.* Newark: University of Delaware Press, 1984.

Davis, Stephen. "Empty Eyes, Marble Hand: The Confederate Monument and the South," *Journal of Popular Culture* 16 (Winter, 1982): 2–21.

Doss, Erika. *Spirit Poles and Flying Pigs.* Washington, D.C.: Smithsonian Institution Press, 1995.

Gillis, John R., editor. *Commemorations: The Politics of National Identity.* Princeton: Princeton University Press, 1994.

Goode, James M. *The Outdoor Sculpture of Washington, D.C.* Washington, D.C.: Smithsonian Institution Press, 1974.

Kammen, Michael. *Mystic Chords of Memory: The Transformation of Tradition in American Culture.* New York: Alfred Knopf, 1991.

Linenthal, Edward Tabor. *Sacred Ground: Americans and Their Battlegrounds.* Urbana: University of Ilinois Press, 1991.

Mayo, James. *War Memorials as Political Landscape: The American Experience and Beyond.* New York: Praeger, 1988.

McPherson, James. *Battle Cry of Freedom: The Civil War Era.* New York: Ballantine Books, 1988.

Montagna, Dennis R. "Henry Merwin Shrady's Ulysses S. Grant Memorial in Washington, D.C.: A Study in Iconography, Content, and Patronage." Ph.D. dissertation, University of Delaware, 1987.

Panhorst, Michael Wilson. "Lest We Forget: Monuments and Memorial Sculpture in National Military Parks on Civil War Battlefields, 1861–1917." Ph.D. dissertation, University of Delaware, 1988.

Peterson, Merrill D. *Lincoln in American Memory.* New York: Oxford University Press, 1994.

Piehler, Guenter Kurt. "Remembering War the American Way: 1783 to the Present." Ph.D. dissertation, Rutgers University, 1990.

Savage, Kirk. "The Politics of Memory: Black Emancipation and the Civil War Monument." In *Commemorations: The Politics of National Identity,* edited by John Gillis. Princeton: Princeton University Press, 1994.

Savage, Kirk. "Race, Memory and Identity: The National Monuments of the Union and the Confederacy," Ph.D. dissertation, University of California, Berkeley, 1990.

Warner, Ezra. *Generals in Blue: Lives of the Union Commanders.* Baton Rouge: Louisiana State University Press, 1992.

Index

The reader may also refer to the lists of monuments and sculptors in the appendices.

LIBRARY OF CONGRESS CATALOGING-IN-PUBLICATION DATA

Jacob, Kathryn Allamong.
Testament to Union : Civil War monuments in Washington, D.C. /
Kathryn Allamong Jacob ; photographs by Edwin Harlan Remsberg.
p. cm.
Includes bibliographical references (p.) and index.
ISBN 0-8018-5861-5 (alk. paper)
1. Soldiers' monuments—Washington (D.C.)—Guidebooks. 2. United States—
History—Civil War, 1861–1865—Monuments—Guidebooks. 3. Washington
(D.C.)—Guidebooks. I. Remsberg, Edwin Harlan. II. Title.
F203.4.A1J33 1998
917.5304'41—dc21 97-32884 CIP